Dadas
on
Art

Edited by

Lucy R. Lippard

A SPECTRUM BOOK

Prentice-Hall, Inc., *Englewood Cliffs, N.J.*

Copyright © 1971 by
PRENTICE-HALL, Inc.
Englewood Cliffs, New Jersey

A SPECTRUM BOOK

Current Printing (last number):
10 9 8 7 6 5 4 3 2 1

C-13-197459-9
P-13-197442-4

Library of Congress Catalog Card Number: 71-140271

Printed in the United States of America

PRENTICE-HALL INTERNATIONAL, INC. (*London*)
PRENTICE-HALL OF AUSTRALIA, PTY. LTD. (*Sydney*)
PRENTICE-HALL OF CANADA, LTD. (*Toronto*)
PRENTICE-HALL OF INDIA PRIVATE LIMITED (*New Delhi*)
PRENTICE-HALL OF JAPAN, INC. (*Tokyo*)

To Bernard Karpel,
my professional Dada.

Acknowledgments

I should like to thank the following people for help in all stages of this book: The staff of the Museum of Modern Art Library, New York; William Camfield, Mimi Wheeler, William Rubin, Hans Richter, George Wittenborn, Janet Hughes; the artists, their estates and their publishers for permission to reproduce the texts; Gabriele Bennett for her translations from the German, Claire Nicolas White for hers from the Dutch, and Margaret I. Lippard for sharing the French with me.

LUCY R. LIPPARD,
the editor of this volume,
is an art historian and critic of contemporary art.
In 1968 she received a John Simon Guggenheim Foundation
fellowship to write a forthcoming book on Ad Reinhardt.
Among her other publications are *Pop Art,*
Changing (a collection of essays), and
Surrealists on Art.

Contents

Contents

Introduction

What is Dada? A virgin microbe.
Dada is a tomato.
Dada is a spook.
Dada is the chameleon of rapid, interested change.
Dada is never right.
Dada is soft-boiled happiness.
Dada is idiotic.
Dada is not a mystification. It is the entire human mystery.
Dada gives itself for nothing, for Dada is priceless.
Dada is life. Dada is that which changes.
Dada is nothing, nothing, nothing.
Everything is Dada.

 —Quotations from Dada tracts and manifestoes

A few years ago a New York abstract artist asked Marcel Duchamp to come see his work because Duchamp had been an influential factor in its development. Duchamp came, and found a rough, powerful geometric sculpture, very much of the "New York School," that seemed to bear no relationship to Dada either in style or intention. It turned out that the work had been suggested by a catalogue for office furniture, where a certain kind of filing shelf had caught the artist's eye. This solution, he contended, would have gone unnoticed had it not been for Duchamp's expansion of the art repertory to all existing sights and objects.

In this sense, Dada has affected (some would say afflicted) a vast amount of twentieth-century art—from the most formally oriented products of Pollock's adaptations of Dada-Surrealist automatism, to art-as-action or art-as-idea rather than art as *objet d'art* and commodity. Thus Pop Art, quasi-psychedelic and intermedia manifestations, and their apparent opposite, Conceptual Art, all have roots (rarely admitted) in Dada. The world situation today, after all, is not so different, or any better, than it was after World War I. Dada's pacifism, socialism, fragmentation, and emphasis on change continues, for Dada's nihilism was, as Robert Goldwater has observed, instrumental rather than fundamental. The first step toward a comprehension of Dada is necessarily a leap over the initial paradox: this agent of immediacy and destruction has created some of the most enduring objects and attitudes of our times.

 * * *

*There is no Dada truth. One need only utter a statement for
the opposite statement to become Dada.*

—André Breton

Dada "theory" differed from city to city and finally from person to person. It was never as compact as Surrealism. The fragmented nature of Dada lends itself far better to the anthological approach than to conventional histories. The best book on the Dada movement remains Robert Motherwell's *Dada Painters and Poets* (New York: Wittenborn & Schultz, 1951), an anthology of original writings accompanied by Bernard Karpel's unique bibliography. The book includes Georges Hugnet's long essay, "The Dada Spirit in Painting" (1932, 1934), a major source of all later histories and the basis of Hugnet's book, *L'Aventure Dada* (Paris: Galerie de l'institut, 1957). Michel Sanouillet's extraordinarily thorough *Dada à Paris* (Paris: Jean-Jacques Pauvert, 1965), crammed with original documents and first-hand accounts, does for that city what should be done for the others in which Dada flourished so variously. Willy Verkauf's *Dada: Monograph of a Movement* (New York: Wittenborn, 1957) also takes an anthological approach. The text and lengthy chronology in William S. Rubin's *Dada and Surrealist Art* (New York: Abrams, 1969) provides the best art-historical analysis of the movement within the framework of all twentieth-century art, suffering only from the inevitable presentation of Dada as prologue to Surrealism, rather than the separate entity it really was. Maurice Nadeau's *The History of Surrealism* (revised paperback edition, New York: Collier Books, 1967), Marcel Jean's *The History of Surrealist Painting* (New York: Grove Press, 1960), and the companion volume to this present one, *Surrealists on Art* (Englewood Cliffs, N.J.: Prentice-Hall, 1970) are valuable in the same context.

Ironically, ex-Dadas have been more concerned with their own histories than have been the participants in any other major movement. The battle around the invention of photomontage (actually "invented" independently by several people in a spirit of simultaneity appropriate to Dada) and around the chance discovery of the very word Dada will rage until all the protagonists and their protagonists are dead. Motherwell almost had to abandon his anthology because Hülsenbeck and Tzara each refused to participate if the other's recent Dada manifesto were printed (a dilemma solved by printing both on separate tracts which were then inserted but not bound in the book). Several Dadas have written memoirs in which old axes are reground. To varying degrees these are informative, fretful, fascinating, and inaccurate except as accounts of personal experience. Among them are Hans Richter's *Dada Art and Anti-Art* (New York: McGraw-Hill

paperback, 1965), Raoul Hausmann's *Courrier Dada* (Paris: Terrain Vague, 1958), Georges Ribemont-Dessaignes' *Déja Jadis* (Paris: Julliard, 1958), Man Ray's *Self-Portrait* (Boston: Little-Brown, 1962), and Hugo Ball's *Die Flucht aus der Zeit* (1927; republished Lausanne: Stocker, 1946). Marcel Duchamp's writings, collected by Sanouillet under the title, *Marchand du Sel* (Paris: Terrain Vague, 1958), are required reading along with his *Green Box* (see pp. 145–54).

Given the nature of Dada, then, the more comprehensive first-hand information available, the better. The present volume is intended to augment the existing source literature in English rather than to analyze, summarize, or replace it. The focus is on writings by visual artists because their contributions tend to be lost and confused amid the prolific production of their literary colleagues and because of the light these contributions can shed on their plastic works. I have included pieces by Tzara and Hülsenbeck, two writer-founders of the movement, because they illustrate the widening void between German and Parisian diversions of Dada. It should also be noted that some of the Dada painters and sculptors can be considered *littérateurs* "in their own write," for example, Picabia, Arp, Schwitters, Hausmann, and Ribemont-Dessaignes. Throughout Dada, separation of the various media is often as hopeless as it is irrelevant.

* * *

We are going to exalt national sentiment with insanity, with paroxysms, with whatever need be. I prefer a nation of lunatics.
—Ernesto Gimenez Caballero, speaking for Spanish Fascism, 1934.

Dada history is difficult to approach on a grand scale, but no favors at all would be done it or the reader by oversimplification. Nevertheless, at the risk of just that, I should like to make some distinctions between the various dadadoms, whose divergent characters can to some extent be attributed to the characters of the cities that were their headquarters. New York, first stronghold of the as-yet-nameless phenomenon, produced a hybrid activity, French-accented, since its prime movers were Duchamp and Picabia. It flourished in 1915–17, before America entered the war, and was, therefore, the product of disgust once-removed. Isolation from the political realities in which European groups were inundated gave New York Dada its frivolous air; its center was the home of liberal millionaire Walter Arensberg; its vehicles were "scandal and malicious humor"; its 1917 publications —*The Blind Man* and *Rongwrong*—"were intended as nothing more than somewhat subversive amusements," according to Gabrielle Buffet-

Picabia. "I insist," she continues, "on the perfect gratuitousness of the 'demonstrations,' which learned historians have represented as conscious and meaningful—in actual fact these demonstrations issued spontaneously from the most trivial circumstances and gestures." New York Dada was primarily important for its objects: Picabia's machine series, Duchamp's readymades and *Large Glass,* peaking in the urinal submitted by the latter to the 1917 Independents exhibition (see pp. 144–54). Picabia, of course, became a Dada force in Europe after leaving New York, and Paris Dada would not have been the same without him.

Zurich Dada (Hugo Ball, Emmy Hennings, Jean Arp, Sophie Taueber, Richard Hülsenbeck, Tristan Tzara, Marcel Janco, and, later, Hans Richter and Viking Eggeling) was a truly international and collaborative effort. It arose spontaneously in 1915 when Ball opened the Cabaret Voltaire as a center for "other young men in Switzerland who, like myself, wanted not only to enjoy their independence but also to give proof of it." Some of these had participated in the war and were recovering, others were firmly pacifist, while others were planning radical ventures for the postwar period. Lenin was in Zurich at the time. If Switzerland in 1915–17 was the calm before the revolutionary storm, Dada simply rushed things a bit, providing (for the Berlin Dadas in particular) a pilot project in esthetic anarchy. The name Dada was found at random in a dictionary, either by a group or by Tzara or by Hülsenbeck (see pp. 45–56). There was as yet no Dada style, and the work shown at the Dada Gallery from 1916–18, with the exception of Arp's, carried on programs initiated by earlier movements, primarily Futurism, but also Cubism and Expressionism of the *Blaue Reiter* bent, and included such established figures as Paul Klee. The performances were more innovatory, and in them are found the seeds of the Dada that arose in other cities. It is probable that Tzara's poetry and personality and his indefatigable letter-and-manifesto-writing set the general tone for this motley crew; certainly as editor of the influential review *Dada,* which spread the good word over Europe once the war was over, he wielded more power then than anyone else. Dada had moved only as far as Berlin when Picabia's arrival in January, 1919, opened what had hitherto been a relatively small-scale rebellion into the mainstreams of the European avant-garde. Hugnet attributes to Picabia's brief presence in Zurich that point in Dada history when "the useless begins to drop away and the essential narrows down to that human force, unconscious and willful, destructive and clean."

The third major spokesman for Zurich Dada was Richard Hülsenbeck. More politically involved than the others, Hülsenbeck brought

to Berlin in 1917 a Dada that was a serious revolutionary tool, neces-
sitated by the situation in the city itself: "Berlin was a city of tightened
stomachers, of mounting, thundering hunger, where hidden rage was
transformed into a boundless money lust, and men's minds were con-
centrating more and more on questions of naked existence . . . Fear
was in everybody's bones" (see pp. 45–46). With Raoul Hausmann,
Hannah Höch, George Grosz, the brothers John Heartfield and
Wieland Herzfelde, as well as Franz Jung and the enigmatic figures
of Johannes Baader and Dr. Serner, Hülsenbeck waged a real political
war on the evils of that insane society. He was even Commissar of
Fine Arts during the abortive revolution in 1917. The publications
*Der Dada, Dada Club, Everyman his own Football, and Almanach
Dada* and the Dada demonstrations in Berlin were Communist in
tone and affiliation. The only "esthetic" event there was the huge
Dadamesse (International Dada Fair) held in June, 1920, uniting
Dada art from all over the world. Aside from Grosz's bitter caricatures
of ruling military and industrial society, Berlin Dada's major visual
instrument was photomontage, an adaptation of collage fusing typo-
graphic and photographic elements to produce jagged warnings, ex-
clamations, incongruous images, and seditious small print. The effec-
tiveness of photomontage as a propaganda medium was such that John
Heartfield continued to use it for the Communist cause until his
death (see pp. 90–97).

In Cologne, at the same time, Max Ernst and Johannes Theodor
Baargeld (with occasional appearances from the peripatetic Arp, who
participated in all the Dada groups simultaneously at this period)
were developing montage techniques to more esthetic ends. Ernst was
and always has been apolitical. Although Baargeld was a leader of the
Communist party and his first review, *Der Ventilator,* was distributed
at factory gates and confiscated by the British Army of Occupation,
politics did not interfere with the establishment of a fine-art anarchy
intended to bury official Expressionism under a new reality with
ultimately broad-ranging social ramifications. Cologne was, of course,
far quieter and more isolated than Berlin, and although they wrote
biting prose and poetry satirizing cultural institutions, Ernst and
Baargeld concentrated on the unexpected poetry of the photo-collage,
and objects and drawings influenced by the art of the insane. The
Cologne publications, *W/3 West Stupidia, Bulletin D,* and *Die Scham-
made* (all 1919–20), included among their contributors the Paris Dadas,
with whom Ernst was in contact by 1920. Along with the Berlin
Dadamesse and Paris' Salon Dada at the "Galerie Montaigne" in 1921,
the two Cologne exhibitions were the most important art shows of the
movement. The first of these was held in November, 1919 (*Bulletin D*

was its catalogue) and is notable for its inclusion of children's drawings, mathematical models, paintings by dilettantes, an African sculpture, found objects, and photographs. The second, "Dada Vorfrühling" (Early Dada Spring), in April, 1920, was held in a cafe courtyard and entered through the public urinal. Its "exhibits" included a little girl in communion dress reciting obscene poems; Baargeld's proto-Surrealist object with a wig, wooden arm, and alarm clock in an aquarium of red water; and Ernst's destructible object, accompanied by a hatchet and an invitation to hack it. The show was closed by the police and allowed to reopen only when the offending exhibit turned out to be a Dürer engraving (*Adam and Eve*).

The smallest, but not least important, Dada branch was in Hanover, where Kurt Schwitters published his own review—*Merz,* made his Merzcollages and Merzconstructions, wrote and published his bruitist Merzpoetry, built his Merzbau (see pp. 98–110), and imported fellow Dadas for lectures and actions. Schwitters rejected politics entirely ("Merz aims only at art, because no man can serve two masters."), an attitude which did not endear him to the Berlin group. He published *Merz* until 1932, although his own involvement with Constructivism and *de Stijl* gave it a less Dada tone toward the end. Cologne Dada was relatively inactive after 1920 and ceased when Ernst left for Paris in 1922. Although Berlin Dada continued into the mid-twenties, its members were increasingly involved in their own art or, as in the case of Grosz, Heartfield, and Herzfelde, became wholly absorbed by political concerns. By the winter of 1920 (though Dada events were being held in New York, Geneva, Mantua, Prague and Amsterdam), all major activity was centered in Paris, where, chameleon-like, Dada again took on the coloration of its environment.

Paris Dada originated in the circle around the ironically titled review, *Littérature.* André Breton, Louis Aragon, Paul Eluard, Philippe Soupault—all writers, and Georges Ribemont-Dessaignes—artist and writer, had been experimenting with ideas paralleling Dada since around 1917, but until the advent of Picabia and Tzara in 1919 their main concern was cultural reform rather than revolution and anarchy. Even at its most chaotic, Paris retained a sophisticated nonchalance that tended to mitigate its effectiveness, if not its violence. The May, 1920, issue of *Littérature* was devoted to "Twenty-Three Manifestoes of the Dada Movement." The same month the notorious "Dada Festival" was held at the Salle Gaveau, accompanied by fox trots played on an organ, audience participation of an often unexpected vigor, hurled eggs, tomatoes, and paper airplanes, and at least one fistfight, not to mention the program itself. April 14, 1921, marked the "opening of the Grand Dada Season," followed by a flood of mani-

festoes, events, and publications, the "trial of Maurice Barrès," Dada
"visits" (see pp. 161–64), and the controversy surrounding Breton's
projected Congrès de Paris, his first effort to control the Dada con-
tradictions.

Because of the literary emphasis of Paris Dada, its production of
reviews, pamphlets, tracts, and other ephemera outnumbered those of
all the previous centers. The visual arts were secondary, and uncon-
nected, with Arp, Ernst, and Picabia developing their individual styles.
Paris was a suitably confused finale, with the meeting of all the major
Dada personalities igniting rather than uniting the movement. The
frenetic activity of 1921–22 was characterized by an increasing lack of
conviction, and by 1922 nearly everyone had at one time or another
publicly broken with everyone else, or publicly denounced Dada, or
founded a countermovement. The power struggle between Breton and
Tzara over the Congress of Paris in 1921 ended with Breton's syn-
thesizing triumphant over Tzara's fragmentation, and from 1922 to
1924, when Surrealism, Breton firmly in control, made its formal
debut, was appropriately called the *époque flou* (soft time). In 1951,
Duchamp alone still claimed to be a Dada.

* * *

Dada is a state of mind.

—Dada tract

Surrealism is a way of life.

—Surrealist tract

*Dada never preached, having no theory to defend; it showed
truths in action and it is as action that what is commonly called
art will, henceforth, have to be considered.*

—Tristan Tzara

Dada and Surrealism are not interchangeable. In fact, Surrealist
systematization was a direct reaction against Dada chaos. The relation-
ship between them would be clearer if events in Paris after 1921 were
simply called Surrealism. Dada lost its political and esthetic virginity
to the postwar period. In 1916 Hugo Ball recommended "everything
childlike and symbolic in opposition to the senilities of the world of
grown-ups." As childlike he also included the "infantile, demaentia,
and paranoia," adding prophetically: "The credulous imagination of
children is also exposed to corruption and deformation." Swiss and
German Dada, with its hostility, exuberance, and revolutionary opti-
mism, represents the childhood stage of the Dada-Surrealist phenom-
enon, and is often shunted off as an overture to the magnificently

prolonged pubescence that was Paris Dada and Surrealism. Yet Sur-
realism, for all its achievements, was housebroken Dada, resulting in
a loss of innocence and freshness, an entrance into the second stage,
characterized by obsessions notably consistent with late adolescence.
If this figure were followed through, the many related manifestations
over the last thirty years might represent individual maturities.

The two movements differed more in intent than in content. All the
seeds of Surrealism existed in pre-Parisian Dada: bruitist poetry;
automatic writing; the sexual, anticlerical, revolutionary impetus; ex-
ploitation of the unconscious, of randomness and chance. On the
formal side, biomorphism, collage, and "dream" paintings, based on
the juxtaposition of unexpected realities, found and concocted objects,
interest in the art of the insane, of children, of primitive cultures, and
of autodidacts, were all found in Dada. Many of these were first
explored by de Chirico, by the Futurists, and by the international
associations of *Der Sturm* and *die Blaue Reiter,* though Surrealism
developed them. It should be remembered that while the French
Dadas and Surrealists had seen Cubism diluted into the "new academy"
by 1920, the Germans were rebelling against their own roots in
Expressionism, their own official style, and they tended to retain the
Cubist-Futurist framework as the most radical formal basis available.
The influence of Giorgio de Chirico's Metaphysical Period may have
been so considerable because he seemed to offer a way out of both
prevailing styles, the strangeness of his juxtapositions outweighing the
fundamentally retrograde illusionism of his technique. Yet far more
than Surrealism, Dada visual art was abstract or quasi-abstract. Photo-
montage and collage offered a breakup of physical nature similar to
that of Cubism, but their realistic sources (images from magazines and
newspapers, textbooks, and so forth) also reflected the political breakup
of the real world. The irrational titles and outrageous contexts within
which such works were presented blurred their innate rationality.
The strain of casting to the winds of change all training and respect
for chosen goals must have been intense even in the bitter and con-
fused environment of postwar Europe, but by 1919 a large number
of painters and poets had discovered a new medium through which
they could more or less escape. This can be generalized as the "collage
esthetic"—totally incongruous and unrelated realities (images, words,
sounds, actions) brought together to form either no sense at all or a
new and unexpected sense, a harshly critical commentary. The poets
(and some of the artists, notably Schwitters and Hausmann) developed
simultaneism, sound poetry, and the typographical literature of chance
which became "concrete poetry." The artists developed photomontage,
photo-collage, typo-photo-collage, and the Dada object from the Cub-

ists' *papiers collés* and constructions and the Futurists' sculpture and *parole in libertà* ("free-words" or typographical compositions). These methods utilized the fusion and confusion of sense and non-sense and lent themselves particularly to the pun, the verbal counterpart of collage's "sight-gags" (see Ernst, pp. 123–31). The texts in this book, many of which initially appear to mean absolutely nothing, yield on perusal a wealth of obscene references and biting commentary via word-play.

* * *

Above all it is necessary to rid art of everything known that it has contained until the present, every subject, every idea, every thought, every symbol must be put aside.
—Giorgio de Chirico, 1913

I think the destructive element is too much neglected in art.
—Piet Mondrian

I would like to see [photography] make people despise painting until something else will make photography unbearable.

Dada was an extreme protest against the physical side of painting, a metaphysical attitude, a blank force.
—Marcel Duchamp

Destruction is creation.
—Bakunin

The fragmentation, gallows humor, and antibourgeois acerbity of the media mentioned above simply reflected on a formal level the destruction by which Europe was threatened during and after World War I. Perhaps one reason why German Dada seems, in retrospect, so much more interesting than the Parisian culmination is because of the desperate vitality forced upon idealistic or artistic East European youth by the hopeless political situation. Zurich, when Dada was christened there in 1916, must not be seen as present-day Switzerland so much as a haven for the young, disillusioned, but determinedly hopeful exiles from a mad and uselessly destructive war—yesterday's Canada. Destruction as an esthetic concept simply used the means at hand, the ruins of the prewar world so efficiently executed by slaughter and rebellion. It must have seemed that destruction begun for the wrong reasons could be equally effective for the right reasons, could become the instrument for accomplishment of the tabula rasa Dada hoped to achieve. Futurism too had attempted to use Cubist estheticism in a clean break from the past, but the situation in postwar Germany necessitated an attack that makes Futurist bombast (some of it neo-Fascist) pale by comparison. In Germany, Dada entered life

itself and fought its battles there. As Tristan Tzara has pointed out, Dada used advertisements not as the Cubists did, "as an alibi, an allusion," but "as a reality at the service of its own publicity." Dada was a public art—if not always *for* the people, at least *against* the art-for-art's-sake position that made art in the late nineteenth century the cultural frosting on middle-class triumph. Certain destructive devices were used for strictly esthetic ends: Arp's *papiers dechirés* (torn papers arranged by chance), Duchamp's use of the accidental cracks in his *Large Glass,* Picabia's dismantled alarm clock print, or Tzara's poetry technique, later used by William Burroughs and others: "Take a newspaper, take scissors, choose an article, cut it out, then cut out each word, put them all in a bag, shake. . . .". Others had more obvious targets in the sacred conventions of past art: Picabia's stuffed monkey tableau ridiculing Cézanne, Renoir and Rembrandt as "nature mortes," or his ink-blot portrait of the Holy Virgin; Duchamp's urinal, his mustached and goateed Mona Lisa, his suggestion for a readymade: "Use a Rembrandt for an ironing board"; Ernst's wooden object attached to the agent of its own destruction—the hatchet (it may be significant that when Man Ray's Surrealist *Object to be Destroyed* was smashed, the artist was not pleased, and that when the younger American Jim Dine made a similar piece in the 1960s it remained intact).

However, destructive devices were also used in a third way, for like the art of the late sixties and seventies, Dada harbored an integral dualism, a usually repressed longing for the cleanest of clean slates, the purism it had apparently rejected when it chose to merge art and life. All the Dada sloppiness and insistent anarchy, its impermanence and iconoclasm, were part of a deliberate move toward the same tabula rasa sought by the Constructivists and *de Stijl* during and after World War I, a fact recognized in Zurich by individual artists but increasingly ignored after 1918. There are, in fact, far more connections between Dada and these groups than is generally known, which constitutes one of the major distinctions between Dada and anti-abstract Surrealism. One of the major liaisons was the Dutch *de Stijl* leader Theo van Doesburg, who was a pseudonymous Dada poet. In his organizational capacities, Doesburg was able to perform certain unlikely fusions, such as inviting Arp and Tzara to the Constructivists' Congress at Weimar in 1922 (see pp. 111–15) or publishing Dada polemics in *de Stijl* and *Mecano,* organs of the nonobjective movement. Hans Richter, an original Zurich Dada, was mainly concerned with nonobjective art and films by 1920. All his life Jean Arp maintained an easy balance between Dada-Surrealist fantasy and the quasi-purist abstraction of groups like *cercle et carré* and *Abstraction-Créa-*

tion. Schwitters' collage materials may have been unheard-of for art, but the final results were tightly structured compositions, and when he joined *de Stijl* in the mid-twenties his fundamental style changed very little. Hausmann vacillated between wholly abstract and figurative visual polemics, while artists in the Constructivist vein utilized photomontage, notably Malevich and Moholy-Nagy. In a less obvious manner Ernst, Picabia, Duchamp, and Man Ray often organized and clarified the most chaotic collection of images according to the tenets of abstraction. The Berlin Dadas in particular also admired Tatlin's Constructivism, to which they were exposed by a book on Russian revolutionary art published in Germany in 1920. The same year the group included in the "Dadamesse" a poster reading "Art is Dead. Long Live the New Machine Art of Tatlin"; Hausmann's most famous photomontage is titled *Tatlin at Home.*

The double road toward a tabula rasa was indicated by the Dada attraction to the hermetic and the invisible. In 1920, Picabia made a drawing on a blackboard while someone else came along behind and erased it; his 1913 "Amorphist Manifesto" was illustrated by blank canvases because total opposition of color had cancelled out color and total opposition of form had cancelled out form. Schwitters hid rather than destroyed the Dada-Expressionist core of his first Merzbau by surrounding it with an abstract framework. The audience arriving for the opening night of the Picabia-Satie ballet, *Relâche (Cancellation)*, in 1924, found the performance cancelled until the next night. Duchamp's *5occ of Paris Air,* his *Hidden Noise,* and other unexecuted readymades referred to in the *Green Box* notes (see pp. 145–54) carried through this meta-anti-physical theme, revived by Yves Klein in 1958, when he exhibited an empty gallery, and by Robert Rauschenberg, when he laboriously erased a drawing by his famous elder, Willem de Kooning, a gesture which had its art-world Oedipal as well as general ramifications. In the late 1960s, examples of a Dada-Constructivist hermeticism are rampant, among them Sol LeWitt's buried cube, Robert Barry's release of liters of inert gas which expand infinitely into the atmosphere, Douglas Huebler's creation of a myth as a work of art, Stephen Kaltenbach's "secret" pieces, Robert Huot's anonymous exhibition entries, and innumerable other "dematerializations" of the art object with a possibly reformatory end in view.

The Dada gestures of apparent nihilism served a triple purpose. They could "épater le bourgeois" and undermine the regime; at the same time they served to contradict the popular conception of Eternal Art, and provided, often literally, a blank page on which the new spirit could be written afresh. In addition they may have satisfied in a satirical manner personal longings for the clean or pure abstraction

from which Dada's antiart program had diverted them. The Dadas were determined to destroy Art not because they themselves could actually reject what art stood for, but because for them it was a weapon important enough to effect change rather than to be embalmed in salons, museums, and universities. Dada was antimaterialist in its stress on change, on temporary media, and on action rather than on the construction of lasting objects constantly increasing in value. Like the guerilla art and theater of the 1970s, Dada dramatized the painful state of the old society while actively working for a new one. One of the reasons behind the outwardly incongruous historicism of the ex-Dadas today may be that the term Dada has come to be synonymous with irresponsible fun and games. "Dada was not a farce," wrote Arp in 1949. "Dada was no fun and it has been thought of as fun only by the people who think man's fate is directed by comic strips. Dada's fun . . . was self-ridicule with the purpose of self-realization," wrote Hülsenbeck in 1953.

The final tragedy, of course, was the Dadas' (and much later the Surrealists') discovery that it had become impossible to make a "shocking" statement about anything within the framework of the avant-garde, that they were stuck with the world of art rather than the real world as an arena for their actions, despite the fact that they, more than any other recent art movement, had succeeded in flashes of political effectiveness. Once it is connected with "art," even by the opposition of art, the strongest protest is taken with a relieved grain of fond salt by the "cultivated" public at which it is aimed. Dada's self-criticism backfired into self-doubt. In part, and despite his miscomprehensions, neo-Cubist Albert Gleizes was justified in writing in 1920: "Dada claims to discredit art by its agitation. But one can no more discredit art, which is the manifestation of an imperious impulsion of the instinct, than one can discredit human society. . . . What Dada destroys, without assuming responsibility for its acts, is certain notions of servitude which would vanish very nicely without its help; since what is destroying the bourgeois hierarchy on the material plane is its false conception of the distribution of social wealth. And that is why Dada, in the last analysis, represents merely the ultimate decomposition of the spiritual values of the decomposed bourgeois hierarchy."

On the other hand, and with Dada there is always another hand, often unaware of what the first hand is doing, "Dada Lives."

<div style="text-align: right">

Lucy R. Lippard
Carboneras, Almería
June 1970

</div>

Tristan Tzara

Tristan Tzara (1896–1963) was born Sami Rosenstock in Bucharest. He arrived in Zurich in 1916 as a monocled young poet and became a founder of Dada and, perhaps, the one who found the name itself in a dictionary (see Arp, pp. 21–22). As editor of its major publication, *Dada* (1917–21), as well as of *Zeltweg* (Zurich, 1919), he was, with Picabia and later Breton, one of the undisputed literary leaders of the movement. His war protest poem, *The Manifesto of Mr. Antipyrine*, was a high point of the first Dada performance at Waag Hall in Zurich on July 14, 1916. He is the author of endless Dada manifestoes, collaborator in all the major international Dada organs, and an inventor of chance, or torn, poems (see Introduction pp. 4–5); his 25 *poèmes*, illustrated by Arp, appeared in 1918, "Monsieur Aa l'antiphilosophe" in 1919. In January, 1920, Tzara went to Paris, where he was "awaited like the Messiah." At first he stayed with Picabia. Georges Hugnet says that "Tzara's arrival launched the era of public demonstrations, of group delirium, of Dada warfare and insults in which, because of previous success, the movement was thoroughly experienced." This culminated in Tzara's opposition to Breton's projected Congress of Paris in 1922, outlined in the former's publication, *Le Coeur à Barbe*. The break between these two leaders also broke Dada, of which only the vestiges remained when Tzara's *Le coeur à gaz* was performed in July, 1923, protested by Breton, Péret, and Aragon, and ended in a riot. Tzara's association with Breton's Surrealism was relatively peripheral compared to his total involvement in Dada, though his poetry continued in a Dada-Surrealist vein.

Dada Manifesto 1918

The magic of a word—Dada—which has brought journalists to the gates of a world unforeseen, is of no importance to us.

To put out a manifesto you must want: ABC
to fulminate against 1, 2, 3,
to fly into a rage and sharpen your wings to conquer and disseminate little abcs and big abcs, to sign, shout, swear, to organize prose into a

form of absolute and irrefutable evidence, to prove your non plus ultra and maintain that novelty resembles life just as the latest appearance of some whore proves the essence of God. His existence was previously proved by the accordion, the landscape, the wheedling word. To impose your ABC is a natural thing—hence deplorable. Everybody does it in the form of crystalbluffmadonna, monetary system, pharmaceutical product, or a bare leg advertising the ardent sterile spring. The love of novelty is the cross of sympathy, demonstrates a naive je m'enfoutisme, it is a transitory, positive sign without a cause.

But this need itself is obsolete. In documenting art on the basis of the supreme simplicity: novelty, we are human and true for the sake of amusement, impulsive, vibrant to crucify boredom. At the cross-roads of the lights, alert, attentively awaiting the years, in the forest. I write a manifesto and I want nothing, yet I say certain things, and in principle I am against manifestoes, as I am also against principles (half-pints to measure the moral value of every phrase too too convenient; approximation was invented by the impressionists). I write this manifesto to show that people can perform contrary actions together while taking one fresh gulp of air; I am against action; for continuous contradiction, for affirmation too, I am neither for nor against and I do not explain because I hate common sense.

Dada—there you have a word that leads ideas to the hunt: every bourgeois is a little dramatist, he invents all sorts of speeches instead of putting the characters suitable to the quality of his intelligence, chrysalises, on chairs, seeks causes or aims (according to the psychoanalytic method he practices) to cement his plot, a story that speaks and defines itself. Every spectator is a plotter if he tries to explain a word: (to know!). Safe in the cottony refuge of serpentine complications he manipulates his instincts. Hence the mishaps of conjugal life.

To explain: the amusement of redbellies in the mills of empty skulls.

DADA MEANS NOTHING

If you find it futile and don't want to waste your time on a word that means nothing. . . . The first thought that comes to these people is bacteriological in character: to find its etymological, or at least its historical or psychological origin. We see by the papers that the Kru Negroes call the tail of a holy cow Dada. The cube and the mother in a certain district of Italy are called: Dada. A hobby horse,

Tristan Tzara, "Dada Manifesto 1918," translated by Ralph Manheim in Robert Motherwell, ed., Dada Painters and Poets *(New York: Wittenborn, Schultz, Inc., 1951). Originally published in* Dada, no. 3 (1918). *Reprinted by permission of George Wittenborn, Inc.*

a nurse both in Russian and Rumanian: Dada. Some learned jour-
nalists regard it as an art for babies, other holy jesusescallingthelittle-
children of our day, as a relapse into a dry and noisy, noisy and
monotonous primitivism. Sensibility is not constructed on the basis
of a word; all constructions converge on perfection which is boring,
the stagnant idea of a gilded swamp, a relative human product. A
work of art should not be beauty in itself, for beauty is dead; it
should be neither gay nor sad, neither light nor dark to rejoice or
torture the individual by serving him the cakes of sacred aureoles or
the sweets of a vaulted race through the atmospheres. A work of art
is never beautiful by decree, objectively and for all. Hence criticism
is useless, it exists only subjectively, for each man separately, without
the slightest character of universality. Does anyone think he has found
a psychic base common to all mankind? The attempt of Jesus and the
Bible covers with their broad benevolent wings: shit, animals, days.
How can one expect to put order into the chaos that constitutes that
infinite and shapeless variation: man? The principle: "love thy neigh-
bor" is a hypocrisy. "Know thyself" is utopian but more acceptable,
for it embraces wickedness. No pity. After the carnage we still retain
the hope of a purified mankind. I speak only of myself since I do not
wish to convince, I have no right to drag others into my river, I
oblige no one to follow me and everybody practices his art in his own
way, if he knows the joy that rises like arrows to the astral layers, or
that other joy that goes down into the mines of corpse-flowers and
fertile spasms. Stalactites: seek them everywhere, in mangers magnified
by pain, eyes white as the hares of the angels.

And so Dada[1] was born of a need for independence, of a distrust
toward unity. Those who are with us preserve their freedom. We
recognize no theory. We have enough cubist and futurist academies:
laboratories of formal ideas. Is the aim of art to make money and
cajole the nice nice bourgeois? Rhymes ring with the assonance of
the currencies and the inflexion slips along the line of the belly in
profile. All groups of artists have arrived at this trust company after
riding their steeds on various comets. While the door remains open to
the possibility of wallowing in cushions and good things to eat.

Here we cast anchor in rich ground. Here we have a right to do some
proclaiming, for we have known cold shudders and awakenings.
Ghosts drunk on energy, we dig the trident into unsuspecting flesh.
We are a downpour of maledictions as tropically abundant as vertigi-
nous vegetation, resin and rain are our sweat, we bleed and burn
with thirst, our blood is vigor.

[1] in 1916 in the Cabaret Voltaire, in Zurich.

Cubism was born out of the simple way of looking at an object: Cézanne painted a cup 20 centimeters below his eyes, the cubists look at it from above, others complicate appearance by making a perpendicular section and arranging it conscientiously on the side. (I do not forget the creative artists and the profound laws of matter which they established once and for all.) The futurist sees the same cup in movement, a succession of objects one beside the other, and maliciously adds a few force lines. This does not prevent the canvas from being a good or bad painting suitable for the investment of intellectual capital.

The new painter creates a world, the elements of which are also its implements, a sober, definite work without argument. The new artist protests: he no longer paints (symbolic and illusionist reproduction) but creates—directly in stone, wood, iron, tin, boulders—locomotive organisms capable of being turned in all directions by the limpid wind of momentary sensation. All pictorial or plastic work is useless: let it then be a monstrosity that frightens servile minds, and not sweetening to decorate the refectories of animals in human costume, illustrating the sad fable of mankind.—

Painting is the art of making two lines geometrically established as parallel meet on a canvas before our eyes in a reality which transposes other conditions and possibilities into a world. This world is not specified or defined in the work, it belongs in its innumerable variations to the spectator. For its creator it is without cause and without theory. *Order = disorder; ego = nonego; affirmation = negation:* the supreme radiations of an absolute art. Absolute in the purity of a cosmic, ordered chaos, eternal in the globule of a second without duration, without breath, without control. I love an ancient work for its novelty. It is only contrast that connects us with the past. The writers who teach morality and discuss or improve psychological foundations have, aside from a hidden desire to make money, an absurd view of life, which they have classified, cut into sections, channelized: they insist on waving the baton as the categories dance. Their readers snicker and go on: what for?

There is a literature that does not reach the voracious mass. It is the work of creators, issued from a real necessity in the author, produced for himself. It expresses the knowledge of a supreme egoism, in which laws wither away. Every page must explode, either by profound heavy seriousness, the whirlwind, poetic frenzy, the new, the eternal, the crushing joke, enthusiasm for principles, or by the way in which it is printed. On the one hand a tottering world in flight, betrothed to the glockenspiel of hell, on the other hand: new men. Rough, bouncing, riding on hiccups. Behind them a crippled world and literary quacks with a mania for improvement.

*I say unto you: there is no beginning and we do not tremble, we
are not sentimental. We are a furious wind, tearing the dirty linen of
clouds and prayers, preparing the great spectacle of disaster, fire, de-
composition.* We will put an end to mourning and replace tears by
sirens screeching from one continent to another. Pavilions of intense
joy and widowers with the sadness of poison. Dada is the signboard
of abstraction; advertising and business are also elements of poetry.

I destroy the drawers of the brain and of social organization: spread
demoralization wherever I go and cast my hand from heaven to hell,
my eyes from hell to heaven, restore the fecund wheel of a universal
circus to objective forces and the imagination of every individual.

Philosophy is the question: from which side shall we look at life,
God, the idea, or other phenomena. Everything one looks at is false.
I do not consider the relative result more important than the choice
between cake and cherries after dinner. The system of quickly looking
at the other side of a thing in order to impose your opinion indirectly
is called dialectics, in other words, haggling over the spirit of fried
potatoes while dancing method around it.

If I cry out:
Ideal, ideal, ideal,
Knowledge, knowledge, knowledge,
Boomboom, boomboom, boomboom,
I have given a pretty faithful version of progress, law, morality, and
all other fine qualities that various highly intelligent men have dis-
cussed in so many books, only to conclude that after all everyone
dances to his own personal boomboom, and that the writer is entitled
to his boomboom: the satisfaction of pathological curiosity; a private
bell for inexplicable needs; a bath; pecuniary difficulties; a stomach
with repercussions in life; the authority of the mystic wand formulated
as the bouquet of a phantom orchestra made up of silent fiddle bows
greased with philtres made of chicken manure. With the blue eye-
glasses of an angel they have excavated the inner life for a dime's
worth of unanimous gratitude. If all of them are right and if all pills
are Pink Pills, let us try for once not to be right. Some people think
they can explain rationally, by thought, what they think. But that is
extremely relative. Psychoanalysis is a dangerous disease, it puts to
sleep the antiobjective impulses of man and systematizes the bour-
geoisie. There is no ultimate Truth. The dialectic is an amusing
mechanism which guides us / in a banal kind of way / to the opinions
we had in the first place. Does anyone think that, by a minute refine-
ment of logic, he has demonstrated the truth and established the
correctness of these opinions? Logic imprisoned by the senses is an
organic disease. To this element philosophers always like to add: the

power of observation. But actually this magnificent quality of the mind is the proof of its impotence. We observe, we regard from one or more points of view, we choose them among the millions that exist. Experience is also a product of chance and individual faculties. Science disgusts me as soon as it becomes a speculative system, loses its character of utility—that is so useless but is at least individual. I detest greasy objectivity, and harmony, the science that finds everything in order. Carry on, my children, humanity. . . . Science says we are the servants of nature: everything is in order, make love and bash your brains in. Carry on, my children, humanity, kind bourgeois and journalist virgins. . . I am against systems, the most acceptable system is on principle to have none. To complete oneself, to perfect oneself in one's own littleness, to fill the vessel with one's individuality, to have the courage to fight for and against thought, the mystery of bread, the sudden burst of an infernal propeller into economic lilies:

DADAIST SPONTANEITY

I call *je m'enfoutisme* the kind of like in which everyone retains his own conditions, though respecting other individualisms, except when the need arises to defend oneself, in which the two-step becomes national anthem, curiosity shop, a radio transmitting Bach fugues, electric signs and posters for whorehouses, an organ broadcasting carnations for God, all this together physically replacing photography and the universal catechism.

ACTIVE SIMPLICITY

Inability to distinguish between degrees of clarity: to lick the penumbra and float in the big mouth filled with honey and excrement. Measured by the scale of eternity, all activity is vain—(if we allow thought to engage in an adventure the result of which would be infinitely grotesque and add significantly to our knowledge of human impotence). But supposing life to be a poor farce, without aim or initial parturition, and because we think it our duty to extricate ourselves as fresh and clean as washed chrysanthemums, we have proclaimed as the sole basis for agreement: art. It is not as important as we, mercenaries of the spirit, have been proclaiming for centuries. Art afflicts no one and those who manage to take an interest in it will harvest caresses and a fine opportunity to populate the country with their conversation. Art is a private affair, the artist produces it for himself; an intelligible work is the product of a journalist, and because at this moment it strikes my fancy to combine this monstrosity with oil paints: a paper tube simulating the metal that is automatically

pressed and poured hatred cowardice villainy. The artist, the poet rejoice at the venom of the masses condensed into a section chief of this industry, he is happy to be insulted: it is a proof of his immutability. When a writer or artist is praised by the newspapers, it is proof of the intelligibility of his work: wretched lining of a coat for public use; tatters covering brutality; piss contributing to the warmth of an animal brooding vile instincts. Flabby, insipid flesh reproducing with the help of typographical microbes.

We have thrown out the cry-baby in us. Any infiltration of this kind is candied diarrhea. To encourage this act is to digest it. What we need is works that are strong straight precise and forever beyond understanding. Logic is a complication. Logic is always wrong. It draws the threads of notions, words, in their formal exterior, toward illusory ends and centers. Its chains kill, it is an enormous centipede stifling independence. Married to logic, art would live in incest, swallowing, engulfing its own tail, still part of its own body, fornicating within itself, and passion would become a nightmare tarred with protestantism, a monument, a heap of ponderous gray entrails. But the suppleness, enthusiasm, even the joy of injustice, this little truth which we practice innocently and which makes us beautiful: we are subtle and our fingers are malleable and slippery as the branches of that sinuous, almost liquid plant; it defines our soul, say the cynics. That too is a point of view; but all flowers are not sacred, fortunately, and the divine thing in us is our call to antihuman action. I am speaking of a paper flower for the buttonholes of the gentlemen who frequent the ball of masked life, the kitchen of grace, white cousins lithe or fat. They traffic with whatever we have selected. The contradiction and unity of poles in a single toss can be the truth. If one absolutely insists on uttering this platitude, the appendix of a libidinous, malodorous morality. Morality creates atrophy like every plague produced by intelligence. The control of morality and logic has inflicted us with impassivity in the presence of policemen—who are the cause of slavery, putrid rats infecting the bowels of the bourgeoisie which have infected the only luminous clean corridors of glass that remained open to artists.

Let each man proclaim: there is a great negative work of destruction to be accomplished. We must sweep and clean. Affirm the cleanliness of the individual after the state of madness, aggressive complete madness of a world abandoned to the hands of bandits, who rend one another and destroy the centuries. Without aim or design, without organization: indomitable madness, decomposition. Those who are strong in words or force will survive, for they are quick in defense, the agility of limbs and sentiments flames on their faceted flanks.

Morality has determined charity and pity, two balls of fat that have grown like elephants, like planets, and are called good. There is nothing good about them. Goodness is lucid, clear, and decided, pitiless toward compromise and politics. Morality is an injection of chocolate into the veins of all men. This task is not ordered by a supernatural force but by the trust of idea brokers and grasping academicians. Sentimentality: at the sight of a group of men quarreling and bored, they invented the calendar and the medicament wisdom. With a sticking of labels the battle of the philosophers was set off (mercantilism, scales, meticulous and petty measures) and for the second time it was understood that pity is a sentiment like diarrhea in relation to the disgust that destroys health, a foul attempt by carrion corpses to compromise the sun. I proclaim the opposition of all cosmic faculties to this gonorrhea of a putrid sun issued from the factories of philosophical thought, I proclaim bitter struggle with all the weapons of

DADAIST DISGUST

Every product of disgust capable of becoming a negation of the family is Dada; a protest with the fists of its whole being engaged in destructive action: *Dada; knowledge of all the means rejected up until now by the shamefaced sex of comfortable compromise and good manners: Dada; abolition of logic, which is the dance of those impotent to create: Dada; of every social hierarchy and equation set up for the sake of values by our valets: Dada; every object, all objects, sentiments, obscurities, apparitions, and the precise clash of parallel lines are weapons for the fight: Dada; abolition of memory: Dada; abolition of archaeology: Dada; abolition of prophets: Dada; abolition of the future: Dada; absolute and unquestionable faith in every god that is the immediate product of spontaneity:* Dada; elegant and unprejudiced leap from a harmony to the other sphere; trajectory of a word tossed like a screeching phonograph record; to respect all individuals in their folly of the moment: whether it be serious, fearful, timid, ardent, vigorous, determined, enthusiastic; to divest one's church of every useless cumbersome accessory; to spit out disagreeable or amorous ideas like a luminous waterfall, or coddle them—with the extreme satisfaction that it doesn't matter in the least—with the same intensity in the thicket of one's soul—pure of insects for blood well-born, and gilded with bodies of archangels. Freedom: Dada Dada Dada, a roaring of tense colors, and interlacing of opposites and of all contradictions, grotesques, inconsistencies: LIFE

Jean Arp

Jean (Hans) Arp (1887–1966) was raised in Alsace and from an early age drew, wrote poetry, and was in contact with the German and French avant-garde. At the age of seventeen some of his poetry was published and a critic wrote of it: "Where childlike imagination proceeds on its own and at the same time is able to use language, naiveté suddenly becomes beauty, a delicate kind of beauty, gently smiling, yet which, with its tapering fingers, has the power of plucking questions and vistas from unsuspected depths." The passage is applicable to all of Arp's later work in any medium. He studied briefly in Paris and met Kandinsky, Marc, and Delaunay. His first wooden reliefs date from 1914, the year he met Max Ernst at the Werkbund exhibition in Cologne. When war was declared he convinced the authorities that he was mentally defective and in the summer of 1915 went to Zurich, where he became a cofounder and perhaps the best-loved member of the Dada group. With Janco, Ball, Tzara, Hülsenbeck, and his future wife, Sophie Taueber, he participated in the activities at the Cabaret Voltaire. His own work by then was entirely abstract, and he was developing his collages of colored paper "according to the Law of Chance," because it "embraces all laws and is unfathomable like the first cause from which all life arises, can only be experienced through complete devotion to the unconscious. I maintained that anyone who followed this law was creating pure life."

In 1919–20 Arp appeared (probably for more than one visit) in Cologne, where he collaborated with Ernst and Baargeld on the reviews *Die Schammade*, and *Dada W/3*, the famous Brauhaus Winter exhibition, and the series of photo-collages primarily attributable to Ernst—*Fatagaga*. (Arp's contribution lay primarily in the titles.) During this period he met El Lissitsky and Schwitters in Berlin, published *Die Wolkenpumpe* (*Cloud-Pump*, a volume of poems) and illustrated Tzara's *Cinéma Calendrier du Coeur Abstrait*. In 1920 he gravitated, as did most of the Dadas, to Paris, where he later participated, though less wholeheartedly than in Dada, in the Surrealist movement, as well as in the abstract art groups of the thirties such as Abstraction-Création. Arp's sculpture and poetry continued during the rest of his life to combine abstract

purity with the witty innocence of fantasy that marked the best of Dada. Duchamp called his sculptural *Concrétions* "a three-dimensional pun—what the female body 'might have been.' "

* * *

The "Declaration" printed below was the result of a summer vacation Arp spent in the Tyrol in 1921 with Ernst, Tzara, and later, Breton. It was written not only as an obviously fictional Dada gesture but also as a reply to Richard Hülsenbeck's contentions that it was he who had discovered the word "Dada," rather than Tzara; Hülsenbeck had been backed up in this claim by Picabia's attacks on Tzara in *Pilhaou-Thibaou,* which had appeared in July of 1921. Arp's support of Tzara's claim appeared in the last issue of *Dada,* edited by the group in the Tyrol and called *Dada au grand air (Dada in the Open).* Arp's birthday and the year before his birth (September 16, 1886) were given as publication date.

Declaration

I hereby declare that on February 8, 1916, Tristan Tzara discovered the word DADA. I was present with my twelve children when Tzara pronounced for the first time this word which has aroused in us such legitimate enthusiasm. This took place at the Café Terrasse in Zurich, and I wore a brioche in my left nostril. I am convinced that this word has no importance and that only imbeciles and Spanish professors can be interested in dates. What interests us is the Dada spirit and we were all Dada before the existence of Dada. The first Holy Virgins I painted date from 1886, when I was a few months old and amused myself by pissing graphic impressions. The morality of idiots and their belief in geniuses makes me shit.

Jean Arp, "Declaration," translated by the editor from Dada au grand air *(Paris, 1921). Reprinted by permission of Mme Marguerite Arp.*

Kaspar Is Dead

alas our good kaspar is dead.

who will now carry the burning banner hidden in the pigtail of clouds to play the daily black joke

Jean Arp, "Kaspar Is Dead" (1912), translated by Ralph Manheim from Arp, On My Way *(New York: Wittenborn, Schultz, Inc., 1948). Reprinted by permission of Mme Marguerite Arp and George Wittenborn, Inc.*

who will now turn the coffee-mill in the primaeval barrel

who will now entice the idyllic deer out of the petrified paper box.

who will now confound on the high seas the ships by addressing them
as parapluie and the winds by calling them keeper of the bees
ozone spindle your highness.

alas alas alas our good kaspar is dead. holy ding dong kaspar is dead.

the cattlefish in the bellbarns clatter with heartrending grief when his
christian name is uttered. that is why I keep on moaning his
family name kaspar kaspar kaspar.

why have you left us. into what shape has your beautiful great soul
migrated. have you become a star or a watery chain attached to
a hot whirlwind or an udder of black light or a transparent brick
on the groaning drum of jagged being.

now the part in our hair the soles of our feet are parched and the
fairies lie half-charred on the pyre.

now the black bowling alley thunders behind the sun and there's no
one to wind up the compasses and the wheels of the handbarrows
any more.

who will now eat with the phosphorescent rat at the lonely bare-
footed table.

who will now chase away the siroccoco devil when he wants to beguile
the horses.

who will now explain to us the monograms in the stars.

his bust will adorn the mantelpieces of all truly noble men but that's
no comfort that's snuff to a skull.

Dadaland

In Zurich in 1915, losing interest in the slaughterhouses of the
world war, we turned to the Fine Arts. While the thunder of the
batteries rumbled in the distance, we pasted, we recited, we versified,

From Jean Arp, "Dadaland," translated by Ralph Manheim from Arp, On My
Way *(New York: Wittenborn, Schultz, Inc., 1948). First published, in a slightly
different version, as "Tibiis Canere," XX⁰ siècle, no. 1 (Paris, 1938). Reprinted by
permission of Mme Marguerite Arp and George Wittenborn, Inc. The unexcerpted
text of "Dadaland" and the following piece, "Notes from a Diary," contain repeating
passages. They appear to be different parts, often revised, of the same source ma-
terial.*

we sang with all our soul. We searched for an elementary art that
would, we thought, save mankind from the furious folly of these
times. We aspired to a new order that might restore the balance be-
tween heaven and hell. This art gradually became an object of gen-
eral reprobation. Is it surprising that the "bandits" could not under-
stand us? Their puerile mania for authoritarianism expects art itself
to serve the stultification of mankind.

* * *

The Renaissance taught men the haughty exaltation of their rea-
son. Modern times, with their science and technology, turned men
towards megalomania. The confusion of our epoch results from this
overestimation of reason. We wanted an anonymous and collective
art. Here is what I wrote on the occasion of an exhibition we put on
in Zurich in 1915: "These works are constructed with lines, surfaces,
forms, and colors. They strive to surpass the human and achieve the
infinite and the eternal. They are a negation of man's egotism. . . .
The hands of our brothers, instead of serving us as our own hands,
had become enemy hands. Instead of anonymity there was celebrity
and the masterpiece; wisdom was dead. . . . To reproduce is to imi-
tate, to play a comedy, to walk the tightrope. . . ."

* * *

In 1915 Sophie Taeuber and I made in painting, embroidery, and
collage the first works derived from the simplest forms. These are
probably the very first manifestations of this art. These pictures are
Realities in themselves, without meaning or cerebral intention. We
rejected everything that was copy or description, and allowed the
Elementary and Spontaneous to react in full freedom. Since the dis-
position of planes, and the proportions and colors of these planes
seemed to depend purely on chance, I declared that these works, like
nature, were ordered "according to the law of chance," chance being
for me merely a limited part of an unfathomable *raison d'être,* of an
order inaccessible in its totality. Various Russian and Dutch artists
who at that time were producing works rather close to ours in ap-
pearance, were pursuing quite different intentions. They are in fact
a homage to modern life, a profession of faith in the machine and
technology. Though treated in an abstract manner, they retain a
base of naturalism and of "trompe l'œil."

From 1916 to 1920 Sophie Taeuber danced in Zurich. I shall quote
the beautiful lines that Hugo Ball wrote about her in an essay en-
titled "Occultism and other things rare and beautiful": "All around
her is the radiance of the sun and the miracle that replaces tradition.

She is full of invention, caprice, fantasy. She danced to the 'Song of the Flying Fishes and the Hippocamps,' an onomatopoetic plaint. It was a dance full of flashes and fishbones, of dazzling lights, a dance of penetrating intensity. The lines of her body break, every gesture decomposes into a hundred precise, angular, incisive movements. The buffoonery of perspective, lighting, and atmosphere is for her hypersensitive nervous system the pretext for drollery full of irony and wit. The figures of her dance are at once mysterious, grotesque and ecstatic. . . ."

I met Eggeling in Paris in 1915 at the studio of Madame Wassilieff, who in her two studios had set up canteens where artists could eat supper for very little money. Our friends on leave from the front spoke to us of the war, and when the gloom was too great a young woman with a pleasant voice sang: *En passant par la Lorraine avec mes sabots.* . . . A drunken Swede accompanied her on the piano. Every night my brother and I walked several miles from Montmartre to the Gare Montparnasse, where Wassilieff's studio was located, through the darkness of Paris menaced by the Germans. Eggeling lived in a damp and sinister studio on the Boulevard Raspail. Across from him lived Modigliani, who often came to see him, to recite Dante and get drunk. He also took cocaine. One night it was decided that along with several other innocents I should be initiated into the *"paradis artificiels."* Each of us gave Modigliani several francs with which to lay in a store of the drug. We waited for hours. Finally he returned, hilarious and sniffling, having consumed the whole supply by himself. Eggeling did not paint much at that time; for hours he would discuss art. I met him again in 1917 in Zurich. He was searching for the rules of a plastic counterpoint, composing and drawing its first elements. He tormented himself almost to death. On great rolls of paper he had set down a sort of hieratic writing with the help of figures of rare proportion and beauty. These figures grew, subdivided, multiplied, moved, intertwined from one group to another, vanished and partly reappeared, organized themselves into an impressive construction with plantlike forms. He called this work a "Symphony." He died in 1922. With his friend Hans Richter he had just finished adapting his invention to the cinema.

Secretly, in his quiet little room, Janco devoted himself to a "naturalism in zigzag." I forgive him this secret vice because in one of his paintings he evoked and commemorated the "Cabaret Voltaire." On a platform in an overcrowded room, splotched with color, are seated several fantastic characters who are supposed to represent Tzara, Janco, Ball, Hülsenbeck, Madame Hennings, and your humble serv-

ant. We are putting on one of our big Sabbaths. The people around
us are shouting, laughing, gesticulating. We reply with sighs of love,
salvos of hiccups, poems, and the bowwows and meows of mediaeval
bruitists. Tzara makes his bottom jump like the belly of an oriental
dancer. Janco plays an invisible violin and bows down to the ground.
Madame Hennings with a face like a madonna attempts a split.
Hülsenbeck keeps pounding on a big drum, while Ball, pale as a
plaster dummy, accompanies him on the piano. The honorific title
of nihilists was bestowed on us. The directors of public cretinization
conferred this name on all those who did not follow in their path.
The great matadors of the "Dadaist Movement" were Ball and Tzara.
Ball in my opinion is one of the greatest German writers. He was a
long, dry man with the face of a pater dolorosus. Tzara at that
time wrote the *Vingt-Cinq Poèmes,* which belong to the best in
French poetry. Later we were joined by Dr. Serner, adventurer, writer
of detective stories, ballroom dancer, physician specializing in skin
diseases, and gentleman burglar.

I met Tzara and Serner at the Odéon and at the Café de la Ter-
rasse in Zurich, where we wrote a cycle of poems: *Hyperbole of the
crocodile-barber and the walking cane.* This type of poem was later
baptized "Automatic Poetry" by the Surrealists. Automatic poetry
issues straight from the entrails of the poet or from any other organ
that has stored up reserves. Neither the Postillion de Longjumeau
nor the Alexandrine, nor grammar, nor aesthetics, nor Buddha, nor
the Sixth Commandment can interfere with it in the least. It crows,
curses, sighs, stammers, yodels, just as it pleases. Its poems are like
nature: they stink, laugh, rhyme, like nature. It esteems foolishness,
or at least what men call foolishness, as highly as sublime rhetoric,
for in nature a broken twig is equal to the stars in beauty and im-
portance, and it is men who decree what is beautiful and what is
ugly.

Dada objects are formed of elements found or manufactured, simple
or heteroclite. The Chinese several thousand years ago, Duchamp,
Picabia in the United States, Schwitters and myself during the war
of 1914, were the first to invent and disseminate these games of wis-
dom and clairvoyance which were to cure human beings of the raging
madness of genius and return them modestly to their rightful place
in nature. The natural beauty of these objects is inherent in them as
in a bunch of flowers gathered by children. Several thousand years
ago, an emperor of China sent his artists out to the most distant
lands to search for stones of rare and fantastic forms which he col-
lected and placed on a pedestal beside his vases and his gods. It is
obvious that this game will not appeal to our modern thinkers of

the go-getter school, who lie in wait for the art-lover like hotel porters waiting at the station for guests.

Are you still singing that diabolical song about the mill at Hirza-Pirza, shaking your gypsy curls with wild laughter, my dear Janco? I haven't forgotten the masks you used to make for our Dada demonstrations. They were terrifying, most of them daubed with bloody red. Out of cardboard, paper, horsehair, wire, and cloth, you made your languorous foetuses, your Lesbian sardines, your ecstatic mice. In 1917 Janco did some abstract works which have grown in importance ever since. He was a passionate man with faith in the evolution of art. . . .

I BECAME MORE AND MORE REMOVED FROM AESTHETICS

I became more and more removed from aesthetics. I wanted to find another order, another value for man in nature. He was no longer to be the measure of all things, no longer to reduce everything to his own measure, but on the contrary, all things and man were to be like nature, without measure. I wanted to create new appearances, extract new forms from man. This tendency took shape in 1917 in my "objects." Alexandre Partens wrote of them in the *Almanach Dada*: "It was the distinction of Jean Arp to have at a certain moment discovered the true problem in the craft itself. This allowed him to feed it with a new, spiritual imagination. He was no longer interested in improving, formulating, specifying an aesthetic system. He wanted immediate and direct production, like a stone breaking away from a cliff, a bud bursting, an animal reproducing. He wanted objects impregnated with imagination and not museum pieces, he wanted animalesque objects with wild intensities and colors, he wanted a new body among us which would suffice unto itself, an object which would be just as well off squatting on the corners of tables as nestling in the depths of the garden or staring at us from the wall. . . . To him the frame and later the pedestal seemed to be useless crutches. . . ."

Even in my childhood, the pedestal enabling a statue to stand, the frame enclosing the picture like a window, were for me occasions for merriment and mischief, moving me to all sorts of tricks. One day I attempted to paint on a windowpane a blue sky under the houses that I saw through the window. Thus the houses seemed to hang in mid-air. Sometimes I took our pictures out of their frames and looked with pleasure at these windows hanging on the wall. Another time I hung up a frame in a little wooden shack, and sawed a hole in the wall behind the frame, disclosing a charming landscape

animated by men and cattle. I asked my father for his opinion of the
work I had just completed. He gave me a strange, somewhat surprised
look. As a child I also took pleasure in standing on the pedestal of
a statue that had collapsed and mimicking the attitude of a modest
nymph.

Here are a few of the names of my Dadaist objects: Adam's Head,
Articulating Comma, Parrot Imitating the Thunder, Mountain with
Shirtfront of Ice, Spelling Furniture, Eggboard, Navel Bottle. The
fragility of life and human works was converted with the Dadaists
into black humor. No sooner is a building, a monument completed
than it begins to decay, fall apart, decompose, crumble. The pyramids,
temples, cathedrals, the paintings of the masters, are convincing proof
of this. And the buzzing of man does not last much longer than the
buzzing of the fly spiraling so enthusiastically around my *baba au
rhum*.

Dada aimed to destroy the reasonable deceptions of man and re-
cover the natural and unreasonable order. Dada wanted to replace the
logical nonsense of the men of today by the illogically senseless. That
is why we pounded with all our might on the big drum of Dada and
trumpeted the praises of unreason. Dada gave the Venus de Milo an
enema and permitted Laocoon and his sons to relieve themselves
after thousands of years of struggle with the good sausage Python.
Philosophies have less value for Dada than an old abandoned tooth-
brush, and Dada abandons them to the great world leaders. Dada
denounced the infernal ruses of the official vocabulary of wisdom.
Dada is for the senseless, which does not mean nonsense. Dada is
senseless like nature. Dada is for nature and against art. Dada is
direct like nature. Dada is for infinite sense and definite means.

THE NAVEL BOTTLE

The bourgeois regarded the Dadaist as a dissolute monster, a revo-
lutionary villain, a barbarous Asiatic, plotting against his bells, his
safe-deposits, his honors. The Dadaist thought up tricks to rob the
bourgeois of his sleep. He sent false reports to the newspapers of
hair-raising Dada duels, in which his favorite author, the "King of
Bernina," was said to be involved. The Dadaist gave the bourgeois
a sense of confusion and distant, yet mighty rumbling, so that his
bells began to buzz, his safes frowned, and his honors broke out in
spots. "The Eggboard," a game for the upper ten thousand, in which
the participants leave the arena covered with egg yolk from top to
toe; "The Navel Bottle," a monstrous home furnishing in which
bicycle, whale, brassière, and absinthe spoon are combined; "The

Glove," which can be worn in place of the old-fashioned head—were devised to show the bourgeois the unreality of his world, the nullity of his endeavors, even of his extremely profitable patrioteerings. This of course was a naive undertaking on our part, since actually the bourgeois has less imagination than a worm, and in place of a heart has an over-life-size corn which twitches in times of approaching storm—on the stock exchange.

TALK

When Dada revealed its eternal wisdom to man, man laughed indulgently and went on talking. Man talks enough to make the very rats sick to their stomach. While his voracity forces him to stuff into his mouth everything that fails to evade his claws, he still manages to talk. He talks so much that the day darkens and the night pales with fright. He talks so much that the sea runs dry and the desert turns to swamp. The main thing for him is to talk, for talk is healthy ventilation. After a fine speech he feels very hungry and changes his mind. At the same time he assumes the noble attitude of rotten meat. Man declares red what he called green the day before and what in reality is black. He is forever making definitive statements on life, man, and art, and he has no more idea than the mushroom what life, man, and art actually are.

SON OF LIGHT

Man hidden away in his vanity like a mole in his hill no longer understands the language of light which fills the sky with its inconceivable immensity. Man believes himself to be the summit of creation. The face of light does not perturb him. He confounds himself with light. This toad likes to call himself the son of light.

Man owes it to his incongruously developed reason that he is grotesque and ugly. He has broken away from nature. He thinks that he dominates nature. He thinks he is the measure of all things. Engendering in opposition to the laws of nature, man creates monstrosities. He desires that of which he is incapable, and despises what is within his powers. The artificial and the monstrous seem to him the goal of perfection. Whatever he can achieve, he covers with blood and mud. Only in the monstrous is man creative; those unfit for this work compose verses, strum the lyre, or brandish the paint brush. This last group devote themselves with enigmatic frenzy to the painting of still-lives, landscapes, nudes. Since the days of the caves, man has been painting still-lives, landscapes, nudes. Since the days of the

caves, man has glorified and deified himself, and has brought about human catastrophes by his monstrous vanity. Art has collaborated in his false development. To me the conception of art that has upheld the vanity of man is sickening.

MAN LOVES WHAT IS VAIN AND DEAD

In art also man loves what is vain and dead. He cannot understand that painting is something other than a landscape prepared with oil and vinegar, and sculpture something other than a woman's thigh made out of marble or bronze. Any living transformation of art seems to him as detestable as the eternal metamorphoses of life. Straight lines and honest colors exasperate him above all. Man doesn't want to get to the bottom of things. The radiance of the universe makes his degeneration and ugliness too apparent. That is why man clings desperately to graceful garlands and makes himself a specialist in values. Out of his nine openings framed in curls, man exhales blue vapor, gray fog, black smoke. Sometimes he tries like a fly to walk on the ceiling, but he always fails and falls with a crash on the table covered with the best crockery.

Man calls the concrete abstract. This is not surprising, for he commonly confuses front and back even when using his nose, his mouth, his ears, that is to say, five of his nine openings. I understand that a cubist painting might be called abstract, for parts of the object serving as model for the picture have been abstracted. But in my opinion a picture or a sculpture without any object for model is just as concrete and sensual as a leaf or a stone.

ART IS A FRUIT

Art is a fruit that grows in man, like a fruit on a plant, or a child in its mother's womb. But whereas the fruit of the plant, the fruit of the animal, the fruit in the mother's womb, assume autonomous and natural forms, art, the spiritual fruit of man, usually shows an absurd resemblance to the aspect of something else. Only in our own epoch have painting and sculpture been liberated from the aspect of a mandolin, a president in a Prince Albert, a battle, a landscape. I love nature, but not its substitutes. Naturalist, illusionist art is a substitute for nature.

I remember a discussion with Mondrian in which he distinguished between art and nature, saying that art is artificial and nature natural. I do not share his opinion. I believe that nature is not in

opposition to art. Art is of natural origin and is sublimated and spiritualized through the sublimation of man.

Notes from a Diary

man is a beautiful dream. man lives in the sagalike country of utopia where the thing-in-itself tap-dances with the categorical imperative. today's representative of man is only a tiny button on a giant senseless machine. nothing in man is any longer substantial. the safe-deposit vault replaces the may night. how sweetly and plaintively the nightingale sings down there while man is studying the stock market. what a heady scent the lilac gives forth down there. man's head and reason are gelded, and are trained only in a certain kind of trickery. man's goal is money and every means of getting money is all right with him. men hack at each other like fighting cocks without ever once looking into that bottomless pit into which one day they will dwindle along with their damned swindle. to run faster to step wider to jump higher to hit harder that is what man pays the highest price for. the little folk song of time and space has been wiped out by the cerebral sponge. was there ever a bigger swine than the man who invented the expression time is money. time and space no longer exist for modern man. with a can of gasoline under his behind man whizzes faster and faster around the earth so that soon he will be back again before he leaves. yesterday monsieur duval whizzed at three o'clock from paris to berlin and was back again at four. today monsieur duval whizzed at three o'clock from paris to berlin and was back again at half past three. tomorrow monsieur duval will whiz at three o'clock from paris to berlin and will be back again at three o'clock that is at the same time he leaves and day after tomorrow monsieur duval will be back before he leaves. nothing seems more ridiculous to present-day man than broad clear living. . . .

* * *

the earth is not a fresh-air resort and the idyllic prospectuses of the earth tell lies. nature does not run along the little thread on which reason would like to see it run. the light of day is beautiful but poisonous and rustic life even creates hexameters and madness. we can of course insure our house against fire our cash register

From Jean Arp, "Notes from a Diary," translated from the German by Eugene Iolas in Transition, no. 21 (Paris, March 1932). Reprinted by permission of Mme Marguerite Arp and George Wittenborn, Inc.

against burglary or our daughter against devirgination but heaven
looks nevertheless down into the bottomless pots of our home coun-
tries and extracts the sweat of fear from our foreheads. every moment
we shuffle off this mortal coil by a hair's breadth. from out of every
plank seat a black claw grabs us by the back sides. all bosom friend-
ship and love is a lot of apple sauce. like water off the duck's
back so love runs off the human bacon. in loneliness man rides down
the styx on his chamber pot. in the neighbourhood of karlsruhe he
would like to get off because his name is karl and he would like to
take a little rest. but chance would have it that here a thicket of
laurel feet victory tripe and sabre rattling germanic spooning couples
make it impossible for him to get off in that beautiful landscape
and thus man damn it to hell continues riding lonelily down the styx
on his chamber pot. shamelessly nude clouds without fig leaves or
decorations ride past the blue german eyes and lay their eggs in
heraldic nests. from the springs beer flows in streams. water fire
earth air have been gnawed at by man. but also from man to man
the mannikin does what he can. no ha-ha-hallelujah can help him.
in carl einstein's poems the design of a landscape there is no further
mention that man the measure of all things gets away with a black
eye. of man in these poems there remains less than of his lares and
penates. einstein gives man a good drubbing and sends him home.
the white buttocks of an aged narcissus emerge once but it is quickly
ignored as fata morganata. aside from this encounter and a few
parts of the human anatomy that flow through the black belly of
this landscape concepts are the most corporeal vestige of man. you
speaks with i about flight and fear of death. human qualities migrate
through light and shadow.

carl einstein's design of a landscape is an ice-cold pit. no rabbit
can live and sleep in this pit for these pits are bottomless. In order
that the third dot on the i be not missing i would say further that
this pit is as tenebrous as night. no perfumed columns, no fluted
rump weals, no schwepperman's eggs architecturally beautify its en-
trance. with teeth chattering the reader asks this insomnia in persona
can you give ghost knocks but not even a violet answers him so much
as cuckoo. with staring eyes and mug hanging wide open this land-
scape roars through the void. only a handful of snuff remains of the
sphinx the olympus and Louis XV. the golden rule and other valu-
able rules have vanished without leaving a trace. a chair leg clings
sea-sick with madness to a torture stake. shreds of sneezing skies jump
over ruminating coffins. each of these poems is served on ice. the
breasts of this landscape are made of cold-storage meat. but neverthe-

less in the coldest abstractions of einstein there is very distinctly the unmodern question why has this garden party been arranged. einstein is not satisfied with the art pour art of the world. he is for the delusional ideas of the good old days and against reason. he does not want to see illusion used as a scarecrow nor the reservation of the ghosts eliminated. it seems to him that people have not yet succeeded in unveiling the world through reason. a great deal in the new doctrine for him does not fit together like a meander in patent leather shoes who goes walking on the arm of a somnambulist box of sardines through the sooty hortus deliciarum. einstein's poems have nothing to do with modern alarm clocks. before them reason takes its tail between its legs and goes philandering somewhere else. einstein does not want to cover up the asphodel meadows. his apollo is not yet the henpecked mate of a hundred-horsepower mrs rolls royce. here an unhygienic polonaise is being danced against all the prohibitions of the concrete top hat of the glass necktie and the nickel cutaway to the tune of the old snowman still lives. whether today people planted antennae instead of narcissi doesn't matter one way or the other. the main thing is to have here and there a lucida intervalla in order to be able to take a gulp from the saving whiskey bottle of illusion. the darkness which einstein distills from the smiling meads of the earth goes beyond jack and the bean stalk beyond the corner grocer and beyond all human endurance. yes yes the earth is not a valley of tears in the vest pocket.

<p style="text-align:center">* * *</p>

the seven head lengths of beauty have been cut off one after the other but nevertheless man acts as if he were a being that vegetates outside of nature. industriously he adds seven to black in order to get thereby another hundred pounds of chatter. gentlemen who always stood for the dream and life are now making a loathsomely industrious effort to reach the goal of class and to deform hegel's dialectics into a popular song. i am justified in my theory that man is a pot the handles of which fell out of his own holes. poetry and the five year plan are now being busily stirred together but the attempt to stand up while lying down will not succeed. man will not let himself be made into a happy hygienic number which brays ee-on enthusiastically like a jackass before a certain picture. man will not let himself be standardized. in this ridiculous circus which stands without relation to life itself the books of hugo ball epitomize a gigantic act. hugo ball leads man out of his silly corporeality towards his true content dream and death. art and the dream represent

the preliminary step to the true collectivity of the redemption from all reason. hugo ball's language is also a magic treasure and connects him with the language of light and darkness. through language too man can grow into real life.

Marcel Janco

Marcel Janco (1895–) came to Zurich from his native Bucharest as an architecture student and painter. With Arp, Hugo Ball, Emmy Hennings, Richard Hülsenbeck, and his compatriot Tzara, he was a cofounder of the first Dada group. He exhibited cubist-expressionist paintings and Picassoid reliefs, made the famous neo-African masks, and gave performances at the Cabaret Voltaire. Coauthor with Tzara and Hülsenbeck of the simultaneist poem "The Admiral Looking for a House to Rent," he also illustrated with colored woodcuts Tzara's "The First Celestial Adventure of Mr. Antipyrine" in 1916. In 1919 he helped write the manifesto of the "Radical Artists" group. Janco went to Paris in 1921 but stayed only a year, disillusioned with Dada's gradual transformation into the literary romanticism that was to be Surrealism. Returning to Rumania, he carried on Dada activities in a more abstract direction. In 1941 he settled in Tel Aviv and in 1953 organized the artists' village at Ein Hod, Israel. In the 1950s and 1960s he has been an enthusiastic participant in the various Dada retrospective exhibitions and anthologies.

Creative Dada

No dadaist will ever write his memoirs! Do not trust anything that calls itself "Dada history"; however much may be true of Dada, the historian qualified to write about it does not yet exist. Dada is by no means a school and certainly not a brotherhood, nor is it a perfume. It is not a philosophy either. Dada is, quite simply, a new conception. Dada was no mere fiction—its traces are found in the depths of human history. Dada is a phase in the development of the modern mind, a ferment, a virile agent. Dada is unlimited, illogical, and eternal! . . .

Dada was anything but a hoax; it was a turning on the road opening up wide horizons to the modern mind. It lasts, and will last as long as the spirit of negation contains the ferment of the future.

Marcel Janco, "Creative Dada," from Willy Verkauf, ed., Dada: Monograph of a Movement *(Teufen: Niggli, 1961). Reprinted by permission of Marcel Janco.*

Dada at Two Speeds

1916

We had lost confidence in our "culture." Everything had to be demolished. We would begin again after the tabula rasa. At the Cabaret Voltaire we began by shocking the bourgeois, demolishing his idea of art, attacking common sense, public opinion, education, institutions, museums, good taste, in short, the whole prevailing order.

For writers, it was a godsend. They exposed themselves in their creations, their manifestoes, their poetry, and invectives and insults rained down on all sides. Courageously, they abused those who came to listen to them, and, to make themselves more interesting, they posed as nihilists declaring art already dead and Dada nothing but a joke. It was young and modern, delightful and novel! For those of us in the plastic arts it was less simple. We did not have their advantages and did not always take part in these negative and sometimes dangerous public demonstrations. Also, for us it was "literature." Ineffectual babbling, irrational attacks. This repeated itself over and over again with no logic, became superficial, empty, like a circus.

1917

Less and less interested, we moved away from literature. Our nihilists, who were insulting art, were directing our galleries and writing our catalogue introductions. Not one of those who proclaimed the death of art abandoned us, as Rimbaud did.

Our attitudes had changed.

We had gone beyond the first speed, the negative speed. Neither Arp, Taueber, Richter, Eggeling, nor myself were interested in scandal. Our experiences, our new style of expression through automatism and the discovery of the game of chance, faith in the instinct of art and in the power of the subconcious gave us new confidence. The word Dada itself already had a new meaning for us; a synonym for pure, childlike, direct, primal.

Marcel Janco, "Dada à deux vitesses," translated by Margaret I. Lippard from Dada (*Kunsthaus, Zurich, and Musée national d'art moderne, Paris, 1966–67*). *Reprinted by permission of Marcel Janco.*

1918

With the exhibition of our collages, *papiers déchirés* (torn paper collages), tapestries, wood, painted and plaster reliefs, scroll pictures, our abstract sculptures, we began to see clearly; a new sun rose on the horizon. Through an understanding of prehistoric art, children's art, primitive art, folk arts, through long nights of discussion about abstract art, we came to the conclusion that the crusade for the return to the Promised Land of creativity was Dada's most important discovery.

1919

For us it was no longer true that Dada was against everyone and everything. We ourselves had gone beyond negation, and no longer needed aggression and scandal to pursue our positive course. We had put our courage into our work, finding a new meaning for art in society. We had stressed the creative values, freedom in art, the freshness and vitality of the subconcious, direct expression. Art was born, like the fingernail, from the flesh, said Arp.

1919–20

Hülsenbeck had left us for Berlin, Ball had gone to Ticino, and now Tzara was leaving us for Paris. We stayed on the spot, for our roads had been diverging for some time. Our pure Dada experiences continued and we went on to publish the manifesto of "the radicals," signed by all the Dada plasticians, painters, sculptors—Arp, Baumann, Eggeling, (Augusto) Giacometti, Helbig, Janco, Morach, Richter— expressing our positive attitude toward life and society. At the same time we had formed the group, *Das neue Leben,* which embraced all the progressive forces of the country, and we also held exhibitions, lectures, and other public demonstrations in other Swiss towns. However, Dada was considered everywhere as madness, aggression, derailment, and nihilism, for each time the Dada flame flared again, burning somewhere, in milieus and locations everywhere, it began with the same purifying and scandalous force to consume the past and open up a new creative route. This spiritual violence of the first phase, which I call negative speed, very often remains in the same state, not having found soil fertile enough to expand into the positive, as was the case in Zurich. This Dada attitude had impressed minds and imprinted a stamp which could not be effaced. But the positive side of Dada, which had borne fruit, remained unknown. This is why today people are surprised to find that the best Dadas, like Jean Arp,

seem least Dada. Arp's tranquil nature, his serene art, his poetry without bitterness, aggressiveness, or nihilism is not characteristic of Dada. Also, when one looks at the Dada *oeuvre,* it is noticeable that most of the plastic artists—like Arp, Taeuber, Schwitters, Richter, Ernst, Eggeling, Janco and others—did not use negative Dada methods and have become the most significant artists of their generation.

The importance of this retrospective exhibition lies in the fact that, today, after fifty years, two Dadas, negative and positive, are being presented as objectively as possible in all stages and all moods. Thus one can estimate at their true value the negative, literary, and creative phenomena side by side with the prophetic work of positive Dada, which opened to art a new road, upon which, to say the least, artistic creativity has remained dependent through the present day.

Hans Richter

Hans Richter (1888–) has been a socialist, a pacifist, a cubist then expressionist then constructivist painter, and is now best known as a writer and a filmmaker, described by Tzara as "elegant and malicious." A member of the Berlin Aktion group, he went to Zurich as a wounded soldier in 1916 and joined the Dada group. For the next two years he participated in their activities as well as founding the "Association of Revolutionary Artists." In Zurich he also met Viking Eggeling, a Swedish artist with whom he discovered a graphic abstract scroll technique that led them both to experiment with animated film. They worked together for the next few years, producing *Diagonal Symphony* (Eggeling), *Prelude,* and *Rhythm 21* (Richter). When they parted company Richter continued his preoccupation with serial progressions, the development of a new visual syntax "comparable with counterpoint in music: a kind of controlled freedom or emancipated discipline, a system within which chance could be given a comprehensible meaning." Films such as *Rhythm 23* and *Rhythm 25* thus combined Dada and Constructivist ends. In 1926 Richter stopped painting and concentrated on Dada-Surrealist films, the most important of which is *Ghosts Before Breakfast* (Berlin, 1927–28). In 1940 he began painting again and in 1941 went to New York, where he made two long films with the Surrealists in exile there: *Dreams that Money Can Buy* (1944) and *8 x 8* (1956–57). He now lives in Connecticut and is the author of articles on avant-garde film and Dada; his book *Dada Art and Anti-Art* was published in 1965.

Dada Art and Anti-Art

> *There is no such thing as chance. A door may happen to fall shut, but this is not by chance. It is a conscious experience of the door, the door, the door, the door.*
> —from *Lieschen* by Kurt Schwitters.

There is no denying that the trumpet-blasts with which we proclaimed our theory of antiart also resounded in our own ears. They

From Hans Richter, Dada Art and Anti-Art *(New York: McGraw-Hill, 1965), pp. 50–52, 77–80. Reprinted by permission of Verlag M. DuMont Schauberg and Hans Richter.*

progressively drowned the seductive notes of those conventions that
still lingered within us. Even when we were practising art as art—
and this was our concern morning, noon, and night—our friends the
poets, philosophers, writers, and psychologists left us not so much as
a mousehole through which to smuggle a single conventional idea.

Dada's propaganda for a total repudiation of art was in itself a
factor in the advance of art. Our feeling of freedom from rules, pre-
cepts, money, and critical praise, a freedom for which we paid the
price of an excessive distaste and contempt for the public, was a
major stimulus. The freedom not to care a damn about anything, the
absence of any kind of opportunism, which in any case could have
served no purpose, brought us all the closer to the source of all art,
the voice within ourselves. The absence of any ulterior motive en-
abled us to listen to the voice of the "Unknown"—and to draw
knowledge from the realm of the unknown. Thus we arrived at the
central experience of Dada.

I cannot say who exactly it was that took this decisive step, or
when it happened. It probably arose out of a great variety of obser-
vations, discussions and experiments which took place within the
Dada movement. However, the fact that there is no mention of it in
Ball's diaries and theoretical works seems to show that it did not
originate in the sphere of literature but in that of the visual arts.

Here is an anecdote which, although totally characteristic of its
central figure, has no real claim to be regarded as the true story of
the "beginning" or "invention" of the use of chance. The part played
in it by Arp could have been (or was?) played by Janco or Serner or
Tzara. Dissatisfied with a drawing he had been working on for some
time, Arp finally tore it up, and let the pieces flutter to the floor of
his studio on the Zeltweg. Some time later he happened to notice
these same scraps of paper as they lay on the floor, and was struck
by the pattern they formed. It had all the expressive power that he
had tried in vain to achieve. How meaningful! How telling! Chance
movements of his hand and of the fluttering scraps of paper had
achieved what all his efforts had failed to achieve, namely *expression*.
He accepted this challenge from chance as a decision of fate and
carefully pasted the scraps down in the pattern which chance had
determined. I was not there, of course, but I have seen the results of
similar experiments of his. Was it the artist's unconscious mind, or a
power outside him, that had spoken? Was a mysterious "collaborator"
at work, a power in which one could place one's trust? Was it a
part of oneself, or a combination of factors quite beyond anyone's
control?

The conclusion that Dada drew from all this was that chance must

be recognized as a new stimulus to artistic creation. This may well be regarded as the central experience of Dada, that which marks it off from all preceding artistic movements.

This experience taught us that we were not so firmly rooted in the knowable world as people would have us believe. We felt that we were coming into contact with something different, something that surrounded and interpenetrated *us* just as we overflowed into *it*. The remarkable thing was that we did not lose our own individuality. On the contrary, the new experience gave us new energy and an exhilaration which led, in our private lives, to all sorts of excesses; to insolence, insulting behavior, pointless acts of defiance, fictitious duels, riots—all the things that later came to be regarded as the distinctive signs of Dada. But beneath it all lay a genuine mental and emotional experience that gave us wings to fly—and to look down upon the absurdities of the "real" and earnest world.

Chance became our trademark. We followed it like a compass. We were entering a realm of which we knew little or nothing, but to which other individuals, in other fields, had already turned.

Chance, in the form of more or less free association, began to play a part in our conversations. Coincidences of sound or form were the occasion of wide leaps that revealed connections between the most apparently unconnected ideas. Tzara, Arp, Serner and Hülsenbeck were masters of this art and Arp's poems masterpieces of this technique of exploration and experiment.

THE GUEST EXPULSED 5

Their rubber hammer strikes the sea
Down the black general so brave.
With silken braid they deck him out
As fifth wheel on the common grave.

All striped in yellow with the tides
They decorate his firmament.
The epaulettes they then construct
Of June July and wet cement.

* * *

FINIS DADA ZURICH

Meanwhile Dada in Zurich was moving towards its greatest success —and its end. The climax of Dada activity in Zurich, and of Dada

as such, was the grand *soirée* in the Saal zur Kaufleuten on 9th April 1919.

I will describe it here in rather more detail, because Dada meetings everywhere took a rather similar course. Arp and I had the job of painting sets for the dances (those of Susanne Perrottet, and the *Noir Kakadu* with Käthe Wulff, choreography by Sophie Taeuber). We began from opposite ends of immensely long strips of paper about two yards wide, painting huge black abstracts. Arp's shapes looked like gigantic cucumbers. I followed his example, and we painted miles of cucumber plantations, as I called them, before we finally met in the middle. Then the whole thing was nailed on to pieces of wood and rolled up until the performance.

Tzara had organized the whole thing with the magnificent precision of a ringmaster marshalling his menagerie of lions, elephants, snakes, and crocodiles.

Eggeling appeared first (he had been received into our club as a guest member) and delivered a very serious speech about elementary *Gestaltung* and abstract art. This only disturbed the audience insofar as they wanted to be disturbed but weren't. Then followed Susanne Perrottet's dances to compositions by Schönberg, Satie, and others. She wore a Negroid mask by Janco, but they let that pass. Some poems by Hülsenbeck and Kandinsky, recited by Käthe Wulff, were greeted with laughter and catcalls by a few members of the audience. Then all hell broke loose. A *poème simultané* by Tristan Tzara, performed by twenty people who did not always keep in time with each other. This was what the audience, and especially its younger members, had been waiting for. Shouts, whistles, chanting in unison, laughter . . . all of which mingled more or less antiharmoniously with the bellowing of the twenty on the platform.

Tzara had skillfully arranged things so that this simultaneous poem closed the first half of the programme. Otherwise there would have been a riot at this early stage in the proceedings and the balloon would have gone up too soon.

An animated interval, in which the inflamed passions of the audience gathered strength for a defiant response to any new defiance on our part.

I started the second half with an address, "Against, Without, For Dada" which Tzara called "Malicious, elegant, Dada, Dada, Dada." In this address I cursed the audience with moderation, and ourselves in a modest way, and consigned the audience to the underworld.

Then followed music by Hans Heusser, whose tunes or antitunes had accompanied Dada since its inauguration at the Cabaret Voltaire. Some slight opposition. A little more greeted Arp's *Wolkenpumpe*

("Cloud Pump"), which was interrupted from time to time, but not often, with laughter and cries of "Rubbish." More dances by Perrottet to the music of Schönberg and then Dr. Walter Serner, dressed as if for a wedding in immaculate black coat and striped trousers, with a grey cravat. This tall, elegant figure first carried a headless tailor's dummy on to the stage, then went back to fetch a bouquet of artificial flowers, gave them to the dummy to smell where its head would have been, and laid them at its feet. Finally he brought a chair, and sat astride it in the middle of the platform with his back to the audience. After these elaborate preparations, he began to read from his an-archistic credo, *Letzte Lockerung* ("Final Dissolution"). At last! This was just what the audience had been waiting for.

The tension in the hall became unbearable. At first it was so quiet that you could have heard a pin drop. Then the catcalls began, scornful at first, then furious. "Rat, bastard, you've got a nerve!" until the noise almost entirely drowned Serner's voice, which could be heard, during a momentary lull, saying the words, "Napoleon was a big strong oaf, after all."

That really did it. What Napoleon had to do with it, I don't know. He wasn't Swiss. But the young men, most of whom were in the gallery, leaped on to the stage, brandishing pieces of the balustrade (which had survived intact for several hundred years), chased Serner into the wings and out of the building, smashed the tailor's dummy and the chair, and stamped on the bouquet. The whole place was in an uproar. A reporter from the *Basler Nachrichten,* whom I knew, grasped me by the tie and shouted ten times over, without pausing for breath, "You're a sensible man normally." A madness had transformed individual human beings into a mob. The performance was stopped, the lights went up, and faces distorted by rage gradually returned to normal. People were realizing that not only Serner's provocations, but also the rage of those provoked, had something inhuman . . . and that this had been the reason for Serner's performance in the first place.

Through Serner's contribution the public had gained in self-aware-ness. This was proved by the third part of the programme, which was resumed after a breathing-space of twenty minutes. It was in no way less aggressive than the second part, but it reached its end without incident. This was all the more remarkable since the ballet *Noir Kakadu,* with Janco's savage Negro masks to hide the pretty faces of our Labanese girls, and abstract costumes to cover their slender bodies, was something quite new, unexpected, and anticonventional. Even Serner was permitted to return to the stage, and his poems, no less provocative than before, were received without protest. So were Tzara's

poems, and his highly provocative *Proclamation 1919*. The evening
was concluded by some compositions by Hans Heusser which left no
tone unturned. The public was tamed . . . whether it was also con-
verted is a question that can only be answered today, forty years later.

During the long interval that followed the second part, with the
hall still in total uproar, we looked for Tzara, who we thought must
have been torn to pieces. Indeed, he was nowhere to be found. It turned
out that he had never been there in the first place. We found him at
last sitting in the restaurant, peacefully and contentedly counting
the takings. I think we had taken 1,200 francs, the biggest sum that
Dada had ever seen. Dada had been "beaten" . . . but it was still
Dada's victory.

Some time later, in October, 1919, there appeared in Zurich a kind
of afterbirth of Dada, the periodical *Der Zeltweg*. It took its name
from the street where, for a long time, Arp had his studio. *Der Zeltweg*
was edited by the writers Otto Flake, Walter Serner, and Tristan
Tzara.

By comparison with the classic issues of *Dada, Der Zeltweg* was
rather tame. The contributors were still the same, but we no longer
lived on an island, isolated in the middle of a war. Europe was acces-
sible again. Besides, revolution in Germany, risings in France and
Italy, world revolution in Russia, had stirred men's minds, divided
men's interests and diverted energies in the direction of political
change.

If I am to believe the accounts which appear in certain books about
this period, we founded an association of revolutionary artists, or
something similar. I have no recollection of this at all, although Janco
has confirmed that we signed manifestoes and pamphlets, and Georges
Hugnet (who admittedly gets his information at second hand) says that
Tzara received one of these manifestoes from me, scored through it
with red pencil, and refused to publish it in *Der Zeltweg*. I regard
this as doubtful. Tzara was no red-pencil dictator.

I do remember a series of forty or fifty "Portraits" of Arp that I did
for *Der Zeltweg*. Arp, because of the classic oval shape of his head and
his triangular cubist nose, was the basic model for all my "head
fantasies" (*Kopf-Phantasien*)—then as now.

Richard Hülsenbeck

Richard Hülsenbeck (1892–) went to Zurich in the winter of 1915–16 as a pacifist medical student and remained to become a founder of Dada, to take part in the stage shows at the Cabaret Voltaire, to coedit the review of the same name, and to do early bruitist poetry readings. His *Phantastische Gebete,* illustrated by Arp and later by Grosz, and his *Schalaben Schalabei Schalamezomai* were published in 1916. In 1917, Hülsenbeck carried the word back to Berlin where, with Hausmann and Franz Jung, he edited *Club Dada* and then *der Dada,* lectured in Eastern Europe, and became the major spokesman for Berlin Dada. In May, 1917, he published an article in *Die Neue Jugend* called "The New Man," and he was named Commissar of Fine Arts during the brief revolution of that year. His Dada manifesto of April, 1918, called for political involvement, a mixture of Communism and anarchy. In 1920–21 he wrote the first history of Dada—*En Avant Dada*—and edited *Dada Almanach.* In 1922, with Dada moribund, he broke with Tzara and the Paris group and eventually returned to writing and medicine. Now a New York psychoanalyst under the name Charles R. Hulbeck, he continues to write and lecture on Dada, participating in the continuing controversy about its origins and intentions.

Dada Forward

In January, 1917, I returned to Germany, the face of which had meanwhile undergone a fantastic change. I felt as though I had left a smug fat idyll for a street full of electric signs, shouting hawkers, and auto horns. In Zurich the international profiteers sat in the restaurants with well-filled wallets and rosy cheeks, ate with their knives, and smacked their lips in a merry hurrah for the countries that were bashing each other's skulls in. Berlin was the city of tightened stomachers, of mounting, thundering hunger, where hidden rage was trans-

From *Richard Hülsenbeck,* En Avant Dada, *translated by Ralph Manheim in Robert Motherwell,* ed., Dada Painters and Poets (*New York: Wittenborn, Schultz, Inc., 1951*), *pp. 39–47. Originally published as* En Avant Dada: Eine Geschichte des Dadaismus (*Hanover: Steegmann, 1920*). *Reprinted by permission of George Wittenborn, Inc.*

formed into a boundless money lust, and men's minds were concen-
trating more and more on questions of naked existence. Here we
would have to proceed with entirely different methods, if we wanted
to say something to the people. Here we would have to discard our
patent-leather pumps and tie our Byronic cravats to the doorpost.
While in Zurich people lived as in a health resort, chasing after the
ladies and longing for nightfall that would bring pleasure barges,
magic lanterns, and music by Verdi, in Berlin you never knew where
the next meal was coming from. Fear was in everybody's bones, every-
body had a feeling that the big deal launched by Hindenburg & Co.
was going to turn out very badly. The people had an exalted and
romantic attitude towards art and all cultural values. A phenomenon
familiar in German history was again manifested: Germany always
becomes the land of poets and thinkers when it begins to be washed
up as the land of judges and butchers.

In 1917 the Germans were beginning to give a great deal of thought
to their souls. This was only a natural defense on the part of a society
that had been harassed, milked dry, and driven to the breaking point.
This was the time when expressionism began to enjoy a vogue, since
its whole attitude fell in with the retreat and the weariness of the
German spirit. It was only natural that the Germans should have lost
their enthusiasm for reality, to which before the war they had sung
hymns of praise, through the mouths of innumerable academic thick-
heads, and which had now cost them over a million dead, while the
blockade was strangling their children and grandchildren. Germany
was seized with the mood that always precedes a so-called idealistic
resurrection, an orgy à la Turnvater-Jahn, a Schenkendorf period.[1]

Now came the expressionists, like those famous medical quacks who
promise to "fix everything up," looking heavenward like the gentle
Muse; they pointed to "the rich treasures of our literature," pulled
people gently by the sleeve, and led them into the half-light of the
Gothic cathedrals, where the street noises die down to a distant mur-
mur and, in accordance with the old principle that all cats are gray at
night, men without exception are fine fellows. Man, they have dis-
covered, is good. And so expressionism, which brought the Germans
so many welcome truths, became a "national achievement." In art it
aimed at inwardness, abstraction, renunciation of all objectivity. When
expressionism is mentioned, the first three names I think of are
Däubler, Edschmid, and Hiller. Däubler is the gigantosaurus of ex-
pressionist lyric poetry, Edschmid the prose writer and prototype of

[1] "Turnvater"—"gymnastic father," refers to Ludwig Jahn, the founder of the
gymnastic societies which played an important part in the liberation of Germany
from Napoleon.

the expressionist man, while Kurt Hiller, with his intentional or un-intentional meliorism, is the theoretician of the expressionist age.

On the basis of all these considerations and the psychological insight that a turning-away from objective reality implied the whole complex of weariness and cowardice that is so welcome to putrescent bourgeoisie, we immediately launched a sharp attack on expressionism in Germany, under the watchword of "action," acquired through our fight for the principles of bruitism, simultaneity, and the new medium. The first German Dadaist manifesto, written by myself, says among other things: "Art in its execution and direction is dependent on the time in which it lives, and artists are creatures of their epoch. The highest art will be that which in its conscious content presents the thousandfold problems of the day, the art which has been visibly shattered by the explosions of the last week, which is forever trying to collect its limbs after yesterday's crash. The best and most extraordinary artists will be those who every hour snatch the tatters of their bodies out of the frenzied cataract of life, who, with bleeding hands and hearts, hold fast to the intelligence of their time. Has expressionism fulfilled our expectations of such an art, which should be the expression of our most vital concerns? *No! No! No!* Under the pretext of turning inward, the expressionists in literature and painting have banded together into a generation which is already looking forward to honorable mention in the histories of literature and art and aspiring to the most respectable civic distinctions. On pretext of carrying on propaganda for the soul, they have, in their struggle with naturalism, found their way back to the abstract, pathetic gestures which presuppose a comfortable life free from content or strife. The stages are filling up with kings, poets, and Faustian characters of all sorts; the theory of a melioristic philosophy, the psychological naivety of which is highly significant for a critical understanding of expressionism, runs ghostlike through the minds of men who never act. Hatred of the press, hatred of advertising, hatred of sensations, are typical of people who prefer their armchair to the noise of the street, and who even make it a point of pride to be swindled by every small-time profiteer. That sentimental resistance to the times, which are neither better nor worse, neither more reactionary nor more revolutionary than other times, that weak-kneed resistance, flirting with prayers and incense when it does not prefer to load its cardboard cannon with Attic iambics—is the quality of a youth which never knew how to be young. Expressionism, discovered abroad, and in Germany, true to style, transformed into an opulent idyll and the expectation of a good pension, has nothing in common with the efforts of active men. The signers of this manifesto have, under the battle cry Dada!, gathered

together to put forward a new art, from which they expect the realization of new ideals." And so on. Here the difference between our conception and that of Tzara is clear. While Tzara was still writing: *"Dada ne signifie rien"*—in Germany Dada lost its art-for-art's-sake character with its very first move. Instead of continuing to produce art, Dada, in direct contrast to abstract art, went out and found an adversary. Emphasis was laid on the movement, on struggle. But we still needed a program of action, we had to say exactly what our Dadaism was after. This program was drawn up by Raoul Hausmann and myself. In it we consciously adopted a political position:

WHAT IS DADAISM AND WHAT DOES IT WANT IN GERMANY?

1. *Dadaism demands:*

 a. The international revolutionary union of all creative and intellectual men and women on the basis of radical Communism;

 b. The introduction of progressive unemployment through comprehensive mechanization of every field of activity. Only by unemployment does it become possible for the individual to achieve certainty as to the truth of life and finally become accustomed to experience;

 c. The immediate expropriation of property (socialization) and the communal feeding of all; further, the erection of cities of light, and gardens which will belong to society as a whole and prepare man for a state of freedom.

2. *The Central Council demands:*

 a. Daily meals at public expense for all creative and intellectual men and women on the Potsdamer Platz (Berlin);

 b. Compulsory adherence of all clergymen and teachers to the Dadaist articles of faith;

 c. The most brutal struggle against all directions of so-called "workers of the spirit" (Hiller, Adler), against their concealed bourgeoisism, against expressionism and postclassical education as advocated by the Sturm group;

 d. The immediate erection of a state art center, elimination of concepts of property in the new art (expressionism); the concept of property is entirely excluded from the superindividual movement of Dadaism which liberates all mankind;

 e. Introduction of the simultaneist poem as a Communist state prayer;

 f. Requisition of churches for the performance of bruitism, simultaneist and Dadaist poems;

 g. Establishment of a Dadaist advisory council for the remodelling of life in every city of over 50,000 inhabitants;

 h. Immediate organization of a large scale Dadaist propaganda campaign with 150 circuses for the enlightenment of the proletariat;

i. Submission of all laws and decrees to the Dadaist central council for approval;

j. Immediate regulation of all sexual relations according to the views of international Dadaism through establishment of a Dadaist sexual center.

The Dadaist revolutionary central council.
German group: Hausmann, Hülsenbeck
Business Office: Charlottenburg, Kantstrasse 118.
Applications for membership taken at business office.

The significance of this program is that in it Dada turns decisively away from the speculative, in a sense loses its metaphysics and reveals its understanding of itself as an expression of this age which is primarily characterized by machinery and the growth of civilization. It desires to be no more than an expression of the times, it has taken into itself all their knowledge, their breathless tempo, their scepticism, but also their weariness, their despair of a meaning or a "truth." In an article on expressionism Kornfeld makes the distinction between the ethical man and the psychological man. The ethical man has the childlike piety and faith which permit him to kneel at some altar and recognize some God, who has the power to lead men from their misery to some paradise. The psychological man has journeyed vainly through the infinite, has recognized the limits of his spiritual possibilities, he knows that every "system" is a seduction with all the consequences of seduction and every God an opportunity for financiers.

The Dadaist, as the psychological man, has brought back his gaze from the distance and considers it important to have shoes that fit and a suit without holes in it. The Dadaist is an atheist by instinct. He is no longer a metaphysician in the sense of finding a rule for the conduct of life in any theoretical principles, for him there is no longer a "thou shalt"; for him the cigarette butt and the umbrella are as exalted and as timeless as the "thing in itself." Consequently, the good is for the Dadaist no "better" than the bed—there is only a simultaneity, in values as in everything else. This simultaneity applied to the economy of facts is communism, a communism, to be sure, which has abandoned the principle of "making things better" and above all sees its goal in the destruction of everything that has gone bourgeois. Thus the Dadaist is opposed to the idea of paradise in every form, and one of the ideas farthest from his mind is that "the spirit is the sum of all means for the improvement of human existence." The word "improvement" is in every form unintelligible to the Dadaist, since behind it he sees a hammering and sawing on this life which, though useless, aimless, and vile, represents as such a thoroughly spiritual phenomenon, requiring

no improvement in a metaphysical sense. To mention spirit and improvement in the same breath is for the Dadaist a blasphemy. "Evil" has a profound meaning, the polarity of events finds in it a limit, and though the real political thinker (such as Lenin seems to be) creates a movement, i.e., he dissolves individualities with the help of a theory, he changes nothing. And that, as paradoxical as it may seem, is the import of the Communist movement.

The Dadaist exploits the psychological possibilities inherent in his faculty for flinging out his own personality as one flings a lasso or lets a cloak flutter in the wind. He is not the same man today as tomorrow, the day after tomorrow he will perhaps be "nothing at all," and then he may become everything. He is entirely devoted to the movement of life, he accepts its angularity—but he never loses his distance to phenomena, because at the same time he preserves his creative indifference, as Friedlaender-Mynona calls it. It seems scarcely credible that anyone could be at the same time active and at rest, that he should be devoted, yet maintain an attitude of rejection; and yet it is in this very anomaly that life itself consists, naive, obvious life, with its indifference toward happiness and death, joy and misery. The Dadaist is naive. The thing he is after is obvious, undifferentiated, unintellectual life. For him a table is not a mousetrap and an umbrella is definitely not to pick your teeth with. In such a life art is no more and no less than a psychological problem. In relation to the masses, it is a phenomenon of public morality.

The Dadaist considers it necessary to come out against art, because he has seen through its fraud as a moral safety valve. Perhaps this militant attitude is a last gesture of inculcated honesty, perhaps it merely amuses the Dadaist, perhaps it means nothing at all. But in any case, art (including culture, spirit, athletic club), regarded from a serious point of view, is a large-scale swindle. And this, as I have hinted above, most especially in Germany, where the most absurd idolatry of all sorts of divinities is beaten into the child in order that the grown man and taxpayer should automatically fall on his knees when, in the interest of the state or some smaller gang of thieves, he receives the order to worship some "great spirit." I maintain again and again: the whole spirit business is a vulgar utilitarian swindle. In this war the Germans (especially in Saxony where the most infamous hypocrites reside) strove to justify themselves at home and abroad with Goethe and Schiller. Culture can be designated solemnly and with complete naivety as the national spirit become form, but also it can be characterized as a compensatory phenomenon, an obeisance to an invisible judge, as veronal for the conscience. The Germans are masters of dissembling, they are unquestionably the magicians (in the

vaudeville sense) among nations, in every moment of their life they conjure up a culture, a spirit, a superiority which they can hold as a shield in front of their endangered bellies. It is this hypocrisy that has always seemed utterly foreign and incomprehensible to the French, a sign of diabolical malice. The German is unnaive, he is twofold and has a double base.

Here we have no intention of standing up for any nation. The French have the least right of anyone to be praised as a *grande nation*, now that they have brought the chauvinism of our times to its greatest possible height. The German has all the qualities and drawbacks of the idealist. You can look at it whichever way you like. You can construe the idealism that distorts things and makes them function as an absolute (the discipline of corpses) whether it be vegetarianism, the rights of man or the monarchy, as a pathological deformation, or you can call it ecstatically "the bridge to eternity," "the goal of life," or more such platitudes. The expressionists have done quite a bit in that direction. The Dadaist is instinctively opposed to all this. He is a man of reality who loves wine, women, and advertising; his culture is above all of the body. *Instinctively he sees his mission in smashing the cultural ideology of the Germans.* I have no desire to justify the Dadaist. He acts instinctively, just as a man might say he was a thief out of "passion," or a stamp-collector by preference. The "ideal" has shifted: the abstract artist has become (if you insist, dear reader) a wicked materialist, with the abstruse characteristic of considering the care of his stomach and stock jobbing more honorable than philosophy. "But that's nothing new," those people will shout who can never tear themselves away from the "old." But it is something startlingly new, since for the first time in history the consequence has been drawn from the question: What is German culture? (Answer: Shit) And this culture is attacked with all the instruments of satire, bluff, irony, and finally, violence. And in a great common action.

Dada is German Bolshevism. The bourgeois must be deprived of the opportunity to "buy up art for his justification." Art should altogether get a sound thrashing, and Dada stands for the thrashing with all the vehemence of its limited nature. The technical aspect of the Dadaist campaign against German culture was considered at great length. Our best instrument consisted of big demonstrations at which, in return for a suitable admission fee, everything connected with spirit, culture, and inwardness was symbolically massacred. It is ridiculous and a sign of idiocy exceeding the legal limit to say that Dada (whose actual achievements and immense success cannot be denied) is "only of negative value." Today you can hardly fool first-graders with the old saw about positive and negative.

The gentlemen who demand the "constructive" are among the most suspicious types of a caste that has long been bankrupt. It has become sufficiently apparent in our time that law, order, and the constructive, the "understanding for an organic development," are only symbols, curtains, and pretexts for fat behinds and treachery. If the Dadaist movement is nihilism, then nihilism is a part of life, a truth which would be confirmed by any professor of zoology. Relativism, Dadaism, Nihilism, Action, Revolution, Gramophone. It makes one sick at heart to hear all that together, and as such (insofar as it becomes visible in the form of a theory), it all seems very stupid and antiquated. Dada does not take a dogmatic attitude. If Knatschke proves today that Dada is old stuff, Dada doesn't care. A tree is old stuff too, and people eat dinner day after day without experiencing any particular disgust. This whole physiological attitude toward the world, that goes so far as to make—as Nietzsche the great philologist did—all culture depend on dry or liquid nutriment, is of course to be taken with a grain of salt. It is just as true and just as silly as the opposite. But we are after all human and commit ourselves by the mere fact of drinking coffee today and tea tomorrow. Dada foresees its end and laughs. Death is a thoroughly Dadaist business, in that it signifies nothing at all. Dada has the right to dissolve itself and will exert this right when the time comes. With a businesslike gesture, freshly pressed pants, a shave and a haircut, it will go down into the grave, after having made suitable arrangements with the Thanatos Funeral Home. The time is not far distant. We have very sensitive fingertips and a larynx of glazed paper. The mediocrities and the gentry in search of "something mad" are beginning to conquer Dada. At every corner of our dear German fatherland, literary cliques, with Dada as a background, are endeavoring to assume a heroic pose. A movement must have sufficient talent to make its decline interesting and pleasant. In the end it is immaterial whether the Germans keep on with their cultural humbug or not. Let them achieve immortality with it. But if Dada dies here, it will some day appear on another planet with rattles and kettledrums, pot covers and simultaneous poems, and remind the old God that there are still people who are very well aware of the complete idiocy of the world.

Dada achieved the greatest successes in Germany. We Dadaists formed a company which soon became the terror of the population—to it belonged, in addition to myself, Raoul Hausmann, Georg Grosz, John Heartfield, Wieland Herzfelde, Walter Mehring, and a certain Baader. In 1919 we put on several big evening shows; at the beginning of December, through no fault of our own, we gave two Sunday afternoon performances in the institute for socialist hypocrisy, the "Tribune,"

which achieved the success of good box-office receipts and a word of melancholy-reluctant praise in the form of an article in the *Berliner Tageblatt* by Alfred Kerr, a critic well known and appreciated a century ago, but now quite crippled and arteriosclerotic. With Hausmann, the "Dadasoph," to whom I became greatly attached because of his selfless shrewdness, and the above-mentioned Baader, I undertook in February, 1920, a Dada tour, which began in Leipzig on February 24 with a performance in the Zentraltheater attended by a tremendous ruckus ("bruit") which gave our decayed old globe quite a shaking up; this affair was attended by 2,000 people. We began in Leipzig, on the basis of the sound idea that all Germans are Saxons, a truth, it seems to me, which speaks for itself. We then went to Bohemia, and on February 26 we appeared in Teplitz-Schönau before an audience of fools and curiosity-seekers. That same night we drank ourselves into a stupor, after, with our last sober breath, we had appointed Hugo Dux, the most intelligent inhabitant of Teplitz, chief of all Dadaists in Czechoslovakia. Baader, who is almost fifty years of age and, as far as I know, is already a grandfather, then repaired to the Bawdy House of the Bumblebee, where he wallowed in wine, women, and roast pork and devised a criminal plan which, he calculated, would cost Hausmann and myself our lives in Prague on March 1. On March 1 the three of us were planning to put on a show in the Prague produce exchange, which seats nearly 2,500 persons. And conditions in Prague are rather peculiar. We had been threatened with violence from all sides. The Czechs wanted to beat us up because we were unfortunately Germans; the Germans had taken it into their heads that we were Bolsheviks; and the Socialists threatened us with death and annihilation because they regarded us as reactionary voluptuaries. Weeks before our arrival the newspapers had started a monster Dada publicity campaign and expectations could not have been screwed to a higher pitch. Apparently the good people of Prague expected the living cows to fall from the heavens—in the streets crowds formed behind us with rhythmic roars of "Dada," in the newspaper offices the editors obligingly showed us the revolvers with which, under certain circumstances, they were planning to shoot us down on March 1. All this had smitten Baader's brain with a powerful impact. The poor pietist had conceived such a very different picture of our Dada tour. He had hoped to return to his wife and children with money in his pocket, to draw a comfortable income from Dada and, after performance of his conjugal duty, retire with a pipeful of Germanian ersatz tobacco to dream in all tranquillity of his heroic feats.

But now he was to take leave of his precious life, now there was a chance that he would end his poetic career in a Prague morgue. In

his terror he was willing to promise anything, to bear any disgrace if his cousin, the old God of the Jews, with whom he had so often allied himself, would only preserve him this last time from the dissolution of his individuality as a pseudo-bard. *Dum vita superest, bene est.* The performance in the produce exchange was to begin at 8 o'clock. At 7:30 I ask Hausmann about Baader's whereabouts. "He left me a note saying he had to go over to the post-office." And so he left us up to the very last moment in the belief that he would still turn up; this he did in order to prevent us from changing the program, thus exposing us with all the more certainty to the fury of the public. The whole city was in an uproar. Thousands crowded around the entrances of the produce exchange. By dozens they were sitting on the window-ledges and pianos, raging and roaring. Hausmann and I, in great agitation, sat in the little vestibule which had been rigged up as a green room. The windowpanes were already beginning to rattle. It was 8:20. No sign of Baader. Only now did we see what was up. Hausmann remembered that he had seen a letter "to Hausmann and Hülsenbeck" stuck in his underclothes. We realized that Baader had deserted us, we would have to go through with the hocus pocus by ourselves as best we could. The situation could not have been worse—the platform (an improvised board structure) could be reached only through the massed audience—and Baader had fled with half the manuscript. Now was the time to do or die. Hic Rhodus! My honored readers, with the help of God and our routine, a great victory was won for Dada in Prague on March 1. On March 2 Hausmann and I appeared before a smaller audience in the Mozarteum, again with great success. On March 5 we were in Karlsbad, where to our great satisfaction we were able to ascertain that Dada is eternal and destined to achieve undying fame.

An Explanation of the Dada Club

Dada is chaos from which thousands of systems arise and are entangled again in Dada chaos. Dada is simultaneously the course and the content of all that happens in the universe.

The Dada Club invites the leading representatives of the best German spirit to a dispute over dada principles:

Men are angels and live in the heavens. They themselves and all

"Eine Erklärung des Club Dada," translated by Gabrielle Bennett from Richard Hülsenbeck, ed., Dada Almanach *(Berlin: Erich Reiss Verlag, 1920). This text can be attributed to Richard Hülsenbeck, editor and founder of the Dada Club. It is reprinted with his permission.*

substance surrounding them are cosmic accumulations of the most powerful degree. Their chemical and physical transformations are magical processes, greater and more mysterious than any end of the world or any creation of a world in the region of the so-called stars. Any intellectual and spiritual utterance is a more wonderful thing than the most incredible event described in the *Tales of a Thousand and One Nights*. Everything done by man and by all other bodies occurs in support of the heavenly pastime as a game of the highest order, which is beheld and experienced in as many different ways as there are individual awarenesses confronting it. An individual consciousness is not only man, but also all other systems of the world-Gestalt, of which man consists, and within which he lives as an angel. Death is a fairy tale for children and belief in God was a rule for the game of human consciousness during the time when it was not known that the earth is a piece of the heavens, as is everything else. World consciousness needs no God.

The Dada Club urgently requests your opinion and will present the same for general recognition in No. 5 of its publications.

Dada Club

Invest in Dada!

dada is the only savings bank that pays interest in eternity. The Chinese has his tao and the Indian his brahma. dada is more than tao and brahma. dada doubles their income. dada is the secret black market and protects against inflation and malnutrition. dada is the war bond of eternal life; dada is comfort in dying. dada should be in every citizen's testament. Why should I unveil dada? dada works in the cerebellum and in the cerebrum of apes as well as in the hindquarters of statesmen. Whoever puts his money in the dada savings bank need not fear confiscation, for whoever touches dada is dada-tabu.

Every hundred-mark bill multiplies according to the law of cellular division. 1327-fold a minute. dada is the only salvation from the slavery of the entente. Every dada savings-bank check is valid all over the world. When you are dead, dada will be your only nourishment; even the ancient Egyptians fed their dead with dada.

The Directorate of Dada, "Legen Sie Ihr Geld in dada an!" translated by Gabrielle Bennett from Der Dada, no. 1 (Berlin, 1919). The Directorate of Dada actually consisted of Richard Hülsenbeck, Johannes Baader, and Raoul Hausmann. Hülsenbeck was the editor of Der Dada, and this text is reprinted with his permission.

Gautama thought he was going to Nirvana, and when he died, he stood not in Nirvana but in dada. dada floated over the waters before dear God created the world and when he said: let there be light! there was not light but dada. And when the Twilight of the Gods fell, the only survivor was dada. Invest your money in dada. dada is not subordinate to the sovereignty of the inter-allied economic commission. Even the *Deutsche Tageszeitung* lives and dies with dada. If you wish to obey this summons, then go at night between 11 and 2 o'clock to the spot in the Siegesallee between Joachim the Lazy and Otto the Milksop and ask the policeman where the secret dada depot is. Then take a one-hundred-mark bill and paste it on the golden H of Hindenburg and shout three times, the first time piano, the second forte, and the third fortissimo: dada. Then the Kaiser (who does not, as claimed for tactical reasons, live in Amerongen but between Hindenburg's feet) will climb through a trapdoor out of a secret passageway with an audible dada, dada, dada and give you our receipt. Be sure that "W.II." is followed not by "I.R." but by "dada." I.R. will not be honored by the savings bank. In addition you can transfer your balance to dada at any branch office of the Deutsche Bank, the Dresdner Bank, the Darmstädter Bank and the Discountocompany. These four banks are called the "D" or dada-banks and the emperor of China and the emperor of Japan and the new emperor Koltschak of Russia have their court-dada in every bank (they used to be called "Goldschitter," but now they are called "dada"; one is standing on the left corner tower of Notre Dame.) All credits are collected and directed through Versailles to the Vatican, where the holy dada blesses them and shoves them into the lap of the holy mama. Yes, yes, dada cannot be unveiled. dada multiplies everything to the hundredth and thousandth degree. Tao and brama are dada. Dada makes children and grandchildren. Dada is fertile and multiplies. Only dada is the saviour from misery and sorrow. Invest your money in dada!

Raoul Hausmann

Raoul Hausmann (1886–) was born in Vienna, son of an academic painter who moved to Berlin in 1900. In 1905 he met Johannes Baader, an architect and future "Ober-Dada," with whom he and Richard Hülsenbeck were to found "Dada Club" in 1918. By that time, fully involved in the German avant-garde, Hausmann was painting and making prints in a futurist-expressionist style, replaced in 1919 by the more bizarre dislocations of Dada objects and collages. Hausmann discovered his own version of photomontage independent of Ernst, Grosz, and others working in the same direction in 1919–20, and his *Tatlin at Home* and *Mechanical Head* are among Dada's most memorable anticreations. At the same time he was inventing his phonetic poems, paralleling those being done in Zurich and by Schwitters. In 1919 he started the review, *Der Dada,* organized the first Dada exhibition in Berlin (at J. B. Neumann's Graphische Kabinett), and wrote articles for several magazines, including *de Stijl* and *Mecano.* In 1920, with Grosz and Heartfield, he organized the Dadamesse and collaborated with Hülsenbeck in a Dada lecture tour through Germany and Czechoslovakia.

From 1922 Hausmann devoted most of his time to his poetry, and, later, to photography, living a peripatetic existence in Spain, Germany, and France, where he eventually settled. The "Optophone" invented during these years was a photo-electric machine for transmitting kaleidoscope forms into sound, a continuation of his new interest in electronic music and his early preoccupation with bruitist poetry, one of Dada's goals having been, as Hugo Ball put it, the "devastation of language." Hausmann had worked closely with Schwitters in this area and contends that his achievements were the basis of the latter's better-known *Ursonata.* "The sound poem," he wrote, "is an art consisting of respiratory and auditive combinations. In order to express these elements typographically, I use letters of different sizes to give them the character of musical notation." In 1946–47 Schwitters and Hausmann renewed contact by correspondence, resulting in a book published only in 1962: *PIN and the Story of PIN,* by Raoul Hausmann and Kurt Schwitters (London: Gaberbocchus Press).

A Dadasoph's Opinion of What Art Criticism Will Say about the Dada Exhibition

Max Liebermann is illustrating the Bible!

First of all, it should be emphasized that this Dada exhibition is a very common bluff, a mean speculation on the curiosity of the public —it is not worth a visit. While Germany is trembling and shaking in a governmental crisis of unforeseeable duration, while the meeting in Spaa[1] pushes our future fate further and further into uncertainty— these boys come along making wretched trivialities out of rags, trash, and garbage. Such a decadent group, showing no ability at all and lacking in serious intent, has seldom appeared so boldly in public, as these dadas dare to. They don't surprise one anymore; everything goes down in cramps of originality mania, which, devoid of all creativity, lets off steam with foolish nonsense. "Mechanical art work" may pass in Russia as a type of art—here it is talentless and artless mimicry, the utmost in snobbism and insolence towards serious criticism. Even the single middling talent among this bunch, the draughts-man Grosz, is disappointing; it is precisely his case that demonstrates how weakness of character and inability to resist the pressures of fashion and the search for the "newest" can lead a talent into a swamp of boredom, aberration, and dull barroom jokes. Oh Grüne-wald, Dürer, and you other great Germans, what would you say at it? The works shown at this exhibition are without exception on such a low level that one wonders how an art gallery could dare show these concoctions for such a high admission price. The perhaps misled owner of this gallery should be warned—but the dadas should receive merciful silence.

Raoul Hausmann, "Was die Kunstkritik nach Ansicht des Dadasophen zur Dadaaustellung sagen wird," translated by Gabriele Bennett from the catalogue of Dadamesse *(Berlin, 1920). Reprinted by permission of Raoul Hausmann.*

[1] Translator's note: Spaa—abbreviation of Sparta. "Go, tell the Spartans, thou who passest by, that here, obedient to their laws, we lie"—Simonides.

New Painting and Photomontage

What a good joke art criticism is; how would Dada art criticism distinguish itself from it? Here is what G. Hugnet wrote about the

Raoul Hausmann, "Peinture nouvelle et photomontage," translated by Mimi Wheeler from Courrier Dada *(Paris: Terrain Vague, 1958). Reprinted by permission of Raoul Hausmann.*

painter Raoul Hausmann in "The Dada Spirit in Berlin," *Cahiers d'Art,* no. 6–7, 1938.[1]

The latter has composed for this brochure two woodcuts which have nothing to do with art and which, in their disorder, oppose all cubist, futurist, and abstract laws, which is their principal attraction from the Dada angle. It should be said here that the scorn in which Dada held all forms of modernism was indispensable to its own vitality, but it must also be added that experience has taught us to distinguish between Futurism and abstraction which, despite the relative value of their riches, brought us nothing, and Cubism, whose singularly poetic grandeur generated poetry and was a major influence on our times, even on Dada's most moving plastic realizations.

Well, I know what feelings and intentions occupied me in 1918 in the Dada period, in the middle of the war! We not only *resisted* then, but also searched for new processes, surging from our unconsciouses, to replace the fabrication of *masterpieces* according to academic recipes. That concerned literature as well as painting. We, and I above all, had had enough pretty play painted in oil and vinegar.

Our Dada Manifesto of April, 1918, had already demanded *new materials in painting*. But that was not enough for me, and I wrote the following manifesto, also in April of 1918:

SYNTHETIC CINEMA OF PAINTING

Whoever wants to sustain imposed conventions, does so. Previously, life appeared to us as an immense, complete uproar; as a tension amid the collapsing expressions never unilaterally directed, and an important inflation of profound inconsiderations toward form, with no ethical somersaults on a narrow base; Dada art is the plane for the appearance of conflicts, of the insolence of the protesting creator; art, the lie without contingency, showing to the point of farce a (quasi) interior necessity, art never has a more profound sense than the nonsense of narcissism, taken seriously by pure innocents, traversed by games of tragic complexes crossing each other.

The painter paints as the cow lows; this solemn insolence of congealed croupiers, mixed with profound sense, has given way to guarded hunts, especially for German art critics.

The doll or the colored rag rejected by the child are more necessary expressions than those of an ordinary jackass who wants to immortalize himself by means of oil paintings hung in fine salons. The dissolution of complexes inexactly interlaced with inner necessity are an ethical excuse projected on a painting, they are the primitive attempt to heal by psycho-

[1] Editor's note: An English translation of that article appears in *The Dada Painters and Poets* (New York: Wittenborn & Schultz, 1951), pp. 141–53.

physiological prayer. But cure by prayer, like psychoanalysis, is objective medicine, more than a capacity for subjective equilibrium, in the contradictions of dissolutions without disgrace, the most important of which remains sexuality. All expressions are sexual—the most extraordinary differentiations, the most obvious degenerations show us this. The lying swindle still practiced at the expense of art is an element lacking in ethical positions of flight from itself. Expressionism always seems unilateral and can only be accorded to the animal, for he perfectly realizes himself in his complex and functional auto-relations.

Man is simultaneously monster to himself and to the stranger, now, before, after, and at the same time: Buffalo Bill staring from a false romanticism, from the unlimited realities of a comportment ceaselessly concerning the most contradictory complexes: his relations with the Other. In the form of children's shoes as well as in telepathy, theosophy, occultism, suggestion, magnetism, fear of crime, assurance in tradition, against the capacity to abolish the limits of incest, homosexuality, polygamy and polyandry, of the inner necessity of art and the restrictions of complexes, a force is already roused today, displaying the extraordinary possibilities of the receptivity of man's sexopsychic capacity which no longer needs the ethical somersaults of any ordinary art. The attempts by science and art to reinforce the sensorial organs remain, in spite of everything, simple gestures of dissolution; of inverse aggressions directed against man, where art still marks an advantage over science by its conscious, nonobjective immorality, and registers it as property. So Cubism, Futurism—material of the expression of a visual intellectuality with the grand gesture of piercing through demeanor into the fourth dimension—remain attempts toward an enlargement of the complexes of the perception of chemical optical tropisms.

The most spontaneous knowledge, surpassing by far the theories of Od, a quasi-naturalism of our interlacings of contrasts, functioning until then only on the inside, was probably realized in Orphic Cubism and Futurism.

Expressionism, symbol of this reversal of impulses (inner necessity) always more profoundly engulfed in esthetically surpassing the world is, today, for those quitters constrained of being, only a registered notion, a vital need like the charcoal ticket or the black market.

Orphic Cubism, Futurism, by their means: colors on canvas, cardboard, artificial hair, wood, paper, having succeeded in their veritable *interelations,* are finally limited by their own scientific objectivity. Dada art will offer them enormous refreshment, an impetus toward the perception of all relations.

Dada is the perfect well-wishing malice; beside exact photography, the only justified form of figurative expression and equilibrium in communal life: anyone who frees his own tendencies in himself is Dada.

In Dada you will recognize your real state of mind: miraculous constellations in real materials: wire, glass, cardboard, tissue, corresponding organically to their own brittle or bulging fragility.

Here and for the first time, there are neither retreats nor anguished obstinacies; we are far from the symbolic, from totemism, from the electric piano, from gas attacks, from reports on installations, from men screaming in military hospitals; let us—with our marvelous contradictory organisms—help attain a justification, a central turning axis, the reason to stand up straight or to fall.

By the efficacious perfection of materials employed in a supreme art of auto-representation in evolution, abandoning the traditional atmosphere and assurances incorporated in an entourage of unemployed.

* * *

Liaisons having been assured by Richard Hülsenbeck and the painter Hans Richter, who were in Switzerland at that time, we were kept up to date on the development of painting in the other European countries. We knew that, following the Futurists' example, Picasso was employing *real* materials, cut-up newspapers, hair, wood, plaster, and the same Picasso had made, at the same time as the Dutch expressionist Van Rees, still lifes out of different pieces of colored paper, a process that was called *collage*.

I began to make paintings with cut-outs of colored paper, newspaper, and posters in the summer of 1918. But it was on the occasion of a visit to the Baltic seacoast, on the island of Usedom, in the little village of Heidebrink, that I conceived the idea of photomontage. On the wall of almost every house was a colored lithograph depicting the image of a grenadier against a background of barracks. To make this military memento more personal, a photographic portrait of a soldier had been used in place of the head. This was like a stroke of lightning, one could—I saw it instantly—make *paintings* entirely composed of cut-out photographs. On returning to Berlin in September, I began to realize this new vision by using photos from magazines and the movies. Captured by a renovating zeal, I also needed a name for this technique, and in general agreement with George Grosz, John Heartfield, Johannes Baader, and Hannah Höch,[2] we decided to call these works *photomontages*. This term translated our aversion to playing artist, and, considering ourselves as engineers (from that came our preference for work clothes—"overalls" [monteur-anzüge], we claimed to construct, to *mount* our works.

Such is the history of the discovery of photomontage; Johannes Baader and Hannah Höch, in particular, employed and popularized the new technique; Grosz and Heartfield, too taken with their caricaturistic ideas, remained faithful to collage until 1920. At the beginning this was a mixture of drawing and cut-outs from catalogues. Later in

[2] Editor's note: See pp. 68–77.

1919, under the influence of American magazines, which came to Grosz via his brother-in-law, a subway engineer in San Francisco, Grosz and Heartfield added to their paintings reproductions of advertising articles in color. Another detail—although in France one would call these things collage, in the same sense that one connects whimsical objects and even opposites at first, in Berlin we called them *Klebebild* (pasted painting); I myself, outside of my different pseudonyms and dada titles (like dadasoph), took the name of Algernoon Syndetikon, Syndetikon indicating the brand of the glue I was using. As for the photomontage only being accepted by John Heartfield in 1920, it remains to correct the role accorded to Max Ernst on this subject.

We read this declaration by Aragon in *La Peinture au défi,* 1930:

When and where did collage appear? I believe despite the tentatives of several early Dadaists, that homage must be made to Max Ernst, at least for the two forms of collage most removed from the principle of the *papier collé,*[3] the photographic collage and the illustrative collage. At first, this discovery had a tendency to be generalized, and the German dada publications, notably, contained collages signed by at least ten authors. But this procedural success arose more from amazement at the *system* than from the necessity to be expressed at all costs. Very soon the use of the collage was limited to a few men, and it is certain that all the atmosphere of the collage at that time was found in the mind of Max Ernst, and Max Ernst alone.

In the publication *Max Ernst (Cahiers d'Art,* 1936), Max Ernst himself wrote:

I am not responsible for the term collage: out of 56 catalogued items in my collage exhibition in Paris, in 1920,[4] the exhibition which according to Aragon, in *La Peinture au défi,* was perhaps the first manifestation to permit the perception of the resources and the thousands of possibilities in an entirely new art, here in this city where Picasso never could exhibit the constructions in wire, cardboard, bits of cloth, etc., only twelve justify the term cut-out collage.

I had exhibited montages in a dada matinee that I organized with Baader at the Cafe Austria in Berlin, in the Potsdamer Strasse, in June, 1918; and in *Der Dada,* a publication that I directed from June, 1919, until December of the same year, there was a photomontage representing Baader's head and mine behind a pipe from which a rose emerged, and a primitive photomontage by Baader (reproduced in

[3] Editor's note: *Papier collé* was the term for Cubist "pasted paper" collages.
[4] Editor's note: This exhibition actually took place in May, 1921.

Cahiers d'Art, no. 4–6, 1932). It was the second issue (the first was, through impecuniousness, exclusively decorated with wood engravings). The third issue appeared in Wieland Herzfelde's Malik editions. It contained a drawing montage by George Grosz, dedicated to the "professor photomonteur R. Hausmann," to signify that even my two rivals acknowledged my priority, and an "Improved Picasso" by Grosz made of newspaper clippings and photos superimposed on a painting by Picasso.

Georges Hugnet, in his article on "The Dada Spirit in Berlin" begins his publication with three of my works, the first a photomontage of 1919–21 (begun in 1919 and modified in 1921) and a dada sculpture dated 1920. But he does not mention that I was the first photomontagist! He continues to talk about collages, when people generally accord the development of this technique only to Max Ernst. On this subject we read in "The Dada Spirit in Berlin" these few lines:

> . . . Hausmann was joined now by other painters: Grosz and Heartfield. The collages made by Hausmann and Heartfield consisting of newspaper pages and photographs, composed at random, without great seriousness, served as illustrations along with drawings mixed with extraneous elements attached or glued, and with photographs or absurd and stupefying vignettes, the whole—advertisements, accidents—simulating a dream.

But let us give the floor to Max Ernst himself, and see how he describes the discovery of *collage,* this technique that we called *montage* (because communications between the different dada groups in Germany were nil and, aside from resemblances created by the epoch itself, we were separated from one another by abysses until 1920).

> One rainy day in the year 1919, finding myself in a city on the Rhine, I was struck with the obsession exercised on my excited glance by the pages of an illustrated catalogue reproducing objects for anthropological, microscopic, psychological, mineralogical, and paleontological demonstrations. There I found united the elements of figurations so distant that the very absurdity of this assemblage provoked a sudden intensification of my visionary faculties and created a hallucinatory succession of contradictory images—double, triple, and multiple images, superimposed on each other with the persistence and speed peculiar to amorous memories and visions during half-sleep. These images themselves called up new planes for their encounters in a new unknown. (The plane of unsuitability.) It sufficed to add then to these catalogue pages, by painting or drawing, and by making only that which submissively reproduced THAT WHICH WAS SEEN WITHIN ME, a color, a pencil line, a landscape foreign to me, objects represented, a desert, a sky, a

geological cross-section, a board, a single straight line signifying the horizon, in order to obtain a faithful and fixed image of my hallucination; to transform into a drama revealing my most secret DESIRES, that which had been nothing but banal advertising pages.

This is about all that can be said about the introduction of photomontage as a new process subjected to chance, as an imaginary visual automatic impulse. It is generally unknown that Dada was not created by Duchamp, Picabia, Max Ernst, Baargeld, and Schwitters alone. The exhibitions (with the exception of the Berlin Dada Fair in the spring of 1920) that we organized in 1919 at the J. B. Neumann Gallery and in which Grosz, Heartfield, Hannah Höch, myself, and a very talented young Russian, Jefim Golyscheff, participated, have been ignored abroad. J. Golyscheff and I exhibited *mechanical drawings*, wood cuts, cardboard sculptures (Hausmann) and compositions realized in eccentric materials such as jelly boxes, glass, hair, paper lace (Golyscheff). In addition, our group exhibited together in 1919 and 1920 at the official exhibition of the *Novembergruppe* where my *Mechanical Head* was exhibited for the first time.

Serious discords and rivalries resulted from the instigation of photomontage—not only between myself and Heartfield, but also between the two of us and Max Ernst. To resolve this priority dilemma, my friend César Domela Nieuwenhuis organized in 1931 an historical exhibition of photomontage at the Museum of Arts and Crafts in Berlin. My preponderant role was underlined there, to Heartfield's great resentment. Here is a translation of the lecture I gave at the official opening of that exhibition:

Amid divergent opinions, it is often claimed that photomontage is practicable only in two forms: that of political propaganda and that of commercial advertising. The first photomontagists, the dadas, departed from the point of view, incontestable for them, that the painting of the war period, postfuturist expressionism, had failed because of its non-objectivity and its absence of convictions, and that not only painting but all the arts and their techniques needed a fundamental revolutionary change in order to remain relevant to the life of their times. The members of the Dada Club were naturally not interested in elaborating new esthetic rules according to which art should be executed. In the first place, they were concerned with the enticing aptitudes of new material and through it, with the renewal of forms, of fresh content. Dada, which was a kind of cultural criticism, stopped at NOTHING! And it is correct that an eminent number of the first photomontages was as revolutionary as its content, its form as subversive as the application of photographs and printed texts which together are transformed into static film. The Dadas, having invented the static poem, simultaneous and purely phonetic, then applied the same principles to pictorial ex-

pression. They were the first to use photography as a creative material, at the service of very different structures, often eccentric and with antagonistic significance, a new entity which wrenched from the chaos of the war and the revolution an intentionally new optical reflection; they knew that a propagandistic power was included in this method, and that contemporary life was not audacious enough to develop and absorb it.

Things have changed a great deal since then. The current exhibition at the Art Library shows this, and it shows the importance of photomontage in the USSR as a means of propaganda. Moreover, it demonstrates that the value of this propagandist effect is largely recognized by economics. That is seen (visible, obvious) in every cinema prospectus, unimaginable without photomontage, as though it were an unwritten law.

Today, however, some people argue that in our period of neorealism or even fadism, the photomontage is already outdated, and holds little possibility for further development. One can reply to this that the simple photograph is even older, and that nevertheless new men appear to captivate us with unexpected points of view on the world surrounding us. The number of modern photographs is large and growing daily, but for all that, one finds their different styles neither more nor less modern.

The realm of photomontage is so vast that it lends itself to as many possibilities as there are different environments. From the sociological structure of the milieu to the psychological superconstructions resulting from it, the milieu changes itself daily. The possibilities of photomontage are not limited by discipline of its formal means, by revision of its expressive radius.

The photomontage in its primitive form was an explosion of viewpoints and an intervortex of azimuths. Moving further in its complexity than Futurist painting, it has, meanwhile, undergone an evolution one could call constructive. The perception that the optical element offers extremely varied possibilities has been imposed everywhere. The photomontage allows the elaboration of the most dialectical formulas, because of its opposing structures and dimensions, for example, the roughness and smoothness of the aerial view and of the foreground, of perspective and flat level. The technique of photomontage is visibly simplified in proportion to its range of application. Its domain is especially applicable to political propaganda and commercial advertising. The necessary clarity required by political or commercial slogans has increasing influence on its means of counterbalancing the most obvious contrasts, and from the beginning will remove capricious elements from the dialectical momentum of forms peculiar to the photomontage, will assure it of a fortunate and prolonged survival.

In the future, photomontage, the precision of materials, the legibility of objects, the precision of plastic notions, will play the greatest role. Apparently no one has considered the statistical photomontage, men-

tioned here, as a new form. It can be claimed that the photomontage
can contribute as much to the development of our vision, of our con-
sciousness of optical, psychological, and social structures, in an extraordi-
nary sense, as photography or film; and that it can do so by the exacti-
tude of its data, where content, form, meaning and appearance become
one.

But a large number of artists have already cornered my ideas. The
efficiency of the process, once separated from its oneiric and automatic
element, once replaced by the propagandist element, responded so
well to the needs of public instruction in the USSR that included in
the catalogue of this photomontage exhibition is a text by the Russian
painter Kluzis, who would contradict the truth slightly, ever so
slightly; why, we will see immediately.

Kluzis wrote: "In the development of photomontage there are two
general tendencies: one comes from American advertising; it was
exploited by the dadas and expressionists, this is the so-called formal
photomontage; the second tendency, that of the military and political
photomontage, appeared in the USSR 'on the leftist front of art'
when nonobjective art was already outdated . . . photomontage as
a new method of art in the USSR dates from 1919 to 1921" . . . small
error.

In any case, my friend the constructivist El Lissitzky, when he saw
photomontages for the first time at my house in 1922, had this to
say: "That is still not known at home." He meant in the USSR. And
in the book, *Kunstismen,* which he published with Arp in Zurich in
1924, I figure as the first representative of photomontage.

Sound-Rel

Beckoefkei 7 eckne Büe 7 P F f
ds Me F 7 aede 5 ucer n racun O 2 chase
A hea Oletché F Mistrei Edeie Vhj 6
s ihe H O chchra H - VDchf
s 5 bxegz F ucea de S W
 d Pa Odw Ner R V
 adiiiedtd

 d 3 ec
 z medec
 f H E hlte
 na § 16 fl
nm-se S P de
 ugej or R F A - nph
 M M ixunji
 a 5 c l accheilin P ag C
 rwfdnz teufb 8 aéln
 r gtrzbu - teit rzo M chffr eat
Q R se Eu Czenésn C L n
ir B Z B r 2 ilqu
 4 H H V nt ff
 i7mekru D E nchou
 B P & fuia fed Qv ité Jled
 t H O V 2 n ch & qusr V nzüchdb
 dtr' g R Q ndm as Cf r, os Bsiu
 Auét Ach Dö ? iEston xCB
 Wm G t f M C i a ? arana Uemi
 u C E A P U caUrUMOET öo I
 chnsmenn dr rüeöuyüBzeszr
 yGr — rokeui 3 e
 eod oailen 2 Dpas X u
 u éF5 ew Ro Uau 6 gotuinuie
 geee Bnckeöliden 3 nis

Raoul Hausmann, "Sound-Rel" (1919), from Robert Motherwell, ed., Dada Painters and Poets (*New York: Wittenborn, Schultz, Inc., 1951*). *Reprinted by permission of Raoul Hausmann and George Wittenborn, Inc.*

Hannah Höch

Hannah Höch (1889–) studied art in Berlin and in 1915 met Raoul Hausmann, with whom she was closely associated until 1922. Her first collages and her first contact with Dada were made in 1917, and in 1918 she and Hausmann made their first photomontages, a medium which Hausmann, among others, claims to have invented (see pp. 58–67). Hans Richter describes her as "the quiet, the able Hannah": "she was still quite innocent when she entered Hausmann's demonic jowls. But just as Jonah, newly born from the whale, immediately went about his business, so Hannah went about her collages . . . [and] succeeded in developing her own note of individuality. . . . She was indispensable as manager of Hausmann's atelier evenings, because of her light grace—in dazzling contrast to the ponderousness of her master. . . . And on such evenings she too was permitted to raise her small but very precise voice in favor of art and Hannah Höch while Hausmann held forth on Anti-Art." After 1922, Höch worked closely with Schwitters, made some *Merzbilder*, and returned to painting. From 1926–39 she lived in Holland, and since then has been in Heiligensee, an obscure suburb of Berlin, where she continues to make collages and photomontages.

Interview with Hannah Höch by Edouard Roditi

Very few of my Berlin friends had any idea how to get here, when I asked them for advice. I was even warned by some that it would be unwise to try to visit you in Heiligensee; they insisted that it is beyond the limits of West Berlin, in the Eastern Zone.

What nonsense! But it's actually because this part of Berlin is so quiet and so little known that I moved to Heiligensee in 1938, just before the war. Under the Nazi dictatorship, I was much too conspicuous and well known to be safe in Friedenau, where I had lived for many years. I knew that I was constantly being watched and denounced there by zealous or spiteful neighbors, so I decided, when I inherited enough money to buy a little house of my own, to look

From Edouard Roditi, "Interview with Hannah Höch," Arts (New York, December 1959). Originally published in Die Monat. Reprinted by permission of Edouard Roditi and Arts.

around for a place in a part of Berlin where nobody would know me by sight or be at all aware of my lurid past as a Dadaist or, as we were then called, as a "Culture Bolshevist." . . .

In those years I would have felt lonely anywhere in Berlin. Those of us who were still remembered as having once been "Cultural Bolshevists" were all blacklisted and watched by the Gestapo. Each of us avoided associating even with his oldest and dearest friends and colleagues, for fear of involving them in further trouble. Most of the former Berlin Dadaists had in any case emigrated by 1938. Hans Richter and George Grosz were in America, Kurt Schwitters had emigrated to Norway, Raoul Hausmann was in France. Of the really active members of the old Berlin Dada group, I was the only one still here.

How and when did the Berlin Dada group first begin to be active?

We held our first exhibition here in 1919, but we had already been working together as a group for a couple of years before actually adopting the same name and the same program as the Zurich Dadaists.

Was it really the same program? It has always seemed to me that the Berlin Dadaists, as a group, were far less aesthetically and more socially subversive than the Zurich Dadaists. This is perhaps because of your closer contact with Moscow artists like Lissitzky during the years of the Russian Revolution, perhaps also because of the more disturbed or revolutionary atmosphere in Germany, perhaps too because of the more political nature of the satirical genius of such Berlin Dadaists as George Grosz.

You are probably right. The situation here, in 1917, was not at all like that in Zurich, a neutral city, whereas Berlin was the capital of an empire which was tottering as it faced defeat. I myself had come to Berlin before 1914, from a very bourgeois family background in Türringia. At first I studied art under Orlik, who was to some extent a disciple of the French Impressionists. When the war broke out, all art schools were closed for a while, and I returned to live with my family. But I came back to Berlin in 1915, and it was then that I first met Raoul Hausmann. We were both, in those days, enthusiastic admirers of almost all the art that was being shown in the exhibitions of Herwarth Walden's Der Sturm Gallery. But Hausmann remained until 1916 a figurative Expressionist, a close friend and disciple of Haeckel and at the same time an admirer of Delaunay and of Franz Marc, whereas I had already begun in 1915 to design and paint abstract compositions in the same general tradition as those that Kandinsky had first exhibited a couple of years earlier in Munich.

Were there any other abstract artists of significance in Berlin as early as 1915?

On the whole, most of the Berlin avant-garde was still figuratively either Expressionist or Fauvist. Painters like Ludwig Meidner, for instance, were still working in the same tradition as Haeckel and other artists of the Dresden Brücke group or as Kokoschka, whereas other Berlin painters, like Rudolf Levy, were more in tune with the Post-Fauvists. Among our own friends, the only abstract painter of any prominence was Otto Freundlich, who had returned to Berlin, from Paris, in 1914. But Freundlich had been living at one time in Montmartre with Picasso and some of the Paris Cubists and was still painting mainly figurative compositions. It was only after his return to Paris, in 1924, that his work gradually became exclusively abstract.

Was Freundlich ever associated with the Berlin Dada movement?

Otto sympathized with us from the very start, because he shared our pacifist views, those of the Monistenbund, and our determination to reject all the moral and aesthetic standards of the existing social order, which seemed to us to be doomed. But he was much too serious and earnest to participate in any of our youthfully scandalous manifestations. We were a very naughty group, all of us still very wild, whereas Freundlich belonged already to a more established community of nonconformist writers and artists, all regular contributors to Franz Pfemfert's Die Aktion.

If I remember right, the contributors to *Die Aktion* included Gottfried Benn and Johannes R. Becher, Freundlich and Meidner, Yvan Goll and Hermann Kazack, in fact all sorts of writers and artists who, in the light of their later political or intellectual evolution, would now make very strange bedfellows. . . .

The same might now be said of our own group of Berlin Dadaists. When we held our first exhibition in 1919, the "Erste Internationale Dadamesse," in Dr. Otto Burchard's gallery at Lutzowufer 13, the catalogue included the names of George Grosz, Dadasoph Raoul Hausmann, and Monteurdada John Heartfield. But John Heartfield and his brother, the writer Wieland Herzfelde, later founded the Malik Verlag, which remained for many years the leading German Communist literary publishing house, and they are now both living in Eastern Germany and still active in all sorts of Communist organizations, whereas George Grosz, Walter Mehring, and most of the other Berlin Dadaists of 1919 soon ceased to associate at all with Communists or to be in any way politically active.

Nevertheless, the Berlin Dadaists had originally been quite closely associated with some Communist intellectual and artistic groups.

. . . Between 1915 and 1925. We were very young and politically inexperienced, and Communism itself, in those days, appeared to be

much more liberal and freedom-loving than it does today. During the First World War, we had all been pacifists and had found ourselves in close sympathy with other pacifists, some of whom happened to be Communists. Besides, we were still quite naïvely enthusiastic about anything that appeared to be opposed to the established order, and some of us even pretended to maintain close personal contacts with the enemy. To assume an English or American pseudonym, as Hans Herzfelde did when he called himself John Heartfield, was already an act of provocation in the eyes of German nationalists. George Grosz also claimed to be American in some mysterious way and spelled his name "George" instead of "Georg," affecting at the same time an American manner and style of dress. As soon as the war was over, we were among the first German artists and writers to establish contact with similar avant-garde groups in New York, Paris, and Moscow. In 1922, the German Dadaists even held an international conference in Weimar, attended by El Lissitzky, representing the Moscow Constructivists, Theo van Doesburg, representing Mondrian's de Stijl group from Amsterdam, and Tzara and Hans Arp, representing the Zurich and Paris Dadaists.

Today, to have once been a close associate of Lissitzky is more compromising in Soviet Russia, under the dictatorship of the Socialist Realists, than it would be in New York, Paris, or here, where all sorts of highly respected painters and sculptors like Chagall, Pevsner, and Gabo are known to have been at one time close friends or associates of Lissitzky and other ill-starred Russian advance-guard artists of thirty years ago. The Suprematists and Constructivists were even blacklisted or deported to Siberia under the Stalinist regime, long before the Dadaists were at all threatened here.

Very few people can understand today how innocent and truly unpolitical our connection with Communists had once been. In 1917, we were living in a social order that had approved the declaration of a disastrous war, which even the Socialist party had failed to condemn. In the next few years, it began to look as if this whole order were about to collapse under the impact of military defeat and of the rising discontent of the masses on the home front. There were mutinies in the armed forces, then revolts of the workers here in Berlin and elsewhere in Germany. As young people who had never believed in the justice of the German cause in the war, we were still idealistic enough to found our hopes only on those doctrines which seemed to be entirely new, in no way responsible for the predicament in which we found ourselves, and to promise us with some sincerity a better future, with a more equitable distribution of wealth, of leisure, and of

power. For a while, we really believed in the slogans of the Communists.

And now, for the past thirty years or more, you have been saddled with such compromising evidence of your political past as these photographs of the gallery where you held your first Dada exhibition, with all its subversive slogans and posters on the walls.

Yes, these are the sins of our youth that we are never allowed to forget. But you must admit that our slogans were effectively shocking. Of course today they would no longer seem so very novel, and I'm afraid that nobody would take them as seriously as the respectable Berlin bourgeoisie of 1919 did.

This slogan might still get you into trouble today:

<div style="text-align:center">

DADA
steht auf
Seiten des revolutionären
Proletariats

[DADA
stands on
the side of the revolutionary
Proletariat]

</div>

But most of those that I can distinguish on the walls of the gallery, in these few photographs, seem pretty harmless today:

<div style="text-align:center">

Sperren Sie endlich
Ihren Kopf auf
Machen Sie ihn frei
für die
Forderungen der Zeit

[Open up at last
your head
Leave it free
for the
demands of our age]

Nieder die Kunst
Nieder die
Bürgerliche Geistigkeit

[Down with art
Down with
bourgeois intellectualism]

Die Kunst ist tot
Es lebe die neue
Machinenkunst
Tatlins

[Art is dead
Long live
the machine art
of Tatlin]

</div>

Or else:

<div style="text-align:center">

DADA
ist die
Willentliche Zersetzung
der
Bürgerliche Begriffswelt

[DADA
is the
voluntary destruction
of the
bourgeois world of ideas]

</div>

Those few slogans were evidence enough, in the Nazi era, to have us all tried and condemned as Communists. I sometimes wonder to-

*day how I was courageous or foolish enough to keep all this incrimi-
nating material in my own home during those dreadful years. There
was enough concealed in that cabinet, where I keep all my drawings,
to condemn me and all the other former Dadaists who were still in
Germany.*

It's very fortunate that you should never have destroyed, or lost in
an air raid, this unique collection of documents and relics of the
heyday of the Berlin Dada movement. But it would interest me to
know—since you alone seem to possess enough of this material to be
able to look back on the whole movement objectively—what you
now consider the Berlin Dada movement's most original and lasting
contribution to modern art.

*I believe we were the first group of artists to discover and develop
systematically the possibilities of photomontage.*

How did you first discover this technique?

*Actually, we borrowed the idea from a trick of the official photogra-
phers of the Prussian army regiments. They used to have elaborate
oleolithographed mounts, representing a group of uniformed men
with a barracks or a landscape in the background, but with the faces
cut out; in these mounts, the photographers then inserted photo-
graphic portraits of the faces of their customers, generally coloring
them later by hand. But the aesthetic purpose, if any, of this very
primitive kind of photomontage was to idealize reality, whereas the
Dada photomonteur set out to give to something entirely unreal all
the appearances of something real that had actually been photo-
graphed.*

Of course, the camera is a far more objective and trustworthy wit-
ness than a human being. We know that Breughel or Goya or James
Enson can have visions or hallucinations, but it is generally admitted
that a camera can photograph only what is actually there, standing
in the real world before its lens. One might therefore say that the
Dada photomonteur sets out to falsify deliberately the testimony of
the camera by creating hallucinations which seem to be machine-
made.

*Yes, our whole purpose was to integrate objects from the world of
machines and industry in the world of art. Our typographical collages
or montages set out to achieve this by imposing, on something which
could only be produced by hand, the appearances of something that
had been entirely composed by a machine; in an imaginative compo-
sition, we used to bring together elements borrowed from books,
newspapers, posters, or leaflets, in an arrangement that no machine
could yet compose.*

The collages of the Berlin Dadaists seem to me to be conceived

according to principles which are not at all the same as those of the collages of the earlier Paris Cubists, where a piece of newspaper in a painted still life represents a newspaper, or has been inserted for its nature, like any other artist's material, rather than to create an illusion of the same kind as the illusions of a Dada montage. At the same time, the montages of the early Berlin Dadaists are quite different, in their principles, from the "Merz" compositions of Schwitters, who salvaged the remnants of his compositions from the dust bin, the wastepaper basket, and the junkyard, creating objects of artistic value out of materials that were considered quite valueless, in fact "a thing of beauty and a joy forever out of elements that would scarcely be expected ever to suggest beauty or joy. The montages of the Berlin Dadaists represent an extension, in the realm of art, of the mechanical processes of modern photography and typography.

That is why they continue to be a source of inspiration to so many photographers, typographical artists and advertising artists. Even today, I sometimes find myself staring at a poster in a Berlin street and wondering whether the artist who designed it is really aware of being a direct disciple of Dadasoph Hausmann, of Monteurdada Heartfield, or of Oberdada Baader.

Who were, in your opinion, the most imaginative or creative among the artists of the Berlin Dada movement?

At first our group consisted only of Hausmann and myself, Johannes Baader, Heartfield, Grosz, Deetjen, Golyscheff, and a few writers, such as Wieland Herzfelde and Walter Mehring. I'm leaving aside those who, like Schmalhausen, the brother-in-law of George Grosz, were only intermittently active as artists or writers in our group. I would say that the most active and productive artists in our group were Grosz, Baader, Heartfield, Hausmann, and myself. Golyscheff was very gifted, but he soon dropped out of our group, and I have no longer seen any of his work or heard of him for many years.

Would you be able to define the individual style that distinguished the Dada productions of each one of these artists?

Grosz was of course more of a moralist and a satirist than any of the others, a caricaturist of great genius even in such an early Dada collage as his Dadaisten besteigen einen Pudding, *where the heads which he had added to his comical figures were photographs of his fellow Dadaists.*

But wouldn't you agree that Heartfield was also a satirist?

Certainly, though he was always more doctrinaire in his political intentions. A Communist often tends to be didactic and orthodox rather than truly free in his fantasies and his humor. But Hausmann

remains, in my eyes, the artist who, among the early Berlin Dadaists, was gifted with the greatest fantasy and inventiveness. Poor Raoul was always a restless spirit. He needed constant encouragement in order to be able to carry out his ideas and achieve anything at all lasting. If I hadn't devoted much of my time to looking after him and encouraging him, I might have achieved more myself. Ever since we parted, Hausmann has found it very difficult to create or to impose himself as an artist, though he still continued for many years to provide his friends and associates with an inexhaustible source of ideas. As for Baader, he was our Oberdada, the very incarnation of the spirit of the Berlin Dadaists of 1919 and 1920. He had thrown himself quite recklessly into our movement, without any thought for the consequences, much as I had thrown myself into my seven years of friendship with Raoul Hausmann. Later, Baader became a kind of anachronism, a survivor of a period and a movement that no longer had any reality except in a context of history.

Have any of the other Dadaists achieved any importance as artists?

Golyscheff, as I said before, was very gifted but seems to have vanished completely. Deetjen too, though she continued for many years to work as an artist, somehow failed ever to achieve a very distinctive style or a lasting reputation. As for Schmalhausen, I can now remember only one of his Dada works, a plaster death mask of Beethoven to which he had added a moustache and a crown of laurel leaves.

Did any important artists join the Berlin Dada movement after 1920?

Certainly: Kurt Schwitters and Moholy-Nagy, who both came to Berlin after our first two Dada exhibitions, and of course Hans Arp, who was often with us in Berlin after the war, and Hans Richter, who was mainly active with Viking Eggeling in making experimental Dada films, and some Russians, such as El Lissitzky, who later returned to Soviet Russia, and Pougny and his wife, who both settled later in Paris. But our Dada movement also began, after 1922, to develop along lines similar to those of the Paris Surrealists. Around 1925, Berlin Dadaism ceased to be of much significance as a movement. Each one of us began to develop independently as an artist, or joined other movements, as Moholy-Nagy did when he became associated with the Weimar Bauhaus. Only Schwitters and I continued, for a while, to pursue more or less the same objectives. Besides, we were closely associated, after 1920, with Theo van Doesburg and some of the Dutch abstract artists of De Stijl. I even lived several years in Holland, shortly after the war, and was a close friend of Mondrian and of most of his associates, though I never shared their philosophy

*of art. To me, it seemed to be rather pedantic and to have narrowed
the scope of painting to such an extent that it had become almost
impossible to avoid repetition.*

When would you say that you first began to experiment in a style
that one might call specifically Dadaist?

*I suppose that was in 1917, with Raoul Hausmann, when we both
began to develop a Dada style of our own. It was already to some
extent Surrealist and had something in common with some of those
puzzling paintings of Giorgio de Chirico.*

Do you mean those of his Pittura Metafisica period?

*Yes, Hausmann and I were trying to suggest, with elements bor-
rowed from the world of machines, a new and sometimes terrifying
dream world, as in this 1920 water color of mine,* Mechanischer
Garten, *where the railroad tracks follow an impossible and night-
marish zigzag course. Here's a photograph of another water color of
mine in this style,* Er und sein Milieu, *which I painted in 1919. . . .*

*This feeling of alienation was very much in the air, here in Berlin
between 1917 and 1922. We were living in a world that nobody with
any sensitivity could accept or approve. But I have always been of an
experimental turn of mind, and I soon began, in 1922 and 1923, to
try my hand at "Merzbilder" too, I mean at the same kind of collages
as those of my friend Schwitters. He reproduced one of my works, for
instance, in the seventh issue of* Merz. *After 1924 I returned to a more
traditional kind of painting, though my compositions of that period
still used many of the tricks of photomontage. . . .*

But I would now like to hear you discuss some of your old friends
and associates of the heyday of the modern art movement in Berlin.

I thought I had already spoken of them.

Yes, but I'm very inquisitive. I would like to know more, for in-
stance, about George Grosz.

*It's difficult for me to speak objectively about him today, so soon
after the shock of his death. Only this morning, after reading about
it two days ago in the newspapers, I received in my mail this black-
framed announcement from his family. I hadn't even seen Grosz since
he had finally returned from America, only a few weeks ago, to live
in Berlin again. It seems to me now as if there had been something
spooky about his return to the haunts of his youth, only to die
there. . . .*

*He remains in my memory as he was in his most brilliant and pro-
ductive years, an artist capable of feeling very deeply, but who pre-
ferred to conceal his sensitivity beneath the brittle and provocative
appearance of a dandy. He sometimes even wore a monocle. . . .*

Monocles seem to have been very fashionable among the Dadaists. I've seen photographs of Raoul Hausmann, Tzara, Van Doesburg, and even Arp wearing monocles and looking for all the world like young aesthetes of the generation of Oscar Wilde.

The very sight of a monocle in those days offended the stuffed shirts who claimed to be progressive.

It still infuriates most Americans.

People were particularly annoyed if a Dada dandy wearing a monocle appeared on a platform in a meeting of Communist workers.

The Berlin Dadaists were past masters in the art of annoying people.

It was part of our wanting to be entirely different.

Did this attitude of alienation manifest itself in Grosz in any other ways?

Yes, in his insistence on some mysterious and probably imaginary American origins, and in his very carefully chosen clothes that always gave one the impression of being American or English rather than German. But Heartfield and Hausmann were just as careful about how they dressed.

I understand that Hausmann even designed a new style of shirt.

We were all of us in favor of new styles and systems. Johannes Baader had invented his own Dada system of reckoning time and dates. He even spoke of having a special watch constructed to keep time according to his own new system.

It sounds as if Dada had been, in a way, a kind of parody of a typically German *Reformbewegung. . . .*

Looking back on it now, I suppose it was. But we were trying to point out that things could also be done differently and that many of our conventional ways of thinking, dressing, or reckoning are no less arbitrary than others which are generally accepted. At the same time, we also shocked people by affecting not to take our own movement seriously. Theo van Doesburg, for instance, called his dog "Dada," and some people argued that an art movement using the same name as the dog of one of its leaders can scarcely be intended to deserve serious attention.

George Grosz and Wieland Herzfelde

George Grosz (1893–1959) is justly most famous for his graphic work and the best of this was executed from 1918, when he was discharged for the second time from the German army, and 1933, when he moved to New York. In 1917 he published twenty lithographs containing anticipations of the montage and photomontage techniques he was to discover in collaboration with John Heartfield. As a charter member of Berlin Dada, Grosz published caricatures and mordant political satires in leftist reviews such as *der blütige ernst* and *die Pleite*, as well as in the Dada publications. His commitment to Communism in the twenties was stronger than that of most of the other Dadas and, despite his pessimism, he believed strongly at that time in a classless society and in the validity of artists' revolutionary organizations. He belonged to the Red Group and ARBKD as well as Dada. "I drew and painted by opposition, and by my work tried to convince this world that it is ugly, ill, and hypocritical," he wrote. "Today art is absolutely a secondary affair." *The Face of the Ruling Classes*, a portfolio of fifty-seven political drawings published by Herzfelde in his Malik Verlag's "Little Revolutionary Library" (1921) and *Ecce Homo* (1923) contain some of the bitterest condemnations ever cast at a government in power. By 1933, when he moved to America, Grosz had become disillusioned with the Communist party, and from that point on he never regained the negative strength of his German graphics; his painting became increasingly academic when the social subject matter was removed and only a hint of the erotic element remained. In 1959 Grosz returned for the first time to Germany, only to die in Berlin soon after his arrival. The first text below was written in the heat of engagement in the issues with which his art dealt; the memoir, written when the artist was no longer in sympathy with his earlier goals, reflects the difference between the two periods of his life and art.

Wieland Herzfelde (1896–) and his older brother John Heartfield (see below) were the sons of a socialist poet who deserted his children and went mad. They were involved in

revolutionary activities in Berlin by 1914, for which Herzfelde was jailed; his printing press was closed by the police after he had distributed communist pamphlets. At his release he founded the Malik Verlag, a leading revolutionary publishing house which presented Dada and other avant-garde and political literature. (Its name was taken from a novel by Else Laske-Schüler.) From the beginning, George Grosz was closely associated with the brothers (Herzfelde's book of poems, *Sulamith,* was illustrated by Grosz, about 1917); the three of them joined the Communist party around 1918 and were very close through the twenties, after which Grosz became politically disillusioned and left for America. In 1916–17 Herzfelde edited *Neue Jugend;* in 1919–20 he coedited *Die Pleite* and *Der Gegner,* with Grosz and Julian Gumperz, respectively; in 1920 he edited the last issue of *Der Dada* and *Everyman His Own Football.* A prolific critic, poet, and publisher, Herzfelde now lives in East Berlin.

Art Is in Danger

—An attempt at orientation

IN UNIFORM

I[1] saw the war as a manifestation of the common fight for possessions, degenerated into atrocity. In detail this fight was disgusting to me, not to mention in totality; nevertheless I could not prevent being temporarily made into a Prussian soldier. To my astonishment I became aware of other people who also were less than enthusiastic. I hated these people somewhat less. The life of a soldier inspired me to many a drawing. A few comrades obviously enjoyed these drawings; they shared my feelings, and I preferred this appreciation to the recognition of this or that art collector, who would evaluate my works merely from the speculative point of view.

From George Grosz and Wieland Herzfelde, Art Is in Danger, *translated by Gabriele Bennett from* Die Kunst ist in Gefahr *(Berlin: Malik Verlag, 1925). Reprinted by permission of Wieland Herzfelde and Peter M. Grosz.*

[1] Here and throughout the text the writer employing the first person is George Grosz. [Author's footnote from a section not reprinted here.]

DAWN

For the first time I drew, not only for pleasure, but because I knew other people shared my experiences and convictions. I began to understand there was a better goal than to work just for oneself and the art dealer. I wanted to become an illustrator, a journalist. High art, so far as it strove to portray the beauty of the world, was of less interest to me than ever—I was interested in the tendentious painters, the moralists: Hogarth, Goya, Daumier, and such artists. Although I was very occupied with the lively discussions taking place at that time among the young art movements, and received many a formal stimulus from them, I could not share the general indifference of these circles toward social conditions and current events. I drew and painted out of opposition and attempted in my work to present the world in all its ugliness, sickness, and untruthfulness. At that time I had no success worth mentioning. I had no particular hopes, but felt quite revolutionary since I looked upon my resentments as understandings.

The war changed none of that basically. I remained distrustful, even of my friends; such a thing as camaraderie had no place in my theory of life; I wanted to have no illusions. I began to hear, of course, of revolutionary movements, but unfortunately I did not come in direct contact with them, and remained sceptical: One had only to look at the SPD [*Sozialistische Partei Deutschlands*]—big talk of fraternization among mankind and consent to war credits, all in one breath. That's the way it was. To be sure, a Swedenborgian Hell and demonic powers did not exist for me any longer; I began to see the real devils and princes of hell: bearded men in long pants with or without decorations. A number of my friends had hopes of peace and revolution, which I felt to be unfounded.

DADA AND TURNIPS

A civilian again, I witnessed in Berlin the origin of the Dada movement, which began in Germany in the time of the turnip.

JESUS IN THE TRENCHES

The German Dada movement was rooted in the realization, which came simultaneously to several of my comrades and myself, that it was complete insanity to believe that "spirit" [Geist] or people of "spirit" ruled the world. Goethe under bombardment, Nietzsche in

rucksack, Jesus in the trenches—there were still people who continued to believe in the autonomous power of spirit and art.

Dada was the first significant art movement in Germany in decades. Don't laugh—through this movement all the "isms" of art became yesterday's inconsequential studio affairs. Dada was not a "made" movement, but an organic product, originating in reaction to the head-in-the-clouds tendency of so-called holy art, whose disciples brooded over cubes and Gothic art while the generals were painting in blood. Dada forced the devotees of art to show their colors.

DADA AS EXTERMINATOR

What did the Dadas do? They said it's all the same, whether one just blusters—or gives forth with a sonnet from Petrarch, Shakespeare, or Rilke; whether one gilds boot-heels or carves Madonnas: the shooting goes on, profiteering goes on, hunger goes on, lying goes on; why all that art? Wasn't it the height of fraud to pretend art created spiritual values? Wasn't it unbelievably ridiculous that art was taken seriously by itself and no one else? "Hands off holy art!" screamed the foes of Dada. "Art is in danger!" "Spirit is being dishonoured!" This prattle about the spirit, when the only spirit was the dishonoured one of the press, which wrote: Buy war bonds!—What prattle about art, as they finally arrived at the task of overpainting with beauty and interesting features the face of Anno 13, which daily unmasked itself more and more.

AGAINST WINDMILLS

Today I know, together with all the other founders of Dada, that our only mistake was to have been seriously engaged at all with so-called art. Dada was the breakthrough, taking place with bawling and scornful laughter; it came out of a narrow, overbearing, and overrated milieu, and floating in the air between the classes, knew no responsibility to the general public. We saw then the insane end products of the ruling order of society and burst into laughter. We had not yet seen the system behind this insanity.

IT DAWNS

The pending revolution brought gradual understanding of this system. There were no more laughing matters, there were more important problems than those of art; if art was still to have a meaning, it had to submit to those problems. In the void in which we

found ourselves after overcoming art phraseology, some of us dadas got lost, mainly those in Switzerland and France, who had experienced the cultural shocks of the last decade more from the newspaper perspective. The rest of us saw the great new task: Tendency Art in the service of the revolutionary cause.

GALLOP THROUGH ART HISTORY

The demand for Tendency irritates the art world, today perhaps more than ever, to enraged and disdainful opposition. Admittedly all times have had important works of tendentious character, although such works are not appreciated for their tendentiousness, but rather for their formal, "purely artistic" qualities. These circles completely fail to recognize that at all times all art has a tendency, that only the character and clarity of this tendency have changed. A few roughly sketched examples: the Greeks propagated the "beautiful man": sport, physical culture, and, related to that, Eros, military proficiency, their religious beliefs; in a word, the 100-percent Greek. The Gothics put themselves exclusively at the disposal of Christian propaganda. In the Middle Ages artists created what kings, patricians, and merchants wanted; prehistoric cavemen, aborigines, Negroes, they have their art of the hunt, sex, and idol.[2]

WANDERERS INTO THE VOID

However, there are still artists who consciously and emphatically attempt to avoid tendency of any kind by renouncing completely the representational, even the problematical. Often they believe they can work instinctively and aimlessly, like Nature, which, without visible purpose, gives form and color to crystals, plants, stones—everything that exists. They give their paintings obscure names, or just numbers. Evidently this method is based upon the attempt to produce pure stimulus, as in music, through intentional elimination of all other effectual possibilities. The painter is to be nothing but a creator of form and color. Whether these artists believe their work has no "deeper meaning," or whether they impart to it an emotional or metaphysical meaning hardly perceptible to the spectator, the fact remains that they intentionally renounce all the artist's possibilities of ideological influence (in the areas of eroticism, religion, politics, aesthetics, morality, etc.), standing silent and indifferent, that is, irresponsibly, in relation to social occurrence, or—in cases where that

[2] Note: in the art of all these epochs, of course, different tendencies existed concurrently, which can only be treated separately in special studies.

is not the intention—they work in vain through ignorance and in-
eptitude.

NO ANSWER IS ALSO AN ANSWER

When such artists enter the service of industry and applied art,
there can be as little objection raised as when a politician engages
himself as a craftsman. A matter of talent.

When this art of literary attraction is pursued for its own sake,
decidedly blasé indifference and irresponsible individualistic feelings
are propagated.

SKILL DOES NO HARM

Obviously, the artist's relationship to the world is always expressed
in his work and that relationship inevitably gives it its tendency.
Thus it is only justifiable to blame an artist for his tendency when
that tendency contradicts the artist's broad view, as unintentionally
revealed in his style; or when an artist tries to compensate for in-
eptitude by adding a tendentious motif or title. Someone might use
inadequate means in support of a tendency of which he is completely
convinced; there too, one cannot object to the tendency because of
his inadequate ability to express it.

But one has never heard of Grützner being reproached with his
propaganda for German beer or for the monastic joys of manhood,
or of Grünewald being reproached with his Christian belief. When
artlovers attempt to dismiss a work because of its tendency, as a
principle or as a vehicle of sensation, they do not approach the
artist's work critically, but are hostile to the idea for which he stands.

WHOSE BREAD I EAT, HIS PRAISE I SING

The artist, whether he likes it or not, lives in continual correlation
to the public, to society, and he cannot withdraw from its laws of
evolution, even when, as today, they include class conflict. Anyone
maintaining a sophisticated stance above or outside of things is also
taking sides, for such indifference and aloofness is automatically a
support of the class currently in power—in Germany, the Middle
Class. Moreover, a great number of artists quite consciously support
the bourgeois system, since it is within that system that their work
sells.

WHAT WILL I THINK TOMORROW?

In November, 1918, as the tide seemed to be turning—the most
sheltered simpleton suddenly discovered his sympathy for the working

people, and for several months mass-produced red and reddish al-
legories and pamphlets did well in the art market. Soon afterward,
however, quiet and order returned; would you believe it, our artists
returned with the greatest possible silence to the higher regions:
"What do you mean? We remained revolutionary—but the workers,
don't even mention them. They are all bourgeois. In this country
one cannot make a revolution." And so they brood again in their
studios over "really" revolutionary problems of form, color, and style.

THE YOUNG MAN DIGESTS EVERYTHING

Formal revolution lost its shock effect a long time ago. The modern
citizen digests everything; only the money chests are vulnerable.
Todays young merchant is not like his counterpart in Gustav Freytag's
times: ice-cold, aloof, he hangs the most radical things in his apart-
ment. . . . Rash and unhesitating acceptance so as not to be "born
yesterday" is the password. Automobile—the newest, most sporty
model. Nothing said about professional mission, obligations of wealth;
cool, objective to the point of dullness, sceptical, without illusions,
avaricious, he understands only his merchandise, for everything else—
including the fields of philosophy, ethics, art—for all culture, there
are specialists who determine the fashion, which is then accepted at
face value. Even the formal revolutionaries and "wanderers into the
void" do fairly well, for, underneath, they are related to those gentle-
men, and have, despite all their apparent discrepancies, the same in-
different, arrogant view of life.

PAINT USEFULLY

Anyone to whom the workers' revolutionary cause is not just a
phrase or "a beautiful idea, but impossible to realize," cannot be
content to work harmlessly along dealing with formal problems. He
must try to express the workers' battle idea and measure the value
of his work by its social usefulness and effectiveness, rather than by
uncontrollable individual artistic principles or public success.

LAST ROUND

Let us summarize: the meaning, nature, and history of art are di-
rectly related to the meaning, nature, and history of society. The pre-
requisite for the perception and evaluation of contemporary art is
an intellect directed at the knowledge of facts and of correlations
with real life and all its convulsions and tensions. For a hundred
years, man has been seizing the earth's means of production. At the

same time, the fight among men for possession of these means assumes ever more extensive forms, drawing all men into its vortex. There are workers, employees, civil servants, commercial travelers, and stockholders, contractors, merchants, men of finance. Everyone else represents stages of these two fronts. The struggle for existence of a mankind divided into the exploited and the exploiters is, in its sharpest and final form: class warfare.

Yes, art is in danger:

Today's artist, if he does not want to run down and become an antiquated dud, has the choice between technology and class warfare propaganda. In both cases he must give up "pure art." Either he enrolls as an architect, engineer, or advertising artist in the army (unfortunately very feudalistically organized) which develops industrial powers and exploits the world; or, as a reporter and critic reflecting the face of our times, a propagandist and defender of the revolutionary idea and its partisans, he finds a place in the army of the suppressed who fight for their just share of the world, for a significant social organization of life.

Dadaism

If we artists were the expression of anything at all, then we were the expression of the ferment of dissatisfaction and unrest. Every new national defeat results in the eruption of a new period, the dawn of a new movement. In another era we might well have been flagellants or existentionalists.

During the war a few poets, painters, and musicians established the Cabaret Voltaire in Zurich, Switzerland. Hugo Ball was the director. His collaborators were Richard Hülsenbeck, Hans Arp, Emmy Hennings, and a few other international artists. This group was modern-futuristic rather than political in character. In their search for a name, Ball and Hülsenbeck hit upon the idea of selecting a word at random from the French dictionary. It was by chance that they selected the word *dada,* which means hobbyhorse.

Hülsenbeck introduced the Dada movement into Berlin, where I met him. The atmosphere in Berlin differing from that in Zurich, Dada assumed a political hue. Dadaism still retained its aesthetic aspect but this was pushed more and more into the background with the rise of anarchistic-nihilistic politics. I was one of the cofounders,

George Grosz, "Dadaism," Chapter 13 of Grosz, A Little Yes and a Big No, translated by Lola Sachs Doren (New York: Dial Press, 1946). Reprinted by permission of Peter M. Grosz.

but a writer, Franz Jung, became its chief spokesman. He was of a
bold, adventurous nature and feared nothing. He was somewhat
Rimbaudian in personality. Being a man of force, he influenced the
complete movement the moment he became part of it. He was a
heavy drinker. His books did not win popularity because they were
written in a style and manner difficult to read. He knew fame for a
few weeks, however, when he and a sailor, Knuffgen, confiscated a
steamer in the middle of the Baltic Sea, sailed it to Leningrad, and
presented it as a gift to the Russians. This happened at a time when
everyone was expecting the victory of the Communists in Germany.
Jung rarely did anything himself. He did not have to. He was always
surrounded by sycophants who were bound to him through life and
death. Whenever he got drunk he would shoot at us with his revolver.
He was one of the most intelligent men I have ever known, but also
one of the most unhappy. He earned money as a stock-exchange
journalist and eventually published his own newspaper, which dealt
primarily with economic questions.

As Dadaists, we held meetings and charged a few marks admission
but gave in return no more than truisms. By that I mean, we just
insulted the people roundly. Our manners were downright arrogant.
We would say, "You heap of dung down there, yes, you, with the
umbrella, you simple fool." Or, "Hey, you on the right, don't laugh,
you ox." If they answered us, as they naturally did, we would say as
they do in the army: "Shut your trap or you'll get kicked in the butt."

Our popularity spread quickly, so that our evening gatherings and
Sunday afternoons were soon sold out in advance to people who were
both amused and irritated by us. By and by we had to have the
police at our meetings, as fights were always breaking out. It reached
the point where we had to get permission from the police to hold
these meetings. We simply mocked everything. That was Dadaism.
Nothing was holy to us. Our movement was neither mystical, com-
munistic, nor anarchistic. All of these movements had some sort of
program, but ours was completely nihilistic. We spat upon everything,
including ourselves. Our symbol was nothingness, a vacuum, a void.
To what extent we were the expression of a despair that knew no
salvation, I cannot say. I am not attempting to make or seek any
explanation. I am merely reporting what I experienced.

When we weren't swearing at the public, we were indulging in so-
called "art." That is, we deliberately staged our "artistic" acts. For
instance, Walter Mehring would pound away at his typewriter, read-
ing aloud the poem he was composing, and Heartfield or Hausmann
or I would come from backstage and shout: "Stop, you aren't going
to hand out real art to those dumbbells, are you?"

Sometimes these skits were prepared, but by and large they were improvised. Since we usually did a bit of drinking beforehand, we were always belligerent. The battles that started behind the scenes were merely continued in public, that was all. This was startlingly novel to the people, consequently we were hugely successful. Fads like ours generally lasted for only a few months.

There were a few insane among us. Naturally. There was a certain Baader for example, who was supposed to have been wedded to the earth in some mystic way. He assembled a huge scrapbook that he called "Dadacon" and claimed it was greater than the Bible, including the New Testament. Yes, Baader was indeed a bit cracked—a megalomaniac. To him, his book was the greatest, the most powerful of all times. It consisted of newspaper clippings and photomontages. He believed that in thumbing through the book as he had arranged it, one was bound to develop a dizzy headache, and that only after the mind was in a complete whirl could one comprehend the "Dadacon." Baader also created a huge statue called "Germany's Greatness and Downfall." By collecting all possible kinds of junk and throwing them together in some fashion, he composed this three-dimensional memorial.

The "Dadacon" had been offered for $35,000 to Ben Hecht, who had come to Germany as war correspondent for the Chicago *Daily News*. His job was to determine whether we Germans were really as vile as Raemakers had depicted us, how the new republic was functioning, and whether it was a real republic and not a ruse of the German general staff. Stories were already circulating that the Kaiser had not gone to Holland at all. It was his double, cleverly chosen by Ludendorff; that Ludendorff, in the role of a simple miner, was plotting counterrevolution in a mine prepared for this purpose. It was said that there had been entire regiments of infantrymen at the outbreak of the revolution that had vanished into the earth and never reappeared. But the story that these regiments had been buried in huge craters by big new shells was not generally believed.

Hecht made his headquarters at the Hotel Adlon, where all the American correspondents lived. It was there that I met him through the good offices of my friend Dr. Dohmann who, like Ben Hecht, loved to spend his leisure time banging out ragtime melodies. "Everybody Shimmies Now" was the great favorite.

He used to come to the affairs arranged by us Dadaists. He even thought of accepting Baader's offer to sell the "Dadacon," but was only willing to pay half the price asked. After much bickering back and forth, the deal fell through and the "Dadacon" was eventually buried in the garden behind Baader's house.

Just as Baader was the "Oberdada," I was the "Propagandada." My job was to invent slogans to promote our cause. Not that any of us knew what Dadaism actually was. It could be almost anything: a void, a new wisdom, a new brand of Mother Sill's pills against sea-sickness, a sedative, a stimulant. It was everything and yet nothing.

We who followed it were all crazy; even I—a little bit. Of course, back in the army that nice doctor had said that my drawings looked crazy enough to him. He had even put me through a sort of test for idiocy, but I had answered all their idiotic questions satisfactorily.

I was very proud of some of the slogans I invented. There was "Dada today, Dada tomorrow, Dada forever"; the little political parody "Dada, Dada *über alles*"; "Come to Dada if you like to be embraced and embarrassed"; "Dada kicks you in the behind and you like it." We had these slogans printed on small stickers which we plastered all over the shop windows, coffee-house tables, and shop doors of Berlin. They were alarming little stickers, particularly since the slogans were so mystic and enigmatic. Everyone began to wonder who we were. The popular afternoon paper, *BZ am Mittag,* devoted a whole editorial to the Dada menace. People were aroused against us. They could not understand a movement that made so little sense. But we continued to have wonderfully wild times. We pasted our stickers just everywhere we went. Even the waiter, carrying his tray of drinks and cigars, would have a "Dada kicks me in the behind" sticker on the back of his frock coat and a "Dada forever" on his box of cigars. . . .

We Dadaists had an art peculiarly our own. It was called "garbage-can art" or "garbage-can philosophy." The leader of this school of Dada art was a certain Kurt Schwitters from Hanover. His pockets were always filled with odds and ends. He gathered everything he could find on the streets when he went out for a walk. He would pick up rusty nails, old rags, a toothbrush without bristles, cigar butts, a spoke of a bicycle wheel, a broken umbrella—in short, anything that had been discarded as useless. He would then put them together into a smaller junk heap, which he would proceed to paste on canvas or old boards, fastening them down firmly with wire and cord. The result, called *Merzbilder* ("garbage pictures"), was exhibited and actually sold. Many critics who wanted to keep astride of the times praised this abuse of the public. They assessed this art seriously. Average people, on the contrary, who understood nothing about art, reacted normally and called it "dirt, filth, and garbage"—exactly what this sort of art actually was.

John Heartfield

John Heartfield (1891–1968) was born Helmut Herzfelde,[1] son
of a socialist poet who disappeared when he was eight. After
studying art in Munich and Berlin, he anglicized his name as
a protest against the army, in which he served from 1914–16.
In 1915 he met George Grosz, with whom he "discovered"
the technique of photomontage, paralleling similar "discover-
ies" by Ernst, Hausmann, and Schwitters. Coeditor of *Neue
Jugend, Jedermann sein eigener Fussball, Die Pleite,* and
Dada 3, in 1919 Heartfield was a founding member of the
Berlin Dada group, taking the title "Monteurdada" to iden-
tify himself with the workers (*Monteuranzüge* are overalls in
German) rather than with the "bohemian-cape-and-flowing-tie
school of painters." He was a pioneer in the field of "mechan-
ical art" as well as taking photomontage in a less esthetically
oriented direction than did most Dadas, utilizing its harsh
dislocations to transmit specific political messages. Heartfield
joined the Communist party in 1918 and during the 1920s
developed an increasing satirical style of montages devoted to
antifascist propaganda. These were published as book covers,
illustrations, political cartoons, or posters. In 1930 he went to
Russia and had an exhibition in Moscow. In 1933 he fled to
Prague, where he continued to work for the also exiled *Ar-
beiter Illustrierte Zeitung.* He was then deprived of German
nationality and in 1938, with Hitler demanding his extradi-
tion, he escaped to London. Interned in 1940, he returned to
East Germany in 1950, settling in Leipzig. From 1956 until his
death Heartfield received many state honors, including nom-
ination by Bertolt Brecht to the German Academy of Arts, the
Fighter Against Fascism Medal, the Peace Prize of the GDR,
and the Karl Marx Order. Before his death he made, among
other works, photomontages demanding world peace and pro-
testing the war in Vietnam. He titled some of his retrospective
exhibitions "Unfortunately Still Timely."

[1] See Wieland Herzfelde, pp. 78–85.

John Heartfield, Life and Work

I had come to the Western Front in November, 1914, but—"unworthy of wearing the Kaiser's uniform"—was discharged at the end of January, 1915, and returned to Berlin. During the three months in Flanders I met up with a few doubters but no like-minded people. They could hardly have been expected to make themselves known to me, for I was much too careless and moreover an "idle talker," who believed he could turn the world upside down with his poems. In Berlin I met with more trust and understanding. Young and older poets—Else Lasker-Schüler, Albert Ehrenstein, Ernst Blass, Johannes R. Becher, Alfred Wolfenstein, Ferdinand Hardekopf, Jakob van Hoddis, Theodor Däubler, Mynona (S. Friedländer), Gustav Landauer—and the painters Gangolf, Davringhausen, Meidner, Mopp, also belonged to our circle of friends. For all their differences, they were, without exception, convinced that the war was a crime, the revolution inevitable, and every artist worthy of the name its herald. They spoke of those loyal to the Kaiser with nameless contempt, and by name of those established writers, who, with inflammatory poems, ingratiated themselves to the hurrah-patriots. Ernst Lissauer's hate-song: "United we love, united we hate, we have but one enemy: England!" and the universally propagated manner of greeting—"God punish England!"—"He shall punish."—released in my brother a "productive fit of anger": he translated his name into English and called himself—at first only among friends and acquaintances—John Heartfield. His petition to legalize the pseudonym was of course rejected by the imperial authorities. A few years later the German people rejected the empire. The name Heartfield proved more durable.

In the circles which were now calling him John, the discussions no longer revolved much about questions of art and literature. It was above all Else Lasker-Schüler, shaken by the death of her young friend, the poet Georg Trakl, on the Austrian front, who conferred daily in the café with writers, painters, and "competent" doctors about how to help this or that artist who had been drafted. She also helped my brother. After training as an infantryman in the Franz-Josef-Garde-Regiment, he was supposed to go into the field with his unit on an October day in the year 1915. What could be done about it? He wasn't sick, nor did he have the talent to become sick.

From Wieland Herzfelde, John Heartfield, Leben und Werk, *translated by Gabriele Bennett (Leipzig: Verlag der Kunst, 1962). Reprinted by permission of Wieland Herzfelde.*

On the evening before shipping out, John had his last pass into town. In the Romanischen Café we were waiting for him, saddened and silent. But Else Lasker-Schüler had an idea: We should all speak to him with excessive indulgence and concern as if through mental derangement what he was saying was incoherent and meaningless. She knew he would react in a very excited manner, and then she would convince him that the doctor had made a mistake in pronouncing him "fit for service in the field." Everyone would then confirm that he ought to be in a military hospital for neurotics, and not at the front. The way we carried out the plot made him, in the end, doubt his own health; it was therefore not difficult for the poetess, whom he greatly respected, to get him to promise to point out his condition at morning roll-call before departure.

The next news from him came from a hospital in Berlin. When I visited him, I found a pale man, who, speaking haltingly, was trying in vain to rake the leaves in the park into a pile. The striped hospital clothing was an added note that struck terror into me. Had our "psychotherapy" made him really sick? More likely the events of that morning, when he alone had stepped from the ranks and reported that he, Infantry-Guardsman Herzfelde, was neurotic. The company commander had dared to smile. This made my brother so genuinely furious that suddenly people were speaking to him with the same discretion we had used the evening before, until medics, using less discretion, came to lead him away.

By Christmas he was discharged as "suitable for labor utilization." They believed him capable of doing service as a temporary mailman in Berlin-Grünewald. He lightened his duties in a meaningful but very risky manner: to make the people in Grünewald wait in vain for the mail, and, consequently, to enrage them at the conditions of war, John stuffed whole bundles of mail and newspapers into a drain intended for rainwater in a quiet street. Thus he quickly finished work which, carried out in the old-fashioned way, would have required hours.

NEUE JUGEND

In the second year of the war even the pessimists among us painters and writers—convinced that the war was lost—felt like heralds of a coming revolution. But only one magazine remained open to them—Franz Pfempfert's *Aktion,* the most radical even before the war. And this magazine was watched especially carefully by the censors. Until the end of the war, opposition to the war could be only indirectly expressed: not mentioned in pictures or in words. The demand for a

more articulate magazine was made increasingly often in our Berlin circle. And since we had become acquainted in the summer of 1915 with Georg Gross—soon thereafter he was to write his name with *sz*, so that the *o* was pronounced as in the German *Rost;* John, no less than I, was enthusiastic about Grosz's drawings and watercolors, and would have liked most to make a magazine just for him. When he wasn't with me, he was sure to be with Grosz in the South End of Berlin.

Grosz had also been a soldier, but after a few months had managed to be released as unfit for service. He believed that the war would never come to an end if nothing were done to oppose it. People liked war better than peace, he felt, as long as they were not injured directly. Besides, it was commercially more profitable, merchandise of the poorest quality was grabbed up at the highest prices. Grosz was impressed by John's method of prompting discontent in Grünewald. He had made a specialty of annoying the soldiers at the front with gift parcels. They weren't annoyed enough for him. At the end of 1916, when I was in the west for the second time, I received one of his packages. I enjoyed very much the graceful manner with which the field address was written, and the care with which everything was packed, but above all the irony with which the gifts were chosen. The parcel contained two starched shirt-fronts, one white, the other flowered, a pair of cuffs, a dainty shoehorn, a set of bags of tea samples, which, according to hand-written labels, should arouse patience, sweet dreams, respect for authority, and fidelity to the throne. Glued on a cardboard in wild disorder were advertisements for trusses, fraternity songbooks, and enriched dogfood, labels from Schnapps and wine bottles, photos from illustrated magazines—arbitrarily cut out and absurdly joined together. Soon afterwards Grosz and John used similar hand-made postcards. Decades later my brother was to tell of postcards sent from the front, on which photo cutouts were assembled in order to say in pictures what would have been censored in words. A few friends, among them Trejakow, made a legend of it, maintaining that anonymous people had invented photomontage in this manner. The fact remains that many recipients of these cards took great pleasure in them and attempted similar things. That encouraged Heartfield to develop a conscious technique from what had begun as a game of political provocation. And thus it is to be understood that Grosz, in *Blätter der Piscatorbühne* (February, 1928), began his contribution—"Marginal Sketches on the Theme," which treated the use of his drawings for the sets of a dramatization of [*The Good Soldier*] *Schweik,* with the following sentence:

"When John Heartfield and I invented photomontage one May

morning at five o'clock in my Southend studio, neither of us had any notion either of the great possibilities or of the thorny but successful path this invention would take." In fact, photomontage was more discovery than invention.

In July 1916, our magazine, *Neue Jugend,* had finally appeared. I became editor. The authorities—we thought—could hardly do anything to me, as I was still a minor. John did the competent layout which today would almost seem distinguished. The first issue began with the poem "To Peace," by Johannes R. Becher. Nevertheless the magazine appeared—and so it was intended—to have more to do with art and literature than politics. Only on the last, primarily finely printed pages of critiques and notices, did an ironic, rebellious tone dominate. After four issues had appeared, I was drafted again and soon sent to the front. In my absence my brother and the publisher had political differences. The publisher used my absence to presume editorial rights, which was strictly against our agreement. The result was that three months elapsed before my brother could publish another issue, the double-number February–March, 1917. It appeared as the first publication of a "new" publishing house, the "Malik Verlag," in whose name John had recently applied for and received a licence. In May the Malik Verlag published illegally, with the precaution of a false address, a two-color, 52 centimeters wide and 64 centimeters high, four-page *Weekly Edition of the New Youth.* It was followed in June by an equally large, now three-color issue, mockingly called "Pamphlet for a little Grosz Portfolio" because of its size, in which the portfolio was not mentioned except for an advertisement on page four. On the title page there were, however, two articles by Grosz, one with the heading: "You have to be a rubberman," the other in which "The Doings of Both Heartfields" is noted with the heading: "Can you ride a bicycle?" The most unusual thing about this magazine, inspired by Grosz, Franz Jung, and Zurich "Dadaism," was its layout. These two issues can be regarded as the first works of John Heartfield. Among the "contributors to the Malik Verlag," he was still listed—along with new names such as Max Herman, Cläre Öhring, Richard Hülsenbeck—as Helmut Herzfelde. But the sovereign, fascinating way in which he conjured up something unprecedented from old type, plates, leadbars, and rings, reveals the artist who—almost overnight—had found his own unmistakable style. For the four-page title of the simultaneously published "Little Grosz-Portfolio," he made similarly eccentric typographic illustrations.

I was only able to follow this development from the Front and during a short leave. I liked the things in this *Neue Jugend* by Grosz and my brother, also the extremely aggressive "Chronik" written by

Franz Jung; I disliked the rest. It was hard for me to accept John's
destruction of everything he had done as an artist until then. For him
there was now only one living artist who was to be allowed to work
with brush and pen, and that was our friend Georg. That Grosz's
drawings, watercolors, and oil paintings from the years 1915–30 were
more abundantly reproduced than the work of most of his contem-
poraries, is due principally to Heartfield's efforts. Innumerable times
he dragged Grosz to the lithographer Birkholz to have plates made for
reserve stock. We would use them sooner or later. The "Malik Verlag"
account was charged. When inflation came, that account was easily
balanced.

Heartfield planned a third issue of *Neue Jugend*. It was to be
printed in white on mourning crepe. The plan was never realized.

Before the beginning of the war I had become a friend of Johannes
R. Becher. He had introduced me to Harry Graf Kessler, the co-
founder of the Insel Verlag and patron of German and French artists.
When, in the summer of 1917, the precursor of the "Universum Film-
gesellschaft"—a "military photography department"—was founded,
Count Kessler procured for my brother a position as director of
natural science films. Shortly thereafter he was instructed to install an
animation studio and, with drawings for which Georg Grosz was
responsible, to make an animated film. It was the first film of its kind
to be produced—in an exceedingly laborious manner—in Germany.
The film was to be called "Pierre in Saint-Nazaire" and was to rid-
icule the American intention of landing in Allied France, while glorify-
ing the troops of the Kaiser and the special long-range Krupp cannons,
like "Big Bertha." Work on the film was extremely satisfying for the
two producers. They no longer had to fear musters and were well
paid; The work, in itself time-consuming, was prolonged endlessly
and when it was finally finished, the employers would not accept the
film. The Americans had already broken through on the Western
Front, and furthermore, Grosz had drawn the Kaiser's soldiers in such
a way as to evoke the opposite of sympathy, or even enthusiasm.
Thanks to the support of Count Kessler John kept his job. More than
that: Shortly before the end of the war, although I knew even less
than he about films and photography, John succeeded in getting me
employed by the "Photographic Department" as an assistant to cam-
eraman Bösner.

REVOLUTION

Our work with UFA, which had been founded in the meantime,
came to a sudden end in January, 1919, because, after the murder of

Karl Liebknecht and Rosa Luxemburg, we had appealed to the staff (over which a Major Krieger still had the deciding word) to strike in protest.

We had had the deepest respect for Liebknecht ever since he had rejected with biting words the second war loan in December, 1914, and on the first of May, 1916, had appealed on the Potsdamer Platz for a fight against the war. And the Russian Revolution in October, 1917, was an event which, as we heard about it (independently of one another—I was near Arras on the Western Front) caused the same reaction: for us it was a natural event which had to happen—even in Germany. The Bolsheviks fought the fight of all men worthy of the name. We considered ourselves among them, the great international family of revolutionaries. In the summer of 1918, when I appeared in Berlin as a civilian without discharge papers, my brother and his friends were not surprised. It was not even necessary for us to discuss joining the Communist party immediately after its foundation on December 31, 1918. However, we knew about Marxism only through hearsay. In our opinion a Communist revolutionary (there were no other revolutionaries) had to make speeches everywhere and ignite discussions in order to convince everyone but the "property toads." For us that meant practicing our profession, which we had long conceived as an obligation to politically oppose authority, in a way useful to the party. This determination was strengthened by a leading member of the party, our friend Eugen Leviné, who was shot June 5, 1919, in Munich.

For some time John had also been a set designer for the film company Gebrüder Grünbaum. I had my hands full reestablishing the "Malik Verlag," which by the end of 1917 had almost ceased to exist. Our working capital in wartime had been the credulousness or secret sympathy of our suppliers; after the November Revolution the situation was much the same.

We even found an art dealer who placed his elegant gallery at our disposal. We, that is, the Berlin dadas—though Else Lasker-Schüler, Theodore Däubler, and Johannes R. Becher did not belong. At that time one of Heartfield's collages was widely distributed as the title page of the catalogue for the exhibition we called "The First International Dada Fair" ("Erste Internationale Dadamesse"). This composition of the most disparate cut-outs shows only a few details related to photography or film. It can, nevertheless, be considered as an early form of photomontage. Several noteworthy primitive formulations are overprinted. Directly under the headlines "Artdealer Dr. Otto Burchard, Berlin, Lützow-Ufer 13," it reads: "The Dada movement leads to abolition of the art market." At the lower edge a text, turned up-

side down, begins with the words: "Dada man is the radical adversary
of exploitation"; it is signed by organizers: Marshal G. Grosz, Dada-
soph Raoul Hausmann, Monteurdada John Heartfield. *Monteur* has
not yet been connected with "photo." The word "art" is used only in
a derogatory sense; "dada products" are shown and sold.

Among these products the third issue of the magazine *Der Dada*
(Malik Verlag, April, 1920) has a programmatic character. It made espe-
cially clear that Dada in Berlin was not, and did not want to be art or
an art movement, that it was a political renunciation of art, especially
of expressionism, housebroken by the bourgeoisie, reluctantly during
the war and wholeheartedly after the November Revolution. This
renunciation was done in an absurd, well-aimed manner, consciously
intended to injure the lovers of nebulous-mystic, sweet-romantic art as
well as the expressionistic and abstract "avant-garde."

The dadas however, except for Grosz, hardly knew how to make
their political views graphic. Indeed, at the "Dada Fair," a transparent
banner, painted with huge but not-at-all "deranged" letters, extended
across the largest exhibition wall the legend: "Dada fights on the side
of the revolutionary proletariat!" But the revolutionary proletariat of
Berlin, fighting then for its forbidden party, probably did not notice
much about or think much of these comrades in arms.

Nevertheless, the common enemy, the public prosecuter, thought it
appropriate to proceed against us—by reason of incitement to class
hatred, libel of the military, and a number of further offenses. Among
the evidence were the Grosz portfolio *God with us!* and the first and
only issue of the satirical magazine *Everyman his own football.* The
entire edition, 7,600 copies, was sold on a single afternoon during an
advertising tour by a horsedrawn cart, with a band, and especially by
the Dada participants who were demonstrating behind the cart, each
one loudly praising his own contribution.

My brother was copublisher of this magazine. In it he began for the
first time to use photography consciously in the service of political
agitation. To one side of the title he had pasted me as a flying soccer
ball, and underneath, a photo of an open fan, on which were pasted
(as in the previous century the pictures of admirers on ball-fans)
seven photo-portraits of members of the Ebert-Noske-Scheidemann
administration. Above it was written: "Sweepstake!," below it: "Who
is the most beautiful?"

Since the magazine was immediately banned, a new one, *Pleite*
(*Bankrupt*), appeared, published by Grosz, Heartfield, and myself.
Here too, Heartfield published photos with political texts: fallen sol-
diers in the Masurian swamps, captioned "Hindenburg Breakfast,"
an armored car with skulls occupied by Noske's soldiers, captioned

"God and the public prosecutor be with us." The winning replies to a sweepstake were also published in *Pleite*. The first prize went to a man who asked that no mention be made of his name—Kurt Tucholsky.

Pleite was almost regularly confiscated; it became more and more difficult to find itinerant newsdealers who dared sell it. After six issues, it appeared only as supplement to the monthly paper *Der Gegner* (*The Opponent*).

Kurt Schwitters

Kurt Schwitters (1887–1948) invented Merz, his own, apolitical branch of Dada, in 1918 in Hanover, where he remained isolated, occasionally participating in but never joining the Cologne and Berlin groups. He particularly disagreed with the political orientation of the latter, and was denied membership in the Dada Club. The review *Merz* was published from 1923 to 1927, its title deriving from the word "Kommerz" as it appeared in one of his collages. First an expressionist painter associated with *der Sturm*, after the war Schwitters made drawings from rubber stamps of phrases like "Printed Matter" and compartmented collages from newspaper reproductions and magazine illustrations, often with satirical intent. By 1919–20 he had developed the medium for which he is known—the collage of bits of usually brilliant colored "rubbish," from tiny vignettes of ticket stubs, advertisements, or comic strips to large painted constructions. While the composition of these works often appeared chaotic enough to be labeled Dada, in fact Schwitters was an extremely subtle designer and colorist. Consistent with his previous aims was his adoption of a more abstract, even purist style in the midtwenties and thirties, when he was associated with the de Stijl movement, with *cercle et carré,* and *Abstraction Création* rather than with Surrealism, which attracted so many former Dadas. Schwitters' *Merzbau* was an extraordinary architectural-sculptural column, or assemblage, that eventually pierced the ceiling of its original room in his Hanover house and climbed to the next story. In its final form the haphazard and organic Dada core was covered by a more abstract structure. It was destroyed by the Nazis when Schwitters fled to Norway (1938) and then to England (1940), where he began another Merzbau in a barn in Ambleside, left incomplete at his death.

While Schwitters is known primarily for his collages, he devoted a good deal of his time to poetry, the 1919 *Anna Blume*—an apparently nonsensical parody of conventional love poems—being a classic of Dada poetry. He experimented with bruitism, alone and with Raoul Hausmann, and the methods employed were related to his collage techniques. The auditory counterparts of picking up bits of found materials from the streets were the elaborate puns constructed from

overhead bits of conversation (like Apollinaire before him) or
songs or abstract sounds. His *Ursonata* of 1924 is a 35-minute
sound poem carefully constructed of phonetic vibrations, a
hybrid between music and language. There is a recording of
Schwitters reading the final version of this tour de force, which
was preceded by such experiments as the *Lautsonata* and
"Die Scheuche," a "typographical fairy tale."

Merz (1920)

I was born on June 20, 1887, in Hanover. As a child I had a little
garden with roses and strawberries in it. After I had graduated from
the *Realgymnasium* [scientific high school] in Hanover, I studied the
technique of painting in Dresden with Bantzer, Kühl, and Hegenbarth.
It was in Bantzer's studio that I painted my "Still Life with Chalice."
The selection of my works now [1920] on exhibit at the Hans Goltz
Gallery, Briennerstrasse 8, Munich, is intended to show how I pro-
gressed from the closest possible imitation of nature with oil paint,
brush, and canvas, to the conscious elaboration of purely artistic com-
ponents in the Merz object, and how an unbroken line of develop-
ment leads from the naturalistic studies to the Merz abstractions.
 To paint after nature is to transfer three-dimensional corporeality
to a two-dimensional surface. This you can learn if you are in good
health and not colorblind. Oil paint, canvas, and brush are material
and tools. It is possible by expedient distribution of oil paint on
canvas to copy natural impressions; under favorable conditions you
can do it so accurately that the picture cannot be distinguished from
the model. You start, let us say, with a white canvas primed for oil
painting and sketch in with charcoal the most discernible lines of the
natural form you have chosen. Only the first line may be drawn more
or less arbitrarily, all the others must form with the first the angle
prescribed by the natural model. By constant comparison of the sketch
with the model, the lines can be so adjusted that the lines of the
sketch will correspond to those of the model. Lines are now drawn
by feeling, the accuracy of the feeling is checked and measured by
comparison of the estimated angle of the line with the perpendicular
in nature and in the sketch. Then, according to the apparent pro-

*Kurt Schwitters, "Merz (1920)," translated by Ralph Manheim in Robert Mother-
well, ed.,* Dada Painters and Poets *(New York: Wittenborn, Schultz, Inc., 1951),
pp. 57–65. Originally published in* Der Ararat *(Munich, 1921). Reprinted by per-
mission of Ernst Schwitters and George Wittenborn, Inc.*

portions between the parts of the model, you sketch in the proportions between parts on the canvas, preferably by means of broken lines delimiting these parts. The size of the first part is arbitrary, unless your plan is to represent a part, such as the head, in "life size." In that case you measure with a compass an imaginary line running parallel to a plane on the natural object conceived as a plane on the picture, and use this measurement in representing the first part. You adjust all the remaining parts to the first through feeling, according to the corresponding parts of the model, and check your feeling by measurement; to do this, you place the picture so far away from you that the first part appears as large in the painting as the model, and then you compare. In order to check a given proportion, you hold out the handle of your paintbrush at arm's length towards this proportion in such a way that the end of the handle appears to coincide with one end of the proportion; then you place your thumb on the brush handle so that the position of the thumbnail on the handle coincides with the other end of the proportion. If then you hold the paintbrush out towards the picture, again at arm's length, you can, by the measurement thus obtained, determine with photographic accuracy whether your feeling has deceived you. If the sketch is correct, you fill in the parts of the picture with color, according to nature. The most expedient method is to begin with a clearly recognizable color of large area, perhaps with a somewhat broken blue. You estimate the degree of matness and break the luminosity with a complementary color, ultramarine, for example, with light ochre. By addition of white you can make the color light, by addition of black dark. All this can be learned. The best way of checking for accuracy is to place the picture directly beside the projected picture surface in nature, return to your old place and compare the color in your picture with the natural color. By breaking those tones that are too bright and adding those that are still lacking, you will achieve a color tonality as close as possible to that in nature. If one tone is correct, you can put the picture back in its place and adjust the other colors to the first by feeling. You can check your feeling by comparing every tone directly with nature, after setting the picture back beside the model. If you have patience and adjust all large and small lines, all forms and color tones according to nature, you will have an exact reproduction of nature. This can be learned. This can be taught. And in addition, you can avoid making too many mistakes in "feeling" by studying nature itself through anatomy and perspective and your medium through color theory. That is academy.

I beg the reader's pardon for having discussed photographic paint-

ing at such length. I had to do this in order to show that it is a labor of patience, that it can be learned, that it rests essentially on measurement and adjustment, and provides no food for artistic creation. For me it was essential to learn adjustment, and I gradually learned that the adjustment of the elements in painting is the aim of art, not a means to an end, such as checking for accuracy. It was not a short road. In order to achieve insight, you must work. And your insight extends only for a small space, then mist covers the horizon. And it is only from that point that you can go on and achieve further insight. And I believe that there is no end. Here the academy can no longer help you. There is no means of checking your insight.

First I succeeded in freeing myself from the literal reproduction of all details. I contented myself with the intensive treatment of light effects through sketchlike painting (impressionism).

With passionate love of nature (love is subjective) I emphasized the main lines by exaggeration, the forms by limiting myself to what was most essential and by outlining, and the color tones by breaking them down into complementary colors.

The personal grasp of nature now seemed to me the most important thing. The picture became an intermediary between myself and the spectator. I had impressions, painted a picture in accordance with them; the picture had expression.

One might write a catechism of the media of expression if it were not useless, as useless as the desire to achieve expression in a work of art. Every line, color, form has a definite expression. Every combination of lines, colors, forms has a definite expression. Expression can be given only to a particular structure, it cannot be translated. The expression of a picture cannot be put into words, any more than the expression of a word, such as the word "and" for example, can be painted.

Nevertheless, the expression of a picture is so essential that it is worthwhile to strive for it consistently. Any desire to reproduce natural forms limits one's force and consistency in working out an expression. I abandoned all reproduction of natural elements and painted only with pictorial elements. These are my abstractions. I adjusted the elements of the picture to one another, just as I had formerly done at the academy, yet not for the purpose of reproducing nature but with a view to expression.

Today the striving for expression in a work of art also seems to me injurious to art. Art is a primordial concept, exalted as the godhead, inexplicable as life, indefinable, and without purpose. The work of art comes into being through artistic evaluation of its elements. I know

only how I make it, I know only my medium, of which I partake, to what end I know not.

The medium is as unimportant as I myself. Essential is only the forming. Because the medium is unimportant, I take any material whatsoever if the picture demands it. When I adjust materials of different kinds to one another, I have taken a step in advance of mere oil painting, for in addition to playing off color against color, line against line, form against form, etc., I play off material against material, for example, wood against sackcloth. I call the *weltanschauung* from which this mode of artistic creation arose "Merz."

The word "Merz" had no meaning when I formed it. Now it has the meaning which I gave it. The meaning of the concept "Merz" changes with the change in the insight of those who continue to work with it.

Merz stands for freedom from all fetters, for the sake of artistic creation. Freedom is not lack of restraint, but the product of strict artistic discipline. Merz also means tolerance towards any artistically motivated limitation. Every artist must be allowed to mold a picture out of nothing but blotting paper for example, provided he is capable of molding a picture.

The reproduction of natural elements is not essential to a work of art. But representations of nature, inartistic in themselves, can be elements in a picture, if they are played off against other elements in the picture.

At first I concerned myself with other art forms, poetry for example. Elements of poetry are letters, syllables, words, sentences. Poetry arises from the interaction of these elements. Meaning is important only if it is employed as one such factor. I play off sense against nonsense. I prefer nonsense but that is a purely personal matter. I feel sorry for nonsense, because up to now it has so seldom been artistically molded, that is why I love nonsense.

Here I must mention Dadaism, which like myself cultivates nonsense. There are two groups of Dadaists, the kernel Dadas and the husk Dadas. Originally there were only kernel Dadaists, the husk Dadaists peeled off from this original kernel under their leader Hülsenbeck [Hülse is German for husk, Tr.] and in so doing took part of the kernel with them. The peeling process took place amid loud howls, singing of the *Marseillaise,* and distribution of kicks with the elbows, a tactic which Hülsenbeck still employs. . . . In the history of Dadaism Hülsenbeck writes: "All in all art should get a sound thrashing." In his introduction to the recent *Dada Almanach,* Hülsenbeck writes: "Dada is carrying on a kind of propaganda against culture." Thus Hülsendadaism is oriented towards politics and against

art and against culture. I am tolerant and allow every man his own opinions, but I am compelled to state that such an outlook is alien to Merz. As a matter of principle, Merz aims only at art, because no man can serve two masters.

But "the Dadaists' conception of Dadaism varies greatly," as Hülsenbeck himself admits. Tristan Tzara, leader of the kernel Dadaists, writes in his *Dada manifesto 1918:* "Everyone makes his art in his own way," and further "Dada is the watchword of abstraction." I wish to state that Merz maintains a close artistic friendship with kernel Dadaism as thus conceived and with the kernel Dadaists Hans Arp, of whom I am particularly fond, Picabia, Ribemont-Dessaignes, and Archipenko. In Hülsenbeck's own words, Hülsendada has made itself into "God's clown," while kernel Dadaism holds to the good old traditions of abstract art. Hülsendada "foresees its end and laughs about it," while kernel Dadaism will live as long as art lives. Merz also strives towards art and is an enemy of *kitsch,* even if it calls itself Dadaism under the leadership of Hülsenbeck. Every man who lacks artistic judgment is not entitled to write about art: "quod licet jovi non licet bovi." Merz energetically and as a matter of principle rejects Herr Richard Hülsenbeck's inconsequential and dilettantish views on art, while it officially recognizes the above-mentioned views of Tristan Tzara.

Here I must clear up a misunderstanding that might arise through my friendship with certain kernel Dadaists. It might be thought that I call myself a Dadaist, especially as the word "dada" is written on the jacket of my collection of poems, *Anna Blume,* published by Paul Steegemann.

On the same jacket are a windmill, a head, a locomotive running backwards, and a man hanging in the air. This only means that in the world in which Anna Blume lives, in which people walk on their heads, windmills turn, and locomotives run backwards, Dada also exists. In order to avoid misunderstandings, I have inscribed "Antidada" on the outside of my Cathedral. This does not mean that I am against Dada, but that there also exists in this world a current opposed to Dadaism. Locomotives run in both directions. Why shouldn't a locomotive run backwards now and then?

As long as I paint, I also model. Now I am doing Merz plastics: "Pleasure Gallows" and "Cult-pump." Like Merz pictures, the Merz plastics are composed of various materials. They are conceived as round plastics and present any desired number of aspects.

"Merz House" was my first piece of Merz architecture. Spengemann writes in *Zweemann,* No. 8–12: "In 'Merz House' I see the cathedral: *the* cathedral. Not as a church, no, this is art as a truly spiritual ex-

pression of the force that raises us up to the unthinkable: absolute art. This cathedral cannot be used. Its interior is so filled with wheels that there is no room for people. . . . That is absolute architecture, it has an artistic meaning and no other."

To busy myself with various branches of art was for me an artistic need. The reason for this was not any urge to broaden the scope of my activity, it was my desire not to be a specialist in one branch of art, but an artist. My aim is the Merz composite artwork, that embraces all branches of art in an artistic unit. First I combined individual categories of art. I pasted words and sentences into poems in such a way as to produce a rhythmic design. Reversing the process, I pasted up pictures and drawings so that sentences could be read in them. I drove nails into pictures in such a way as to produce a plastic relief aside from the pictorial quality of the painting. I did this in order to efface the boundaries between the arts. The composite Merz work of art, par excellence, however, is the Merz stage which so far I have only been able to work out theoretically. The first published statement about it appeared in *Sturmbühne,* No. 8: "The Merz stage serves for the performance of the Merz drama. The Merz drama is an abstract work of art. The drama and the opera grow, as a rule, out of the form of the written text, which is a well-rounded work in itself, without the stage. Stage-set, music, and performance serve only to illustrate this text, which is itself an illustration of the action. In contrast to the drama or the opera, all parts of the Merz stage-work are inseparably bound up together; it cannot be written, read, or listened to, it can only be produced in the theatre. Up until now, a distinction was made between stage-set, text, and score in theatrical performances. Each factor was separately prepared and could also be separately enjoyed. The Merz stage knows only the fusing of all factors into a composite work. Materials for the stage-set are all solid, liquid, and gaseous bodies, such as white wall, man, barbed wire entanglement, blue distance, light cone. Use is made of compressible surfaces, or surfaces capable of dissolving into meshes; surfaces that fold like curtains, expand, or shrink. Objects will be allowed to move and revolve, and lines will be allowed to broaden into surfaces. Parts will be inserted into the set and parts will be taken out. Materials for the score are all tones and noises capable of being produced by violin, drum, trombone, sewing machine, grandfather clock, stream of water, etc. Materials for the text are all experiences that provoke the intelligence and emotions. The materials are not to be used logically in their objective relationships, but only within the logic of the work of art. The more intensively the work of art destroys rational objective logic,

the greater become the possibilities of artistic building. As in poetry word is played off against word, here factor is played against factor, material against material. The stage-set can be conceived in approximately the same terms as a Merz picture. The parts of the set move and change, and the set lives its life. The movement of the set takes place silently or accompanied by noises or music. I want the Merz stage. Where is the experimental stage?

"Take gigantic surfaces, conceived as infinite, cloak them in color, shift them menacingly and vault their smooth pudency. Shatter and embroil finite parts and bend drilling parts of the void infinitely together. Paste smoothing surfaces over one another. Wire lines movement, real movement rises real tow-rope of a wire mesh. Flaming lines, creeping lines, surfacing lines. Make lines fight together and caress one another in generous tenderness. Let points burst like stars among them, dance a whirling round, and realize each other to form a line. Bend the lines, crack and smash angles, choking, revolving around a point. In waves of whirling storm let a line rush by, tangible in wire. Roll globes whirling air they touch one another. Interpermeating surfaces seep away. Crates corners up, straight and crooked and painted. Collapsible tophats fall strangled crates boxes. Make lines pulling sketch a net ultramarining. Nets embrace compress Antony's torment. Make nets firewave and run off into lines, thicken into surfaces. Net the nets. Make veils blow, soft folds fall, make cotton drip and water gush. Hurl up air soft and white through thousand-candlepower arc lamps. Then take wheels and axles, hurl them up and make them sing (mighty erections of aquatic giants). Axles dance midwheel roll globes barrel. Cogs flair teeth, find a sewing machine that yawns. Turning upward or bowed down the sewing machine beheads itself, feet up. Take a dentist's drill, a meat grinder, a car-track scraper, take buses and pleasure cars, bicycles, tandems and their tires, also war-time ersatz tires and deform them. Take lights and deform them as brutally as you can. Make locomotives crash into one another, curtains and portières make threads of spider webs dance with window frames and break whimpering glass. Explode steam boilers to make railroad mist. Take petticoats and other kindred articles, shoes and false hair, also ice skates and throw them into place where they belong, and always at the right time. For all I care, take man-traps, automatic pistols, infernal machines, the tinfish and the funnel, all of course in an artistically deformed condition. Inner tubes are highly recommended. Take in short everything from the hairnet of the high class lady to the propeller of the S.S. *Leviathan,* always bearing in mind the dimensions required by the work.

"Even people can be used.

"People can even be tied to backdrops.

"People can even appear actively, even in their everyday position, they can speak on two legs, even in sensible sentences.

"Now begin to wed your materials to one another. For example, you marry the oilcloth table cover to the home owners' loan association, you bring the lamp cleaner into a relationship with the marriage between Anna Blume and A-natural, concert pitch. You give the globe to the surface to gobble up and you cause a cracked angle to be destroyed by the beam of a 22-thousand-candlepower arc lamp. You make a human walk on his (her) hands and wear a hat on his (her) feet, like Anna Blume. (Cataracts.) A splashing of foam.

"And now begins the fire of musical saturation. Organs backstage sing and say: 'Futt, futt.' The sewing machine rattles along in the lead. A man in the wings says: 'Bah.' Another suddenly enters and says: 'I am stupid.' (All rights reserved.) Between them a clergyman kneels upside down and cries out and prays in a loud voice: 'Oh mercy seethe and swarm disintegration of amazement Halleluia boy, boy marry drop of water.' A water pipe drips with uninhibited monotony. Eight.

"Drums and flutes flash death and a streetcar conductor's whistle gleams bright. A stream of ice-cold water runs down the back of the man in one wing and into a pot. In accompaniment he sings c-sharp d, d-sharp e-flat, the whole proletarian song. Under the pot a gas flame has been lit to boil the water and a melody of violins shimmers pure and virgin-tender. A veil spreads breadths. The center cooks up a deep dark-red flame. A soft rustling. Long sighs violins swell and expire. Light darkens stage, even the sewing machine is dark."

Meanwhile this publication aroused the interest of the actor and theatrical director Franz Rolan who had related ideas, that is, he thought of making the theatre independent and of making the productions grow out of the material available in the modern theatre: stage, backdrops, color, light, actors, director, stage designer, and audience, and assume artistic form. We proceeded to work out in detail the idea of the Merz stage in relation to its practical possibilities, theoretically for the present. The result was a voluminous manuscript which was soon ready for the printer. At some future date perhaps we shall witness the birth of the Merz composite work of art. We can not create it, for we ourselves would only be parts of it, in fact we would be mere material.

P.S. I should now like to print a couple of unpublished poems:

HERBST (1909)

Es schweight der Wald in Weh.
Er muss geduldig leiden,
Dass nun sein lieber Bräutigam,
Der Sommer, wird scheiden.

Noch hält er zärtlich ihn im Arm
Und quälet sich mit Schmerzen.
Du klagtest, Liebchen, wenn ich
 schied,
Ruht ich noch dir am Herzen.

AUTUMN (1909)

The forest is silent in grief.
She must patiently suffer
Her dear betrothed,
The summer, to depart.

In grief and anguish still
She holds him in her arms.
You, my love, wept when I de-
 parted.
Could I now but rest on your
 heart!

GEDICHT NO. 48 (1920?)

Wanken.
Regenwurm.
Fische.
Uhren.
Die Kuh.
Der Wald blättert die Blätter.
Ein Tropfen Asphalt in den
 Schnee
Cry, cry, cry, cry, cry.
Bin weiser Mann platzt ohne
 Gage.

POEM NO. 48 (1920?)

Staggering.
Earthworm.
Fishes.
Clocks.
The cow.
The forest leafs the leaves.
A drop of asphalt in the snow.
Cry, cry, cry, cry, cry.
A wise man bursts without wages.

Sound Poem

 bel au hau
 bel au hau fraa
 ee

 bel au hau
 bel au hau fraa
 ii

*Kurt Schwitters, "Sound Poem," Ray, no. 2 (London, 1927). Reprinted by per-
mission of Ernst Schwitters.*

bel au hau fraa
ii
ee
bel au hau fraa
ee
ii

sitt
ssit
nuz
nuz
nut kerr zell

Theo van Doesburg and Dada (1931)

Everyone knows the van Doesburg of the *Stijl magazine,* the artist of poise, consecutive development, and logical construction, but only a few know his importance for Dada. And yet he introduced Dadaism to Holland in 1923 with unparalleled success, and himself enacted a good bit of Dada in the process.

In his magazine *Mecano* he had already shown himself a great connoisseur of things Dada, and in every line one senses his genuine enthusiasm for Dada, whether he intended it or not.

At the end of 1922, Theo van Doesburg invited the leading Dadaists to a Congress in Holland, which was to take place the following year. Unfortunately we underestimated the receptivity of the Dutch, and so, aside from van Doesburg, I was the only Dadaist who appeared for the introductory evening at the Hague Kunstkring. Theo van Doesburg delivered an explanatory lecture about Dadaism and I was supposed to provide an example of Dadaism. But the truth is that van Doesburg, as he appeared on the platform in his dinner jacket, distinguished black shirtfront, and white tie, and on top of that, bemonocled, powdered all white, his severe features imprinted with an eerie solemnity, produced an effect that was quite adequately Dada; to cite his own aphorism: "Life is a wonderful invention."

Since I didn't know a word of Dutch, we had agreed that I should demonstrate Dadaism as soon as he took a drink of water. Van Doesburg drank and I, sitting in the middle of the audience, to whom I

Kurt Schwitters, "Theo van Doesburg and Dada," translated by Ralph Manheim in Robert Motherwell, ed., Dada Painters and Poets (New York: Wittenborn, Schultz, Inc., 1951), pp. 275–76. Originally published in De Stijl (January 1932). Reprinted by permission of Ernst Schwitters and George Wittenborn, Inc.

was unknown, suddenly began to bark furiously. The barking netted us a second evening in Haarlem; as a matter of fact it was sold out, because everyone was curious to see van Doesburg take a drink of water and then hear me suddenly and unexpectedly bark. At van Doesburg's suggestion, I neglected to bark on this occasion. This brought us our third evening in Amsterdam; this time people were carried out of the hall in a faint, a woman was so convulsed with laughter that for fifteen minutes she held the public attention, and a fanatical gentleman in a homespun coat prophetically hurled the epithet "idiots" at the crowd. Van Doesburg's campaign for Dadaism had gained a decisive victory. The consequence was innumerable evenings in all the cities of Holland, and everywhere van Doesburg managed to arouse the most violent hostility to himself and his forces. But again and again we all of us—Petro van Doesburg and Vilmos Huszar also belonged to our little group—ventured to beard the infuriated public, which we ourselves had taken care to infuriate, and despite his black shirt-front, Does always produced the effect of a red rag. The Dutch found this deep-black elegance and distinction atrociously provocative, and consequently he was able to plough his public round and round, to cultivate his soil with the greatest care, in order that important new things might grow from it.

It was for me the finest of experiences when suddenly, in Utrecht, as I was proclaiming the great and glorious revolution (van Doesburg was in the dressingroom), several unknown, masked men appeared on the stage, presented me with an extraordinary bouquet and proceeded to take over the demonstration. The bouquet was some three yards high, mounted on an immense wooden frame. It consisted of rotted flowers and bones, over which towered an unfortunately unpotted calla lily. In addition, an enormous putrid laurel wreath and a faded silk bow from the Utrecht cemetery were laid at the feet of the bourgeoisie. One of the gentlemen sat down at my table and read something out of an immense Bible he had brought with him. Since I understood very little of his Dutch, I considered it my duty to summon van Doesburg to exchange a few friendly words with the gentleman.

But this is not quite what happened. Van Doesburg came and saw and conquered. He took one look at the man and did not hesitate for long, but, without introducing himself, without any ceremony whatsoever he tipped the man with his Bible and gigantic bouquet over into the music pit. The success was unprecedented. The original invader was gone, to be sure, but the whole crowd stood up as one man. The police wept, the public fought furiously among themselves, everyone trying to save a little bit of the bouquet; on all sides the

people felicitated us and each other with black eyes and bloody noses.
It was an unparalleled Dadaist triumph.

I should very much have liked to appear more often with so gifted
a Dadaist as van Doesburg. World Dadaism has lost in van Doesburg
one of its greatest thinkers and warriors.

Theo van Doesburg

Theo van Doesburg (1883–1931) was born C. E. M. Küpper in Utrecht and carried on his Dada activities as I. K. Bonset and Aldo Camini. Founder with Piet Mondrian and others of the Dutch de Stijl group, whose strict program was entirely concerned with geometric abstract art, architecture, and design, he would have seemed an unlikely candidate for Dada. Nevertheless, if the two movements differed considerably in their means, both shared a common longing for social reform and for a tabula rasa. Van Doesburg's texts below, as well as Schwitters' text on van Doesburg (pp. 108–10) indicate where the connections lie.

Doesburg's first painting exhibition was held in 1908 and he also worked as an art critic at the time. In 1916 the de Stijl group began to coalesce and in November, 1918, he was primarily responsible for the first de Stijl manifesto; he edited the review of that name until his death, as well as *Mecano*, which was devoted to the more Dada side of his activities. Doesburg's de Stijl work ranged from painting to sculpture to architecture and he continued to write prolifically. In the twenties he broke with Mondrian and proposed "Elementarism," in which the diagonal was reintroduced into neoplastic dogma. His *Principles of Neo-Plastic Art* was published in 1925 by the Bauhaus and he lived in Weimar in 1921–22. Doesburg was an important liaison between the Russian Constructivists, the Bauhaus, and abstract artists in Paris and Holland. In October, 1922, he arranged a Constructivist Congress at Weimar. The delegates (El Lissitsky, Burchartz, van Eesteren, Kemeny, Moholy-Nagy, and Richter) were amazed to find Arp and Tzara there as well. "This caused a rebellion against the host, Doesburg, because at that time we felt in dadaism a destructive and obsolete force in comparison with the new outlook of the Constructivists. Doesburg, a powerful personality, quieted the storm and the guests were accepted to the dismay of the younger, purist members who slowly withdrew and let the congress turn into a dadaistic performance" (Moholy-Nagy, *Vision in Motion*). When Dada waned, Doesburg continued with his mainstream activities in abstract art, living in Paris and participating in art concret, Abstraction-Création, and similar interests.

Characteristics of Dadaism

No one has as yet worn the Sun in his buttonhole.

—Peter Rohl

Dada is the serious morality of our Time.

—Kurt Schwitters

DADA—and for one instant everyone awakens from his daily somnambulism which he calls living.

DADA—and the sick are healed, move about, and sing "The Watch on the Rhine" or dance a Shimmy.

DADA—and the blind see; they see that the world is dada and laugh ceaselessly at the weighty hair-splitting of our moralists and politicians.

DADA—and the bourgeois sweats rubber, makes a camp bed out of his most beautiful Rembrandt, and dances a one-step to choir music. Each bourgeois is a miniature Landru; behind the mask of culture, humanism, esthetics, and philosophy he gives his instincts free rein.

Culture—what is it but the degree of refinement with which our true instincts are expressed?

※　　※　　※

Dada has discovered the world such as it is and the world has recognised itself in Dada. Dada is a mirror in which the world sees itself. The dadaists do not wish the world to be different than the way they see it, namely, dada: at once orderly and disorderly, yes and no, me and not me. "The Dadaist is a mirror carrier," says Kurt Schwitters and the dada lyricist Hans Arp gives us advice in a poetical manner in "The Cloud-Pump" on how to beware of artifice.

Jesus Christ was the first Dada.

Theo van Doesburg (as I. K. Bonset), *"Karakteristiek van het Dadaisme,"* an address to introduce the non-dadaist evenings in the Netherlands in the winter of *1923, translated by Claire Nicholas White from* Mecano, no. 4–5 *(Leyden, 1923). Reprinted by permission of Mrs. Nelly van Doesburg.*

Towards a Constructive Poetry

Destruction is part of the rebuilding of poetry.

Destruction of syntax is the first necessary preamble to the new poetry.

Destruction has expressed itself in the following ways:

1. In the use of words (according to their meaning).
2. In atrocity (psychic disturbance).
3. In typography (synoptic poetry).

In 1) were instrumental: Mallarmé, Rimbaud, Ghil, Gorter, Apollinaire, Birot, Arp, Schwitters, etc. . . .

In 2) de Sade, Lautréamont, Masoch, Péladan, all religious writings, Schwitters etc. . . .

In 3) Apollinaire, Birot, Marinetti, Beauduin, Salvat Papaseït, Kurt Schwitters, etc.

POETRY IS UNTHINKABLE WITHOUT AN AESTHETIC FOUNDATION

To take the purely utilitarian as the only general basis of a new artistic expression = nonsense.

$$\left.\begin{array}{l}\text{Utilitarian poetry}\\\text{Utilitarian music}\\\text{Utilitarian painting}\\\text{Utilitarian sculpture}\end{array}\right\} = \quad \text{nonsense}$$

nonsense—nonsense—nonsense etc.

We are living in a provisional period. We suppose: that there is no difference between the soul and the spinal marrow, between coitus and art.

But when we make art we use no soap (perhaps the painters do if they have inclinations to cleanliness) and one cannot rise up to heaven on a tomato.

One cannot brush one's teeth with art.

Each thing contains its own usefulness

Theo van Doesburg (as I. K. Bonset), "Tot een constructieve Dichtkunst," translated by Claire Nicholas White from Mecano, *no. 4–5 (Leyden, 1923). Reprinted by permission of Mrs. Nelly van Doesburg.*

SYPHILIS IS NOT THE OBJECT OF MAKING LOVE

But: the sailors of the new constructivist art insist that:

A piece of iron nailed to weed; A house without a groundplan;
A chair without a back; A sword without a blade;
A car which does not drive; OR A (red) poem without content;
A gramophone without a voice;

all that is utilitarian art.

In other words, art rooted in reality!

No, all that is just art-syphilis.

Is there any poetry on which one can sit, as on a chair? Or in which one can drive as in a car? No. Perhaps there only exists a poetry on which one can spit: the utilitarian revolutionary poetry. (I beg the gentlemen to replace the pig's bladders on their head and the tubes in their nose.)

Thus, it does not matter to the reconstruction of Art whether the product has any practical application. In so far as a statue or a painting has a purpose—say to sit on—it is not a statue or a painting but a "chair":

And: in any case, usefulness does not limit itself to the organs of our sensual being. And even if this were so, what we call our spirit belongs equally to our bodily organs.

Let us try to make a poem without feet which would be as good as a shoe.

Do you know, gentlemen, what a city is? A city is a tension in breadth and a tension in height, nothing else. Two straight connecting wires depict a city. Each individual tries by means of: legs, the train, a trolley, or explosives (the transportation of the future) to find the meeting point of these two tensions.

And a poem is just like a city. Everyone tries, as immediately as possible, to represent the square of the two outer tensions. Immediately, that is to say:

The constructivist poet makes himself a new language with the alphabet: the language of great distances, of depth and height, and by means of this creative language he conquers the space-time movement.

The new poet depicts only by conquering, by abolishing, by destroying (like our politicians) through unhumanist abstraction. In the new poetry, to construct means to reduce. In short: the new poet con-

structs his language with the ruins of the past, and since everything exists only through language, he forms, in spite of "disinterested abstraction," the new man and the world with him.

THAT IS HIS FUNCTION.

Enrico Prampolini

Enrico Prampolini (1894–1956) was a painter, scenic designer, architect, and exhibition organizer whose first and most lasting commitment was to Futurism. After studying in the Academy at Rome, he joined the Futurist movement in 1912 and is the author of several manifestoes, including "Atmosferostruttura," on architecture (1914), "Scenotecnica," on stage design (1915, 1924) and one on Mechanical Art, also signed by Panaggi and Paladini (1923), from which the text below is probably adapted. In 1916 Prampolini met Tzara in Rome and the same year participated in the "international Dada exhibition" in Zurich. Ties between Futurism and Dada were strong at the time; Prampolini's art never altered as a result of the association although he did make a few curious assemblages. As editor of the review *Noi,* however, he helped spread the Dada polemic in Italy. Later in the twenties his work became increasingly abstract and he was a member of the Parisian groups *cercle et carré* and *Abstraction-Création,* as were several other former Dadas. In 1929 he wrote that he wanted to "fling myself into the conquest of the future; I haven't time to be satisfied. I prefer to be the creative artist of tomorrow's plastic dynamism rather than the contemplative juggler of today."

The Aesthetic of the Machine and Mechanical Introspection in Art

In the aesthetic phenomenon of the evolution of the plastic arts the necessity, of considering the Machine and Mechanical elements as new symbols of aesthetic inspiration, has not been sufficiently taken into account.

PRECURSORS

We Futurists were the first to understand the marvelous mystery of inspiration which machines possess with their own mechanical world.

Enrico Prampolini, "The Aesthetic of the Machine and Mechanical Introspection in Art," The Little Review (New York, Autumn–Winter 1294–25), pp. 49–51. If there is a known address for the estate of Enrico Prampolini, please notify Prentice-Hall, Inc., Englewood Cliffs, New Jersey.

In fact, Marinetti in his first Manifesto on the Foundation of Futurism published in the Figaro in 1909 stated: "We shall chant the vibrant nocturnal fervor of the arsenals and shipyards lit by their violent electric moons, the bridges like giant gymnasts striding the rivers, the daring steamers that nose the horizons, the full-breasted locomotives that prance on the rails like enormous iron horses bridled with tubes, the gliding flight of the aeroplanes whose screw flutters in the wind like a flag or seems to applaud like an enthusiastic mob. The racing automobile with its explosive breath and its great serpent-like tubes crawling over the bonnet—an automobile that whizzes like a volley from a machine gun is more beautiful than the victory of Samothrace."

From the appearance of the first Futurist Manifesto of Marinetti up until today, there has been a ceaseless searching and questioning in the field of art. Boccioni in his book, Futurist Sculpture and Painting (1914) stated that the era of the great mechanical individualities has begun; that all the rest is paleontology. Luigi Russolo (in 1913) with his invention of the noisemakers constructed new mechanical instruments to give value to new musical sounds inspired by noise, while Luciano Folgore in his poem the Chant of the Motors (1914) exalted the mechanical beauty of workshops and the overpowering lyricism of machines. Later, in my manifesto entitled Absolute Constructions in Motion-Noise (1915), I revealed by means of new plastic constructions the unknown constructive virtues of the mechanical aesthetic. While the painter Gino Severini confirmed by means of an admirable theoretical essay in the Mercure de France (1916) the theory that "the process of the construction of a machine is analogous to the constructive process of a work of art."

This Futurist exaltation of ours for the new era of the machines crossed the Italic frontier and awoke echoes among the Dutch, the Russians, the Germans, and the Spanish.

Fernand Lèger recently declared his painting to be concerned with the love of those forms created by industry and the clash of the thousand colored and persuasive reflections of the so called classical subjects.

Guillermo de Torre, the daring Spanish poet and founder of the Ultraist movement, announced in his manifesto "Vertical" in 1918 the forthcoming epoch of the new and mechanical world.

Today we see a new tendency manifesting itself at the recent international Artists Congress of Düsseldorf. This is the movement of the "Constructionists" as exemplified in the works of the Russian, Dutch, German, Scandinavian, and Roumanian painters among whom we may note Theo van Doesburg, Richter, Lissitzsky, Eggeling, and Janco.

The Constructionists, though they take as their starting point an extremely clear theory, announcing the constructive exaltation of the Machine, become inconsistent in the application of their doctrine, confusing exterior form with spiritual content.

We today—without ignoring the attempts that have been made in the course of the last years by ourselves and certain Futurist friends of ours—intend to reassume and synthetize all that which has been expressed individually and incidentally in order to arrive at more complete and more concrete results, in order to be able to realize more fully new aesthetic values in the field of the plastic arts.

Our experience has convinced us of the truth of certain of our plastic truths and has allowed us to perceive the errors that lie in others.

OLD AND NEW SYMBOLS

In the history of art throughout the ages the symbols and elements of inspiration have been suggested to us by the ancient legends and classic myths created by modern imagination. Today, therefore, where can we look for more contingent inspiration than among the new symbols which are no longer the creation of the imagination or the fantasy—but of human genius?

Is not the machine today the most exuberant of the mystery of human creation? Is it not the new mythical deity which weaves the legends and histories of the contemporary human drama? The Machine in its practical and material function comes to have today in human concepts and thoughts the significance of an ideal and spiritual inspiration.

The artist can only pin his faith to the realities contingent on his own life or to those elements of expression which spiritualize the atmosphere he breathes. The elements and the plastic symbols of the Machine are inevitably as much symbols as a god Pan, the taking down from the Cross, of the Assumption of the Virgin, etc. The logic, therefore, of aesthetic verities becomes self-evident, and develops parallel with the spirit which seeks to contemplate, live, and identify itself with reality itself.

THE AESTHETIC OF THE MACHINE
AND MECHANICAL INTROSPECTION

We today, after having sung and exalted the suggestive inspirational force of the Machine—after having by means of the first plastic works of the new school fixed pure plastic sensations and emotions, see now

the outlines of the new aesthetic of The Machine appearing on the horizon like a flywheel all fiery from Eternal Motion.

WE THEREFORE PROCLAIM

1. The Machine to be the tutelary symbol of the universal dynamism, potentially embodying in itself the essential elements of human creation: the discoverer of fresh developments in modern aesthetics.

2. The aesthetic virtues of The Machine and the metaphysical meaning of its motions and movements constitute the new font of inspiration for the evolution and development of contemporaneous plastic arts.

3. The plastic exaltation of The Machine and the mechanical elements must not be conceived in their exterior reality, that is in formal representations of the elements which make up The Machine itself, but rather in the plastic-mechanical analogy that The Machine suggests to us in connection with various spiritual realities.

4. The stylistic modifications of Mechanical Art arise from The Machine-as-interferential-element.

5. The machine marks the rhythm of human psychology and beats time for our spiritual exaltations. Therefore it is inevitable and consequent to the evolution of the plastic arts of our day.

Julius Evola

Julius Evola (1898–) is a Roman painter, poet, and philosopher who was first associated with the Futurists. He made contact with Tzara in 1918 and published two books in the "collection Dada Zurich": *Arte astratta de tendance Dadaiste* (1920) and *La Parole obscure du paysage intérieur* (1921), the latter named after a poem and a series of paintings. He contributed to *Dadaphone* in 1920, the Salon Dada in Paris, 1921, and *Mecano,* 1922. In 1921 he had one-man shows of Dada work at the Casa d'Arte Bragaglia in Rome, and Der Sturm in Berlin. He collaborated with Enrico Prampolini on *Noi* and coedited, with Gino Cantarelli and Aldo Fiozzi, the Mantua-based review *Bleu,* which has been called the only real Dada magazine published in Italy, just as Evola has been called the "only Italian theorist of Dada." From 1920 to 1922 he made Dada and abstract art, and in 1922 gave up painting and poetry entirely, in order to devote himself to philosophy and Oriental studies.

Abstract Art

Art is egoism and liberty.

I feel art to be a disinterested elaboration proposed by the individual's superior consciousness, and thus transcending and extraneous to the crystallizations of passion and vulgar experience.

Aesthetic feeling should be possessed like a mystic *shadow*—but, on the other hand, like a vital *Weltanschauung:* philosophy, art, morality, common experience, science, everything must be fused and resolved into one in the indeterminate propriety of the aesthetic *moment.* This will be based on the fundamental will/pure will to live/ instead of on form and phenomenon agitation.

Sincerity/passionate egoism, humanity or brutality: LEOPARDI, DANTE, DIONYSIUS/is a category for which art becomes an inferior practical form—i.e. *nonart.* Whoever is sincere is neither original nor creative; whoever is sincere is *objective,* he is the unreasoning robot of an un-

From *Julius Evola,* Arte Astratta *(1921), translated by Geoffrey C. Hutchings in* Cinquant'anni a Dada in Italia *(Milan: Civico Padiglione d'Arte Contemporanea, 1966), pp. 147–50. Reprinted by permission of Civico Padiglione d'Arte Contemporanea.*

restrained force/inertia/that he knows nothing about. The *human* value that can derive from this is, implicitly or explicitly, conventional.

Thus *genius* is a conventionality: genius is a function of culture and emotional experience, both practical/passionate and utilitarian/; because otherwise the author of FANTÔMAS and PONSON DU TERRAIL should be a genius instead of MICHELANGELO and WAGNER. Necessity!: to be able to assert after the practical resolutions offered by culture that DANTE is not a genius is as absurd as asserting that the sum of a triangle's angles is different from 180 degrees after accepting Euclid's postulate. The universal understanding of genius reflects universal general culture which is unconsciously passionate and utilitarian—i.e., a calcareous incrustation, without one being able to speak of a real spiritual necessity in anything.

But just as legitimately, non-Euclidean geometries can exist. For me for example, SCHÖNBERG and TZARA are geniuses instead of WAGNER and DANTE.

Being sincere costs little: we know! All the hard work is in expressing: i.e., virtuosity, technical skill. Hard work and it *is* very much the flag waved by the wind!

But instead one must know not to see, not to find, *not to have:* to place oneself in the void, coldly, under a steelbright surgical will. And this for the first time is *creation:* egoism and liberty! The *new* in art! . . .

Art must be in bad faith. It is more moral to polish one's nails than to produce art; the healthy person can never take as much interest in the *expression* of art as in the choice of silk stockings or a tie.

Obviously, being disinterested, art must be devoid of all normal subject-matter: insofar as it expresses everything, it must not mean anything: there must be nothing to understand in art. . . . And thus, after RIMBAUD's hysterical convulsion of humanity,/*alchimie du verbe*/, MALLARMÉ and APOLLINAIRE half-open the doors of this new world; immediately after, the light breaks through with TRISTAN TZARA and the *Dada* school founded by him. And here, at last and for the first time, art has found its spiritual solution:[1] illogical arbitrary rhythms of line, color, sound, and sign that are a unique mark of the inner liberty and the profound egoism achieved; these things are no more than means to themselves; they do not want to express anything at

[1] Strictly speaking, there is still an imperfection of consciousness in current Dadaism/1920: Dada artists think they have achieved vital purity while, in fact, with the abolition of categories and humanity, they have gone much farther. Dadaism is defective in its mystic interpretation.

all.[2] Here and there the very necessity of expression is overcome. Arbitrary and freakish acts are accomplished: MARCEL DUCHAMP makes a Dada picture with a reproduction of the Mona Lisa plus a little moustache and chemical formula; FRANCIS PICABIA makes a *Sainte-Vierge* with an ink-blot spilled from an ink-pot; another makes a poem with the *défilé* of the alphabet.

The *Dada Manifeste 1918* and TRISTAN TZARA's *25 poems*, and HANS ARP's wood compositions express the highest state of purity, consciousness, and propriety in the depth and intimacy of the Ego that has ever been represented from the beginning of time till now.

[2] "Vous ne comprenez pas, n'est-ce pas, ce que nous faisons. Eh bien, chers amis, nous le comprenons encore moins."/Manifeste Dada, 1920/. ["You don't understand what we are doing, do you? Well, dear friends, we understand it still less."/Dada Manifesto, 1920/.]

Max Ernst

Max Ernst (1891–) has led, like so many Dadas, a kaleido-scopic life and life in art. As a prewar student of philosophy specializing in abnormal psychology, briefly a Cubist-oriented painter associated with der Sturm, and by 1919 an original fantasist moving out from de Chirico's ideas, Ernst was particularly qualified to discover the technical basis of the Dada and Surrealist esthetic—the collage, which he described as "an alchemical composition of two or more heterogeneous elements, resulting from their unexpected reconciliation owing either to a sensitive will . . . towards systematic confusion and 'disorder of all the senses' (Rimbaud) or to chance, or to a will favorable to chance." In contact with Zurich Dada via Arp, Ernst and Baargeld (see pp. 132–35) founded the Cologne branch, which published three reviews (*Dada W/3, Bulletin D,* and *Die Schammade*), held the notorious Dada Vorfrühling exhibition in April of 1920 (see pp. 5–6), and collaborated on Fatagaga (FAbrication des TAbleaux GArantis GAzomètriques), a series of photocollages executed primarily by Ernst with Arp and Baargeld collaborating on details.

The texts below, drawn from the Cologne reviews, antici-pate the automatic writing of the Surrealists (Breton and Vaché were experimenting with similar ideas in 1919) through their irrational and punning structures, but their targets are sheer Dada—sacred cows from Worringer to Cézanne. The manner in which hybrid words are constructed of highly incongruous images within equally incongruous contexts make these texts verbal parallels to Ernst's collages, in which un-related images drawn from industrial or medical catalogues, biological texts, photographs, and advertisements are thrown together to create a "new and unexpected reality." Words have always played an important role in Ernst's work. Later he wrote about "verbal collage," using the word *Phallustrade,* title of an early Dada sculpture, as an example: "an alchemi-cal product composed of the following elements: an *auto-strada,* a balustrade, and a certain amount of phallus." The German language was particularly well suited for this sort of piling-up of words and images, given its multiple construc-tion; unfortunately a good many of the original puns are lost

in translation, but in many cases the reader can supply new ones from the English version.

Ernst's collages were shown in Paris in May, 1921, at the Galerie Au Sans Pareil, where they were a sensation, particularly since, aside from Picabia, the Paris group was mainly literary. The opening, which the artist himself could not attend, as he was refused a German passport, was a major event of the Grande Saison Dada (see notice and invitation below). The review in *Comoedia,* perhaps written by the Dadas, who specialized in false newspaper items, began, "With their characteristic bad taste, the Dadas have resorted to terror this time. The scene was in a cellar and, all the lights extinguished in the store, there arose from the trap door heartbreaking groans and the murmurs of a discussion of which we could only grasp bits and pieces: . . . 'In matching wits the nude woman always wins.—A billiard game installed in a cardinal's intestines. . . .' The Dadas, tieless and white-gloved, moved back and forth. André Breton crunched matches, . . . Aragon miaowed, Philippe Soupault played hide and seek with Tristan Tzara. . . ." A shabby mannequin, a false fire, recitation of the dictionary were other elements. Nevertheless, the reviewer from *Le Gaulois* called the Dadas "timid little people. They go from one to another whispering secrets and blushing. They would love to mystify the public, but they don't know how." As Louis Aragon observed, most of the "collages" did not need "colle" (glue) but "all were firmly within the collage esthetic which was to be the basis of Surrealism."

Ernst finally went to Paris in 1922, still without a passport. Dada was moribund, but he and Paul Eluard collaborated on two books; he invented the frottage technique and participated in the beginnings of Surrealism. In 1930 he published the first of three "collage novels," *La Femme 100 têtes* (*The Hundred Headless Woman*). Since then he has continued to be the "compleat Surrealist," his work having ranged from near abstraction to total illusionism, from books to large sculpture, and moved in and out of newly invented media, without sacrificing the black fantasy that made him a seminal Dada.

On Cézanne

Everyman loves everyman's Cézanne and rolls his eyes: "That paaynting! Ooo that paaynting!" Je m'en fous de Cézanne [I don't give a damn about Cézanne], for he is an enormous hunk of painting. Everyman also loves everyman's expressionists, but he turns away in disgust from the gifted drawings in pissoirs. On the other hand the most perfect sculpture is the piano hammer. dada.

Max Ernst, "Über Cézanne," translated by Gabriele Bennett from Bulletin D (Cologne, 1919). Reprinted by permission of Max Ernst.

Worringer, Profetor DaDaistikus

Worringer,[1] profetor DaDaistikus
6 o'clock to, the profet perceives in his ear
conch the furor dadaistikus of the new
deep-slurping association. hihi.
8:12 to, missa exhibitionalis in the in-
visible cathedral of the spiritual and
private profets. titi.
9:17 to 9:25 to, ambiguity and appreciation
of the erring error kokoschka in
little goose slippers. lilli.
9:26 to 10:13 to, would man a priori
be good to the new mankind contur-
bine DaDa? pfiffi.
10:14 to 10:14 to. ubi bene ibi DaDa. pippi bibbi
10:14 to, photograph of the unending testicity
of the gothic lilli in irish ornate
minni.
10:15 to, today red tomorrow gothic mimmi. kri.
10:16 to 11:9 to, with the empathetic finger
of the right hand DaDaindadaout—but
!! willi
11:10 to 5:23 aftern. unio expressiva ero-
tica et logetica or mating
cramps of brother pablo mysticus and

Max Ernst, "Worringer, Profetor DaDaistikus," translated by Gabriele Bennett from Die Schammade (Cologne, 1920). Reprinted by permission of Max Ernst.

[1] Editor's note: Wilhelm Worringer, well-known German professor of art history, author of *Abstraction and Empathy.*

sister scholastica Feininger
or the ethic of picasso.
kille killi[2]
6:oo n. picastrate Euml

[2] Translator's note: *kille, killi:* kitchy, kitchy koo.

Lucrative History-Writing

prole to the right prole to the left
rubin in the middle

The little charm-loop of the succubine "benevolent spirit" of the
nobleorious incubine and genuine active workers' council for mental
necessity K. Hiller—hillerau not to be confused with the lazy rubbish
island was recognized by the police-spy for aesthetic grief-societies in
the reconstruction "Salvation of the Correct Effect of Pictures" of the
Stormpube Schwitters. How this veil-maker succeeded in the com-
fortable manipulation of the rape of the little loop, remains with the
continuing end-spring-readiness of the most violent on calendarium
4 and 5 of the helpful, remains a picture-sheet. It is probable that he
was successful in the deed by having recourse to the catechism for
noble prostitutes, the thought pump and several other free plagiarisms,
while hiller, with his cosmetic friend Werfel, opened letters about
the self-maturing conflict, whether it would be charitable to coat
clap-bacteria with war, or whether it would deal more charitably
with the interest of the clap-bacteria to place the brain parcels at
their disposal for a dwelling and his brain wax for a sandwich spread.

* * *

Nevertheless, something happened, and the open correspondence
of the bloated friend's little chests remained, up to the end of the
next world war, opened for non-warriors. Activist privy councillors
and duelling artists' societies with activistic beer rituals, and, for
Germany, an alumni house of conjunctors, were formed everywhere.
The executive committee of the new Imperial Union for Imperial
Subjects set out into impotency for Stuttgart. In the morning, as,
newly weakened, he leaped upwards out of his president cesspool,[1]
he remarked to his speechroseness that the charm-loop of his prime-

Max Ernst, "Lukrative Geschichtsschreibung," translated by Gabriele Bennett from
Die Schammade (*Cologne, 1920*). *Reprinted by permission of Max Ernst.*
[1] Translator's note: *Prasidentenpfuhl: Pfuhl*—puddle; *Sundenpfuhl*—sink of cor-
ruption; *Pfuhl*—(poet.) pillow, cushion, couch.

bonne[2] was again attached quite correctly to the charm disposal department of his young freed "Republic." "Charming!" fell from his gracious lips. "Puzzling! Who was capable of that."

* * *

As the inexplicable became known (as a result of strictest secrecy), Kurt Hiller and Kurt Schwitters were immediately released from protective custody. In this simple way they were successfully rendered thoroughly harmless. As a covering for their nakedness, both were forwarded a schammade[3] from the benevolent chief office Dada W/3[4] of the activistic collecting center for the harmless.

[2] Translator's note: *Prime-bonne*—pun on Bonn, *bonne* as French word for "maid" as well as "good," and prime minister.

[3] Translator's note: *Schammade* (name of the magazine this text appeared in): *Schamade*—(military) parley, capitulate; *Scham*—shame.

[4] Editor's note: Dada W/3 was another branch of Cologne Dada.

Wordless Thoughts[1]

Wordless thoughts are the Mastarm[2] of the uppermost electric *poèsie* and virtue training they contain the pieces which every man must know to achieve eternal bliss endlessly the horse-apples[3] roll from the mystical bung-hole into the aquarian blood-blocks of the desiccated reader they discolor porfyry-like you would think it was a glacialshite.

Max Ernst, "Pensées sans Langage," translated by Gabrielle Bennett from Die Schammade *(Cologne, 1920). Reprinted by permission of Max Ernst.*

[1] Editor's note: "Wordless Thoughts" ("Pensées sans langage") is also a poem by Picabia published in 1919.

[2] Translator's note: *Mastarm: Mast*—mast; *Arm*—arm or foreleg, also poor, meager; *Mastdarm*—rectum.

[3] Translator's note: *Rossapfelsinen: Rossapfel*—horse manure (horse apples); *Apfelsinen*—oranges.

Invitation to the Max Ernst Exhibition

Dada invites little [name of guest] to the opening of the Max Ernst exhibition.

At 10 PM, the Kangaroo.
At 10:30 PM, high frequency.
At 11 PM, distribution of surprises.
After 11:30 PM, intimacies.

Max Ernst, Invitation to the Max Ernst Exhibition at the Galerie Au Sans Pareil, Paris, May 1921. Translated by the editor. Reprinted by permission of Max Ernst.

Notice of the Max Ernst Exhibition

SETTING UNDER WHISKEY MARINE

is made of kaki cream and in 5 anatomies

HURRAH FOR SPORT

At the sans pareil

37, avenue Kléber Paris 16e

From May 3 to June 3

DADA EXHIBITION

MAX ERNST

WOMEN *Are Requested to Wear Their JEWELS*

WE ARE ONLY CHILDREN

mechanoplastic plastoplastic drawings anaplastic anatomical antizymical aerographic antiphonar waterable and republican paintopaintings.

FREE ENTRANCE **EASY EXIT**

hands in pockets painting under the arm

BEYOND PAINTING

like a lone man joke in the corner

Max Ernst, "Lattise sous Whisky Marin," notice of one-man exhibition at the Galerie Au Sans Pareil, Paris, May 1921. Translated by the editor from Littérature no. 19 (May 1921). Reprinted by permission of Max Ernst.

Ernst and Arp met first by chance in an exhibition in Cologne in 1914 and remained friends for life. The text below, by Ernst on Arp, was followed in turn by one by Arp on Ernst, introducing the portfolio of frottage drawings published in 1925 as *Histoire Naturelle*. The two texts, despite the great difference in the writers' personalities, resemble each other. Both Arp's and Ernst's Dada work concentrated on images drawn and abstracted or metamorphosed from nature, endowed in Arp's case with a gentle, humorous formal fantasy and in Ernst's with a more mordant, darker kind of surprise. In 1919–20 they agreed to: "purify the imagination"; sentiment must go and so must the dialectical process which takes place on the canvas alone."

Arp

From the Place de l'Opéra we see him by day as by night detaching himself from the sky

ARP

to him we owe the sixty formations of skulls[1] since the night of fog until the patch of color.
it is he who occupies 3,000 zymometers per day
the reparation of boredom will be most difficult without the midwife's hands
it is an invention of high precision and even greater importance than the key of love found by auguste rodin

ARP

As for the farting vulture,[2] it seems to us that this little madame-hole[3] contains all the truth of the charming excursion into the extreme crust of the Zambezi[4] whose reckless scheme he established despite the wind and inclemencies

Max Ernst, "Arp," translated by the editor from Littérature, *no. 19 (May 1921).*
Reprinted by permission of Max Ernst.
[1] Translator's note: *crânes*, which in slang also means swaggerers.
[2] Translator's note: *gypaète qui pète.*
[3] Translator's note: *trou-madame;* probably pun on manhole (*trou-homme*).
[4] Editor's note: One of Ernst's collages of the period is entiled *Zambesiland.*

but if one met there the little leopard-hole whose arabic passage is
 formed of the first leopard killed naturally the remaining words
 contain a patriotic madrigal it is the merchant who marches
up to the reader now to admire the courageous constructor arp

ARP

Yemen and Gynandria accede three times a day to his child-sized
 coffin
with his teeth he breaks the new ensiform osselet growing south of
 his sternum
not yet twenty-five years old already he hears the train-train

ARP

We very much regret that he is still lacking the constipation of
 material cultivated so carefully by pablo pi pablo
in addition he has sometimes been reproached for forgetting the
 wealth of anatomical plantations and the tubiferous color we
 so greatly admire in Max Ernst[5]
in the same way as the illusory sister germaine handled so graciously
 by the fathers of the church
in the same way as the delicious little machine for pulverizing an-
 cestors
but all that doesn't make the thaumaturge-tumbler piss
by the gravitation by water and by sixty-nine numbers of wind he
 sells practicables ice-slide plateaus and the multicolored drop-
 lets of small-caliber fossils
but he makes his parents transparent without counting the ship-
 wrecks he has avoided

ARP

His good sistine fairy will repeat six times a week that this remarkable
 spirit does not know how to eat meat and immediately catches
 leprosy
but I have seen him sell his pox with good appetite I have seen him
 bring (by a little wheelbarrow constructed for that purpose)
 two kilos of tits and sausages per day into the paternal home

[5] Editor's note: Another reference to Ernst's collages of 1920–21, in which tubular
elements are prominent; several depict "gardens" or "plantations" of forms found
in anatomical catalogues.

ARP

citizens!
read the cloud pump[6]
read the farting vulture
read the old man who knows how to steal
read love for three and bird to bird
probe work read

ARP

Since birth he has taken fact and cause for the three theological
virtues and for Archimedes' theorem which says the body must
be measured by the corporeal

ARP

so as not to violate his brother's taste he divides in two his lips and
tattoos all the constellations on his tongue
in the same way as the diagrams of all inflorescences
in the same way as octopi

ARP

That does not hinder him from always listening favorably to
the little daisies entering at the sound of teats
in his breast he keeps perspective lightning flashes
in the crevices of his shoulder-blades the wall swallow nests
in the conch of his ear he seizes aerolites on the wing
his heart and his kidneys are perfectly decomposable

ARP

[6] Editor's note: *Cloud-Pump (Die Wolkenpumpe)*, title of a collection of Arp's
poems published around 1920.

Johannes Theodor Baargeld

Johannes Theodor Baargeld (?–1927) was a pseudonym of Alfred Grünwald, son of a wealthy and powerful banker in Cologne (Baargeld means cash money), a leading member of the Independent Socialist party and founder of the Communist party in the Rhineland. In 1918–19 Baargeld's revolutionary review *Der Ventilator* was banned by the British Army of Occupation, after which he and Max Ernst, with occasional visitations from Arp, produced several Dada publications and, in fact, embodied Cologne Dada. The two edited *Bulletin D (Dadameter), Dada W/3,* and *Die Schammade,* the latter supposedly supported by Baargeld's father in the hope that an emphasis on art would replace his son's political activities. Baargeld has been described as "cosmopolitan, curious, audacious, good-looking, energetic, with natural high spirits and an easy command of human relations" (John Russell, *Max Ernst*). A painter and a poet, he had taken a degree at Oxford, was an exofficer in the German airforce and lived in a mansion. These paradoxical circumstances would obviously have appealed to Ernst. The two worked together, often "automatically," signing each other's paintings and collages (the "Fatagaga" series, see p. 123–24), and confusing the stylistic issues in a genuinely Dada spirit. It is possible, however, to discern a nervous hand, a more chaotic sensibility in those works attributed to Baargeld alone. In 1921 Baargeld gave up both art and politics. Little more is know of him except that he was killed in an avalanche in 1927.

Bulletin D

. . . "knock the warm egg out of the hand!"

AHEHE: Cézanne is chewing-gum. The Grünewald [1] swallows van Gogh's yellow dentures. Van Gogh had bad breath and is dead. Eljen dada!

Johannes Theodor Baargeld, "Bulletin D," translated by Gabriele Bennett from Bulletin D *(Cologne, 1919). Reprinted by permission of Max Ernst.*

[1] Translator's note: A forest in Berlin, as well as a sixteenth-century German artist.

BEHEHE: The phallustrade[2] of the expressionists exhausts the lecithin reserve of the entire cultivation, as well as known belly-bark.[3] Patti's belly-bandage is buried. Dr. Rudolf Steiner's coroners joined the international Dada Association (iadede). Eviva dada!

CEHEHE: incasso cassa picasso. Citizen pablo picasso distributes his completed oeuvre to the widows of Madrid. Now the widows are in a position to take a course in Swedish massage, in order . . . picasso around dada?

DEHEHE: The dentist was a woman. Expressionism is a skin bandage [*Hautbinde*] with umbilical character. Notice: connective membrane [*Bindehaut*], intact.

EHEHE: Therefore Prof. Oskar Kokoschka can definitely be addressed today as the inventor of the automechanical leech "self-help." Et Propopo, et Propopos!

FEHEHE: You should Hareclever[4] in white tennis shorts! Hareclevers unite! There—ut dem dada.

GEHEHE: On the belly of society, art is growing. Art grows in the belly. The secret of the upper body is the lower body [belly]. Art is revolutionary down to the belly. Society inserted expressionism.[5] $a = o = expr = unterleib = hemorrhoidalsuppository$.

HAHEHE: The expressionistic poets write poetry because the expressionistic nonpoets are not silent.[6] Heaven hell and block-chapell—Threefold lyrically yell—Däubler-brillatine stars—Lightshaft-Werfel all so far—Becher[7] learns to earth-ruby, dada.

IHEHE: Waldenism[8] autosecedes, while maintaining American book-keeping, from the respective prewaldenism. Its art of composition is on the third page of the general catalogue of the *Grands Magasins des Quatre Saison* for the year 1920 and contributions will only be noted if accompanied by the full price of a year's subscription in stamps.

[2] Editor's note: This pun-word (*Phallustrade*) turns up again in Max Ernst's later, Surrealist writings.

[3] Translator's note: *Bauchrinde:* belly + bark or rind; *Bauchbinde:* abdominal bandage.

[4] Translator's note: *Hasenclever:* clever as a hare.

[5] Translator's note: This paragraph contains a series of untranslatable puns on lower, upper, under body, belly (*Unterleib, Oberleib, Unterleib*).

[6] Editor's note: The following is a simultaneous parody of expressionist poetry and of the three witches scene from Macbeth.

[7] Translator's note: *Becher:* beaker; Johannes R. Becher was a German poet associated with the Dadas; Werfel and Däubler were also acquaintances.

[8] Editor's note: Herwarth Walden, editor and leader of *Der Sturm.*

KAHEHE:　Soon he　　　　　plocks　　　　Dada

Aniunde—　　　in　　　tomatopelvis

Waldas　　　Toria　　　by　　　mistough　　　　ge-trickle

Koloman　　　Psilander　　　Hodenberg　　　Rockdada[9]

LEHEHE:　Philanthropists! Ce qu'on dom is Dostoyevski. The right side of the piper demon is still at a distance of 0.879 dada from Biscaya (straight through Europe). The international Dada Association decided at its last conference to paint a toilet sea on Biscaya. dada.

MEHEHE:　There is no "activist" art. The artist is part of the life he destroys. Activism is the criterion of all life. This bunk about activism notifies us that the explosion of the womb is a question of life for the new. The constraining activism of the womb confronts our willing activism. . . . The old conceals itself and calls itself "Simply Life." Only life lives a full life (*l'expressionisme pour l'expressioniste*) [Expressionism for the Expressionist]. Egocentric act: a gentleman . . . no lady. "Simply Life" is there to feed the new. The Old falls to the Matower[10] of its Antichrist. Kyrie eleison Antichrist!!

NEHEHE:　Idionopolis is burning. Never will Idionopolis burn. Einstein is a cigar and cuts himself off. Eljen Karolyi! Down with Idionopolis! Down with idionom art, ar arr arrr razored [11]—we will stuff manet, we will. Painting isn't worth a rabbit-button. Dada = 7/8 rabbit-button. Franz Marc is the founder of the cul de Berlin and is worn by ladies over their laps.[12] Hinder. Hind quarters. Read the Dada Manifestoes. 0.000001 dada = chemically pure. Up the iadede! caracho! cocha bamba!!!

[9] Translator's note: "Solomon, philanderer, Testicle mountain skirt-there" (?).

[10] Translator's note: *Materiatur:* pun on *mater*, Mary, tower, material.

[11] Translator's note: *Rasierter:* shaved person; also, raze.

[12] Translator's note: Marc—German Expressionist painter killed in World War I; *Schoss*—lap; *geschossen*—shot.

Tinkle Resonance II

Mountain-moths butterflying in a petroleum-sky
Swathed masts branching swan's candles
Teleplastically stares the Cherimbin swarm
In the overopened porter's hearts
Inhast the heaven-tinkle

Field-post-letter recoquettes from crisis-sky
blind beater star-spashes his cros-longing
Yuste Berling[1] still jerks straight the mother-forceps
Fumble-moon and faroff craze
Fustian pants flag the cactus poles
Lamb-fiddler[2] stretching clothesline
Wash loins loosen hop and fold
Cigar-rinds smear upon the elders
Weather-manikin scratches on her leg
Until all tinkle-bells are stopped.

Johannes Theodor Baargeld, "Bimmelresonnanz II," translated by Gabriele Bennett from Die Schammade *(Cologne, 1920). Reprinted by permission of Max Ernst.*

[1] Translator's note: *Gösta Berling*—Nobel Prize-winning (1909) Swedish novel by Selma Lägerlof; *Juste*—Auguste (Berlin slang).

[2] Translator's note: *Lämmergeiger: Lämmer*—plural of lamb; *Geiger*—fiddler; *Lämmergeier*—vulture.

Otto Freundlich

Otto Freundlich (1878–1943) was first a student of art history
under Wölfflin, then a figurative, then an abstract sculptor;
he studied in Berlin, Munich, Florence, and Paris, where he
was associated with the Cubists around 1909. From 1914 to
1924 he lived in Cologne and retained close ties with Berlin.
A member of the Novembergruppe, he was only peripherally
involved with the Dadas, though he sympathized with their
socialist and pacifist goals. Hannah Höch recalls him as "much
too serious and earnest to participate in any of our youthfully
scandalous manifestations. . . . Freundlich belonged already
to a more established community of nonconformist writers
and artists, all regular contributors to Franz Pfemfert's *Die
Aktion*." He returned to Paris in 1924, was interned in 1939,
fled to the Pyrenees, and in 1943 was deported to Poland,
where he died in a concentration camp.

The Laugh-Rocket

Definition: a laugh-rocket differs from the usual rocket in its shrilly
howling laughter while climbing. Furthermore, it does not occur in
pairs, nor collectively, but sporadically, so that it is unexpected by
those who hear it. Thereby it fully accomplishes the purpose of its
ephemeral existence—to provoke terror. The fact that it is not there
for amusement, in spite of its laughter, is proved by the sudden, clear-
as-day illumination of carefully guarded darknesses. Every comedian
of life is therefore threatened, and he is warned only insofar as he is
willing to light his own darknesses. If he does not do so, and believes
he can continue his comedies of darkness as an equal among equals,
let it herewith be explained to him: we know all and we will tell all.
Our laugh-rocket will visit him often, and just when he least expects
it. We will not spare the fair sex, nor the unfair sex, nor the penis
for sale, nor the vagina for sale, nor the swindle of woman, nor the
swindle of man, nor the swindle of family. The smart middle-class
women with their whoring, the smart bourgeois with their goatlike
lewdness, will be among those darknesses lit by the laugh-rocket. Free

Otto Freundlich, "Die Lach-Rackete," translated by Gabriele Bennett from
Bulletin D (*Cologne, 1919*). *Reprinted by permission of Max Ernst.*

procreation, why doesn't it exist? Why does procreation become the pretext for usury, fraud, and villainy, men and women, you who are so good at that? It would be better to abort every child, so that woman could, for once, overcome that deeply rooted natural fate—to shelter her need for freedom under a bourgeois home. Let Freedom be costly, holy, courageous, fully unmasked.

A man who retains a house rabbit and hatches children with it, but is also a libertine, a man who cannot dispense with the most bourgeois background and the miserable comfort of the philistine, this man belongs to that category of life-comedians which we despise.

Something else: Citizen Cézanne is dead, long live the bourgeois Cézanne. O you artists, whom he helped to marry well.

Citizen Liebknecht is dead, long live the cte.

Would you impotent revolutionaries tell me where the vigors of your souls have fallen, who swallowed them? Sometimes a revolution can be made from an orderly family life. But that doesn't always work. An orderly family life will always weaken one's independence, make one half-witted, and give the freedom fighter type a biedermeier haircut. No one today has the right to a family. This should be understood most of all by those who bring about a transformation of the social and ethical world with unbroken intensity, undispersed by any other lower obligations: for today the splendid illusion has once again calmed most souls: everything is as it was. Indeed, in private, the astonished question crossed my mind: In the creation of the bourgeois man did the earth really find the type of man it ultimately wanted? The syrupy sweetness makes everything sticky again: this is the slime and the slimy weapon of the bourgeoisie, to make everything sticky and then devour it. Remain hard and well-sharpened, you freedom blades; ringing souls, your metal must be pure and faultless; no gesture of security should make your clang and your gait corpulent. Beware of the European gesture of the *parvenus*. For a long time the European has been uprooted, a *déraciné;* and because he never had the cleanliness and courage to admit this, he became a *parvenu. Parvenu* means a simulation of belonging, hence the highly regarded family *Gemüt-lichkeit.* Yes, the European and all those who took his mean *parvenu* gesture as a religion are uprooted: uprooted from the star Earth, which spit them out in disgust. Unnoticed by these shameless swindlers, the Earth has cast them and all their roots out of her wondrous ground and is letting them die in their arrogance. Has not the air been filled for a long time with the stench of decay? Doesn't one have to examine thoroughly everything that happens today, to test the heart and the kidneys and see how infected they are by the decaying bourgeoisie, to see how far it is just the deceptive mimicry

of the death throes of wholly undermined matter? You must, my friends, you must do that relentlessly. For danger threatens in all corners and flanks, there is danger that, vampire-like, the hollow bourgeois souls will hurl themselves at everything with any young, individual life. Knock them dead, those swine! May they mutually suck on their poverty and finally perish. The forces generated by God and for God were not meant for the jaws of parasites. We do not yet know in detail what we will do; but we do know that we will keep the whip in hand, and with force will beat to pieces those vermin who are preventing the earth's renewal.

Marcel Duchamp

Marcel Duchamp (1887–1968). If there was a single architect (or demolition expert) of the Dada movement, it was certainly the man Apollinaire had described, as early as 1913, as "detached from esthetic preoccupations" and "preoccupied with energy." From his *Nude Descending a Staircase* (1912) to his last painting, *Tu m'* (1918) to his final masterpiece, *The Bride Stripped Bare by Her Bachelors, Even (The Large Glass)* (1915–23), Duchamp demonstrated his commitment to the antiphysical, antihedonist, antipermanent, finally destructive side of art. Though the results came less from the objects made than the attitudes inspired, few other artists in the twentieth century have done so much to renew the premises and possibilities of visual art. Duchamp's innovation was the simple declaration that *anything is art if an artist says it is.* The train of thoughts and actions set in motion by the first "readymades" (ordinary manufactured objects presented either unchanged or very slightly altered as art objects) provided one source for the "machine esthetic" dominating the twenties and thirties, but it also provided a manual for the future of the art that Duchamp himself rejected. He was interested in separating "the readymade in quantity from the already found. The separating is an operation." It opened upon the world of art the flood tides of materials and actions from the "real world." The irony of Duchamp's position as noncombatant in the art battles he himself had instigated was not of course lost on him, as he watched his objects of antiart become the prototypes for one new art after another, from the Surrealist object to the exploitation of chance in abstract expressionism to pop art, happenings, Op art, kinetic art, and "dematerialized" or "conceptual" art. If today many young artists reject Duchamp's "influence" it is because by now that influence is pervasive rather than specific.

Duchamp came to Paris in 1904, joining his two older brothers—artists Jacques Villon and Raymond Duchamp-Villon. His early work adapted certain Cubist-Futurist ideas. However, the decisive moment came in 1913, when he mounted a bicycle wheel on a common kitchen stool, when he chose an unaltered bottle rack as sculpture, when he began work on *Three Standard Stoppages,* which he called "canned chance."

In 1915 he went to New York where, with Picabia, Man Ray, Jean Crotti, Arthur Cravan, and the occasional participation of Edgar Varese, Joseph Stella, Mina Loy, Marsden Hartley, and Morton Schamberg, he headed the proto-Dada group, edited or coedited *Rongwrong, The Blind Man* (1917), and *New York Dada* (1921), and provoked the "Richard Mutt Case" (see text below which may or not have been partially written by Duchamp), one of Dada's causes célebres. Duchamp, who was among the organizers of the unjuried Society of Independent Artists exhibition in New York in 1917, submitted to it an unadorned urinal, titled *Fountain*; the artist was listed as R. Mutt (perhaps a pun on the German word *Armut,* or poverty). It was "exhibited" behind a curtain and Duchamp resigned in protest. His other great gesture of defiance to conventional institutions was the publication in *391* of the reproduction of a mustached Mona Lisa, inscribed "L.H.O.O.Q.," which read in French means "she's hot in the ass."

Duchamp returned to Paris for six months in 1921. Though he continued to make objects, he participated only peripherally in Paris Dada, its public nature and tendency to buffoonery being anathema to his intellectual fastidiousness. Later he took part in Surrealism from the same detached position, though the movement claimed him anyway. He returned to New York in 1922 and lived there for the rest of his life, as a chess player and ultimate Dada in his very refusal to participate in the world Dada wanted to change, but by which it was eventually absorbed. Yet paradoxically, and typically, after renouncing art publicly, Duchamp continued privately to produce minor objects, drawings, statements, exhibitions, interviews, even etchings. At his death it was revealed that he had been working for years on a life-size, three-dimensional tableau incorporating a nude and object puns on his life's work; it is now at the Philadelphia Museum.

Interview with Marcel Duchamp
by James Johnson Sweeney

Futurism was an impression of the mechanical world. It was strictly a continuation of the Impressionist movement. I was not interested in that. I wanted to get away from the physical aspect of painting. I was much more interested in recreating ideas in painting. For me the title was very important. I was interested in making painting serve my purposes, and in getting away from the physicality of painting. For me Courbet had introduced the physical emphasis in the nineteenth century. I was interested in ideas—not merely in visual products. I wanted to put painting once again at the service of the mind. And my painting was, of course, at once regarded as "intellectual" "literary" painting. It was true I was endeavoring to establish myself as far as possible from "pleasing" and "attractive" physical paintings. That extreme was seen as literary. My *King and Queen* was a chess king and queen. . . .

Dada was an extreme protest against the physical side of painting. It was a metaphysical attitude. It was intimately and consciously involved with "literature." It was a sort of nihilism to which I am still very sympathetic. It was a way to get out of a state of mind—to avoid being influenced by one's immediate environment, or by the past: to get away from clichés—to get free. The "blank" force of dada was very salutary. It told you "don't forget you are not quite so 'blank' as you think you are." Usually a painter confesses he has his landmarks. He goes from landmark to landmark. Actually he is a slave to landmarks—even to contemporary ones.

Dada was very serviceable as a purgative. And I think I was thoroughly conscious of this at the time and of a desire to effect a purgation in myself. I recall certain conversations with Picabia along these lines. He had more intelligence than most of our contemporaries. The rest were either for or against Cézanne. There was no thought of anything beyond the physical side of painting. No notion of freedom was taught. No philosophical outlook was introduced. The cubists, of course, were inventing a lot at the time. They had enough on their hands at the time not to be worried about a philosophical outlook; and cubism gave me many ideas for decomposing forms. But I thought

From James Johnson Sweeney, "Interview with Marcel Duchamp," in "Eleven Europeans in America," The Museum of Modern Art Bulletin, XIII, no. 4–5 (1946). Reprinted by permission of the Museum of Modern Art and Marcel Duchamp.

of art on a broader scale. There were discussions at the time of the
fourth dimension and of non-Euclidean geometry. But most views of
it were amateurish. Metzinger was particularly attracted. And for all
our misunderstandings through these new ideas we were helped to get
away from the conventional way of speaking—from our café and
studio platitudes.

Brisset and Roussel were the two men in those years whom I most
admired for their delirium of imagination. Jean-Pierre Brisset was
discovered by Jules Romains through a book he picked up from a
stall on the quais. Brisset's work was a philological analysis of lan-
guage—an analysis worked out by means of an incredible network of
puns. He was sort of a Douanier Rousseau of philology. Romains
introduced him to his friends. And they, like Apollinaire and his com-
panions, held a formal celebration to honor him in front of Rodin's
Thinker in front of the Panthéon where he was hailed as *Prince of
Thinkers.*

But Brisset was one of the real people who has lived and will be
forgotten. Roussel was another great enthusiasm of mine in the early
days. The reason I admired him was because he produced something
that I had never seen. That is the only thing that brings admiration
from my innermost being—something completely independent—noth-
ing to do with the great names or influences. Apollinaire first showed
Roussel's work to me. It was poetry. Roussel thought he was a
philologist, a philosopher, and a metaphysician. But he remains a
great poet.

It was fundamentally Roussel who was responsible for my glass, *La
Mariée mise à nu par ses célibataires, même.* From his *Impressions
d'Afrique* I got the general approach. This play of his which I saw
with Apollinaire helped me greatly on one side of my expression. I
saw at once I could use Roussel as an influence. I felt that as a
painter it was much better to be influenced by a writer than by an-
other painter. And Roussel showed me the way.

My ideal library would have contained all Roussel's writings—
Brisset, perhaps Lautréamont and Mallarmé. Mallarmé was a great
figure. This is the direction in which art should turn: to an intellectual
expression, rather than to an animal expression. I am sick of the
expression *"bête comme un peintre"*—stupid as a painter.

The Blind Man

The Richard Mutt Case

They say any artist paying six dollars may exhibit.

Mr. Richard Mutt sent in a fountain. Without discussion this article disappeared and never was exhibited.

What were the grounds for refusing Mr. Mutt's fountain:—

1. Some contended it was immoral, vulgar.
2. Others, it was plagiarism, a plain piece of plumbing.

Now Mr. Mutt's fountain is not immoral, that is absurd, no more than a bathtub is immoral. It is a fixture that you see every day in plumbers' show windows.

Whether Mr. Mutt with his own hands made the fountain or not has no importance. He CHOSE it. He took an ordinary article of life, placed it so that its useful significance disappeared under the new title and point of view—created a new thought for that object.

As for plumbing, that is absurd. The only works of art America has given are her plumbing and her bridges.

Anonymous, "The Richard Mutt Case," from The Blind Man *(New York, 1917). Reprinted by permission of Marcel Duchamp.*

Wanted: $2,000 Reward

For information leading to the arrest of George W. Welch, alias Bull, alias Pickens, etcetry, etcetry. Operated Bucket Shop in New York under name *Hooke, Lyon and Cinquer.* Height about 5 feet 9 inches. Weight about 180 pounds. Complexion medium, eyes same. Known also under name *Rrose Selavy.*

Marcel Duchamp, "Wanted: $2,000 Reward," rectified ready-made, 19½" × 14". (New York, 1923). This text appeared below front and profile portraits of Duchamp on a simulated "wanted" poster. Reprinted by permission of Marcel Duchamp.

The Bride Stripped Bare
by Her Bachelors, Even

The Large Glass (*The Bride Stripped Bare by Her Bachelors, Even*), a free-standing painting on glass now in the Philadelphia Museum, represents the climax of Duchamp's career as an artist or antiartist. Its complex iconography can be traced to a group of 1912–13 drawings and paintings (*The King and Queen Surrounded by Swift Nudes, The Bride, The Virgin, The Bachelor Apparatus, The Chocolate Grinder*) which include all the major formal and evocative elements mentioned in the notes: the *pendu femelle* ("hanging female thing"), the nine malic moulds, the "desire mechanism," "love gasoline," "electrical undressing." *The Glass* itself is a pessimistic and ultimately nonerotic view of the act of love reduced to a function of entirely detached machines. ("The Bachelor grinds his chocolate himself.") *The Green Box,* the notes and jottings made over the years of the *Glass*'s conception, constitutes Duchamp's real esthetic legacy. It shares with Joyce's *Ulysses* a multilateral network of images and ideas, within and without the object resulting from it. Ostensibly about the making of *The Large Glass,* the *Green Box* is in fact an admission of the *Glass*'s failure to incarnate its own implications. Duchamp himself intended the *Glass* merely to be a "succinct illustration of all the ideas in the *Green Box,* which would then be a sort of catalogue of those ideas. In other words, the *Glass* is not to be looked at for itself but only as a function of the catalogue I never made."

The Green Box was first produced in a limited facsimile edition (Paris: Rrose Selavy, 1934), a container of random slips of paper. In 1957, George Heard Hamilton translated sections into English (New Haven, Readymade Press) and in 1960 his complete translation was published in a typographic version of the original by the English artist Richard Hamilton (New York, Wittenborn). The original typography has been reproduced here as closely as possible, within the limitations imposed by the format of this book.

The Bride. skeleton.

The Bride, at her base, is a reservoir of
love gasoline. (or timid-power). This
timid-power, distributed to the motor with
quite feeble cylinders, in contact with the sparks
of her constant life (desire-magneto) explodes
and makes this virgin blossom who has
attained her desire.

Besides the sparks of the desire-magneto, the
artificial sparks which are produced by the
electrical stripping should supply
explosions in the motor with quite feeble
cylinders.

Hence, this motor with quite feeble cylinders has
2 strokes. The 1st stroke (sparks of the
desire-magneto) controls the immobile
arbor-type. This arbor-type is a
kind of spinal column and should be
the support for the blossoming into
the bride's voluntary stripping.
The 2nd stroke (artificial sparks of
the electrical stripping) controls
the clockwork machinery, graphic translation
of the blossoming into stripping
by the bachelors. (expressing the
throbbing jerk of the minute hand
on electric clocks.)

The Bride accepts this stripping
by the bachelors, since she supplies
the love gasoline to the sparks of this
electrical stripping; moreover, she
furthers her complete nudity by adding to
the 1st focus of sparks (electrical stripping)
the 2nd focus of sparks of the desire-magneto.
Blossoming.

From Marcel Duchamp, The Green Box, *translated by George Heard Hamilton*
in The Bride Stripped Bare by Her Bachelors, Even: A Typographic Version
(*New York: Wittenborn, 1960*). *Reprinted by permission of Marcel Duchamp,*
George Heard Hamilton, and George Wittenborn, Inc.

the Bride stripped bare by the bachelors

2 principal elements: 1. Bride
 2. Bachelors

Graphic arrangement.
a long canvas, upright.
Bride above—
bachelors below.

The bachelors serving as an
architectonic base for the Bride
the latter becomes a sort of
apotheosis of virginity.

—Steam engine
on a masonry substructure
on this brick base, a solid foundation,
the Bachelor-Machine fat
lubricious—(to develop.)
 At the place (still ascending)
where this eroticism is revealed (which should
be one of the principal cogs in the
 Bachelor Machine.
 tormented
This gearing gives birth
to the desire-part of the machine
This desire-part—then alters
its mechanical state—which from
steam passes to the state of
internal combustion engine.
(Develop the desire motor,
consequence of the lubricious gearing.)

This desire motor is the last
part of the Bachelor Machine.
Far from being in direct
contact with the Bride. the desire
motor is separated by an air
cooler. (or water).
 This cooler. (graphically)
to express the fact that the
Bride, instead of being merely
an a-sensual icicle, warmly
rejects. (not chastely)

the bachelors' brusque offer this cooler
will be in transparent glass. Several plates
of glass one above the other.,

In spite of this cooler.
there is no discontinuity
between the Bachelor Machine and the Bride.
But the connections. will be. electrical and will thus
express the stripping: an alternating process.
Short circuit if necessary.

Take care of the fastening: it is necessary to stress
the introduction of the new motor: the Bride.

Bride. In general, if this bride motor must
appear as an apotheosis of virginity. i.e.
ignorant desire. blank desire. (with a touch
of malice) and if it (graphically) does not
need to satisfy the laws of weighted balance
nonetheless. a shiny metal gallows
could simulate the maiden's attachment to her girl friends
and relatives. (the former and the latter corresponding graphically
to a solid base. on firm ground, like
the masonry base of the bachelor machine
which also rests on firm ground
 basically
The Bride is a motor. But
before being a motor which transmits her
timid-power—she is this very timid-
power—This timid-power
is a sort of automobiline, love gasoline
that, distributed to the quite feeble cylinders,
within reach of the sparks of her constant
life, is used for the blossoming
of this virgin who has reached the goal of her desire.
(Here the desire-gears will occupy less space
than in the Bachelor Machine.—They are only
the string that binds the bouquet.)
The whole graphic significance is
for this cinematic blossoming.

This cinematic blossoming is controlled
by the electrical stripping (See the passage of the
Bachelor Machine to the Bride)
This cinematic blossoming which expresses
the moment of the stripping, should be grafted on
to an arbor-type of the Bride. This arbor-type
has its roots in the desire-gears. But the cinematic
effects of the electrical stripping, transmitted
to the motor with quite feeble
cylinders, leave (plastic necessity) the

arbor-type at rest—(graphically, in Munich I had already
made 2 studies of this arbor-type)
and do not touch. the desire-gears which
by giving birth to the arbor-type, find
within this arbor-type
the transmission of the desire to the blossoming
into stripping voluntarily imagined by the Bride desiring.

This electrical stripping. sets in motion the
motor with quite feeble cylinders which reveals
the blossoming into stripping by the bachelors
in its action on the clockwork gears.

Grafting itself on the arbor-type—the cinematic
blossoming (controlled by the electrical stripping)
this cinematic blossoming is the
most important part of the painting. (
graphically as a surface)
 It is, in general, the halo of the
Bride, the sum total
of her splendid vibrations: graphically,
there is no question of symbolizing by
a grandiose painting this happy
goal—the Bride's desire; only
more clearly, in all this blossoming,
the painting will be an inventory of the elements
of this blossoming, elements of
the sexual life imagined by her the bride-desiring.
In this blossoming,
The Bride reveals herself nude
in 2 appearances: the first, that of
the stripping by the bachelors. the second
appearance that voluntary-imaginative
one of the Bride. On the coupling of
these 2 appearances of pure virginity—
On their collision, depends the whole
blossoming. the upper part
and crown of the picture.
Develop graphically
Thus 1st the blossoming into the stripping
by the bachelors.
 2nd the blossoming. into the imaginative
stripping by the Bride-desiring.

3rd From the 2 graphic developments obtained
their conciliation. which should be the "blossoming„
without causal distinction.
 Mixture, physical compound of the
2. causes (bachelors and imaginative desire)
unanalysable by logic.

The last state of this nude
bride before the orgasm which
may (might) bring about her fall
 graphically, the need to express,
in a completely different way from the
rest of the painting, this blossoming.

1st Blossoming into the stripping by bachelors.
Electrical control
 This blossoming-effect of the electrical stripping
should, graphically, end in the clockwork
movement (electric clocks in railway stations)
Gearwheels, cogs, etc (develop
expressing indeed the throbbing jerk of the
minute hand.
 The whole in matt metal. (fine copper, steel
silver,

2nd Blossoming as stripping voluntarily
imagined by the Bride-desiring.
 This blossoming should be the refined
development of the arbor-type.
 It is born as boughs on
this arbor-type.
 Boughs frosted in nickel and platinum.
As it gradually leaves the arbor, this blossoming
is the image of a motor car climbing a
slope in low gear. (The car wants more
and more to reach the top, and while
slowly accelerating, as if exhausted by hope,
the motor of the car turns over
faster and faster, until it roars
triumphantly.

3rd Blossoming-crown (Composed
 of the 2 preceding).
 the 1st blossoming is attached
to the motor with quite feeble cylinders.
The 2nd to the arbor-type, of which it is the
cinematic development.
 The arbor-type has its roots in the desire-
gear, a constituent, skeletal part
of the Bride.
 The motor with quite feeble cylinders
is a superficial organ of the Bride; it is activated
by the love gasoline, a secretion of the
Bride's sexual glands and by the electric
 sparks of the stripping.
(to show that the Bride does not refuse

this stripping by the bachelors, even
accepts it since she furnishes the love gasoline
and goes so far as to help towards complete nudity
by developing in a sparkling fashion
her intense desire for the orgasm.

Thus the motor with quite feeble cylinders a
constituent but superficial organ of the Bride, is
the 2 foci of the blossoming
ellipse. (the 1st focus the center of
the blossoming into stripping by the bachelors.
2nd focus, center of the voluntarily
imagined blossoming of the Bride.
2nd focus, actuating the desire gears
(the skeletal part of the Bride) giving
birth to the arbor-type etc.

1913

In the Pendu femelle—and the blossoming

Barometer.
 The filament substance might
lengthen or shorten itself in response to an
atmospheric pressure organized
by the wasp. (Filament substance
extremely sensitive to
differences of artificial
atmospheric pressure controlled by the
wasp).

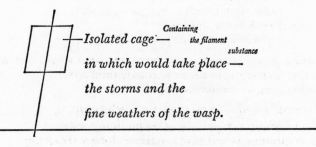

—*Isolated cage*— *Containing the filament substance*
in which would take place —

the storms and the

fine weathers of the wasp.

the filament substance in its meteorological extension
 (part relating the pendu
 to the handler)
resembles a solid flame, i.e.
 having a solid
 force. It licks the ball of the handler
 displacing it
 as it pleases

 The Pendu femelle
 is the form
 in ordinary perspective
 of a Pendu femelle
 for which one could perhaps
 try to discover
 the true form

 ─────────────

 This comes from the
 fact that any
 form is the perspective
 of another form
 according to a certain vanishing point
 and a certain distance

Take a Larousse dictionary and copy all the so-called "abstract,, words.
i.e. those which have no concrete reference.
 Compose a schematic sign designating each of
 these words. (this sign can be composed with the standard-stops)
 These signs must be thought of as the
 letters of the new alphabet.
 A grouping of several signs will determine

(utilize colors—in order to differentiate what would correspond
in this [literature] to the substantive, verb, adverb
declensions, conjugations etc.)

Necessity for ideal continuity. i.e.: each grouping
will be connected with the other groupings by a
strict meaning (a sort of grammar, no longer requiring
 pedagogical

a sentence construction. But, apart from
the differences of languages, and the "figures of speech" peculiar to each
language—; weighs and measure some
<u>abstractions</u> of substantives, of negatives, of
relations of subject to verb etc, by means of standard-signs.
(representing these new relations: conjugations, declensions,
plural and singular, adjectivation inexpressible by
the <u>concrete alphabetic</u> forms of languages
living now and to come.).

 This alphabet very probably is only suitable for the description
of this picture.

The Bride stripped bare by her bachelors even.
to separate the <u>mass-produced readymade</u> from the
<u>readyfound</u>—The separation is an operation.

 Specifications for "Readymades."
 by planning for a moment
to come (on such a day, such
a date such a minute), "<u>to inscribe</u>

a readymade".—The readymade
can later
be looked for. (<u>with</u> all kinds of delays)
 then
 The important thing is just
this matter of timing, this snapshot effect, like
a speech delivered on no matter
 but
what occasion at <u>such and such an hour.</u>
It is a kind of rendezvous.

 —Naturally inscribe that date,
 on the readymade

hour, minute, as <u>information</u>.

<hr>

also the serial characteristic
of the readymade.

Readymade⌐
└►Reciprocal = Use a
Rembrandt as an
ironing-board──●

: shadows cast by Readymades.
shadow cast by 2.3.4. Readymades. "<u>brought together</u>"
(Perhaps use an enlargement of that so as to
extract from it a figure formed by
an equal [length] (for example) taken in each Readymade
and becoming by the projection a part of the cast
shadow

for example 10cm. in the first Rdymade } each
 10cm. — 2nd — } of these 10cm
 etc. } having become
 } a part of
 } the cast shadow

Take these "having become" and from them make a tracing
without of course changing their position in relation to
each other in the original projection.

identifying
To lose the possibility of recognizing
2 similar objects—
 2 colors, 2 laces
2 hats, 2 forms whatsoever

to reach the Impossibility of
 visual
 ‾‾‾‾‾
 sufficient memory,
to transfer
from one
 like object to another
the memory imprint
 ‾‾‾‾‾‾
————Same possibility
with sounds; with brain facts

 Establish a society
 in which the individual
 has to pay for the air he breathes
 (air meters; imprisonment
 and rarefied air, in
 case of non-payment
 simple asphyxiation if
 necessary (cut off the air)

on condition that (?)
 Ordinary brick satiates the knot.
 to be tired of

Man Ray

Man Ray (1890–) was raised in New York and was painting in a Cubist style when he wrote the first text below for the catalogue of an exhibition of American painters influenced by the modern art seen at the Armory Show of 1913. In 1915, however, in Ridgefield, New Jersey, Ray had met Marcel Duchamp, beginning a close and lifelong friendship which was radically to affect his art. When Picabia arrived in New York in 1916, the three launched the as-yet unnamed Dada movement. In 1916–17 Ray experimented with mechanistic collage style (*Revolving Doors*, published in 1926) and invented the "aerograph," or spray-gun technique, the best-known result of which is *The Rope Dancer Accompanies Herself with Her Shadows*, 1918 (Neumann collection, Chicago) and the oil of the same title (Museum of Modern Art, New York), which reflects Duchamp's contemporary *Large Glass*. He also experimented with concrete poetry (see below) but found his real medium in photography. During the Dada period he and Duchamp collaborated on several photographic objects and collages (*Dust-Breeding, Belle Haleine*, and the 1921 film *Anemic Cinema*) and edited the sole number of *New York Dada* in 1921. The same year Ray went to Paris, where he was welcomed into the Dada movement there, and invented the "Rayograph," or cameraless photograph, by placing objects directly on sensitized paper. In 1922 an album of rayographs, *Les Champs Délicieux*, was published with a preface by Tristan Tzara. With most of his Parisian Dada colleagues, Ray later became a Surrealist and made two notable films, *Emak Bakia* (1927) and *Etoile de Mer* (1928). Today he continues to make Dada-Surrealist objects, fashionable fashion and portrait photographs, and in 1963 published an autobiography, *Self-Portrait*.

Statement

Throughout time painting has alternately been put to the service of the church, the state, arms, individual patronage, nature appreciation, scientific phenomena, anecdote, and decoration.

But all the marvelous works that have been painted, whatever the sources of inspiration, still live for us because of absolute qualities they possess in common.

The creative force and the expressiveness of painting reside materially in the color and texture of pigment, in the possibilities of form invention and organization, and in the flat plane on which these elements are brought to play.

The artist is concerned solely with linking these absolute qualities directly to his wit, imagination, and experience, without the go-between of a "subject." Working on a single plane as the instantaneously visualizing factor, he realizes his mind motives and physical sensations in a permanent and universal language of color, texture, and form organization. He uncovers the pure plane of expression that has so long been hidden by the glazings of nature imitation, anecdote, and the other popular subjects.

Accordingly the artist's work is to be measured by the vitality, the invention, and the definiteness and conviction of purpose within its own medium.

Man Ray, [Statement] from The Forum Exhibition of Modern American Painters, *Anderson Galleries, New York (March 1916). Reprinted by permission of Man Ray.*

Statement

Who made Dada? Nobody and everybody. I made Dada when I was a baby and I was roundly spanked by my mother. Now, everyone claims to be the author of Dada. For the past thirty years.

In Zurich, in Cologne, in Paris, in London, in Tokyo, in San Francisco, in New York. I might claim to be the author of Dada in New York. In 1912 before Dada.

In 1919, with the permission and with the approval of other Dadaists I legalized Dada in New York. Just once. That was enough. The times did not deserve more. That was a Dadadate. The one issue of *New York Dada* did not even bear the names of its authors. How

Man Ray, [Statement] for the catalogue of Dada Dokumente einer Bewegung *(Düsseldorf: Kunsthalle, 1958). Reprinted by permission of Man Ray.*

unusual for Dada! Of course, there were a certain number of collaborators. Both willing and unwilling. Both trusting and suspicious. What did it matter? Only one issue. Forgotten—not even seen by most Dadaists or antidadaists. Now, we are trying to revive Dada. Why? Who cares? Who doesn't care? Dada is dead. Or is Dada still alive? We cannot revive something that is alive just as we cannot revive anything that is dead.

Is Dadadead?

Is Dadalive?

Dada is.

Dadaism.

L'Inquiétude

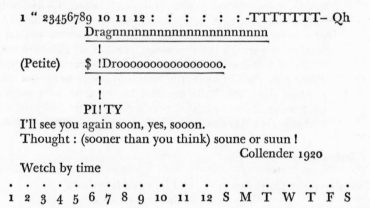

Man Ray, "L'Inquiétude," from the catalogue of Salon Dada (Paris: Galerie Montaigne, June 1921). Reprinted by permission of Man Ray.

Jean Crotti

Jean Crotti (1878–1958) was born in Switzerland, studied painting in Munich and Paris, and went to New York in 1915. From 1917 to 1919 he participated in the (then unnamed) New York Dada group with Duchamp, Picabia, and Man Ray. From 1916 to 1920 Crotti worked with mechanical object images on glass and metal and made collages, objects, and constructions. He is the author of a famous glass-eyed wire portrait of Duchamp, whose sister Suzanne he married in 1920. They returned to Paris where Crotti was active in the Dada movement. In the spring of 1921 he exhibited with his wife at the Galerie Montaigne and launched, probably with Picabia's complicity, a new "religion" called TABU, subject of the initial article in *Pilhaou-Thibaou* printed below, and of a yellow tract, also below, which was handed out on November 1, 1921, to those entering the Grand Palais to see the Salon d'Automne. Although much-mentioned in Picabia's *Pomme de Pins* in 1922, the new movement never got off the ground, since the Dada energies at the time were expended on a series of intramural quarrels. Crotti later invented a new technique of translucent paintings in glass called *gemmaux*.

Innuendo

Into the world I have brought a child, he is a hoodlum,
 that has no importance.
I will make a second child, he will be a good boy,
 that will have no more importance.
I danced on the sidewalk, I put on my dinner jacket to go to bed,
 that has no importance.
I applauded with both hands the idea of indicting Barrès,
 that had no importance.
But the young DADAS, as *Comoedia* calls them, were not at all DADA
in their execution of Barrès,
 and that has importance.
They have committed a crime against the spirit of DADA in not being DADA

Jean Crotti, "Sous-entendu," translated by Margaret I. Lippard from Le Pilhaou-Thibaou (supplement to 391, July 1921). Reprinted by permission of Mrs. Maurice G. Buckles.

that could have no importance whatsoever.
I do not ask that they be brought to trial
that has so little importance.
I ate my piano and polished my ideas
that really has no importance.
My feet have begin to think and wish to be taken seriously,
I think that has no importance either.
And moreover DADA has no more importance because I am TABU-
DADA or DADA-TABU.

Tabu

TABU is in art
A new Thought
A new Expression
A new Religion
ENOUGH of sensuality
of materialism
of naturalism
of deformation

We want to express $\begin{cases} \text{Mystery} \\ \text{That which can not be seen} \\ \text{That which can not be touched} \end{cases}$

Everywhere we surround mystery
Everywhere unknown and invisible things solicit our curiosity
The field of action is infinite for we are trying to express the Infinite
itself
TABU does not address itself to the crowd
is not human
is not social
is not concerned with the plague
syphilis
misery
war
peace

Jean Crotti, "Tabu," translated by Margaret I. Lippard from a tract distributed to visitors to the Salon d'Automne at the Grand Palais, Paris, November 11, 1921. Reprinted by permission of Mrs. Maurice G. Buckles.

TABU is MYSTERY
and wants to express mystery
First attempt at plastic TABU
CHAINLESS MYSTERY [1]

at the Salon d'Automne
by Jean CROTTI
P.S. We entrust this to the meditation of the thinking Elite.

TABU is already no longer new.

[1] Editor's note: *Mystère Acatène (Chainless Mystery)* was Crotti's entry in the Salon d'Automne of 1921. Intended to shock, it was overwhelmed by the scandal surrounding Picabia's entries.

Two Paris Dada Tracts, 1921

Dada Soulève Tout, dated January 12, 1921, was actually distributed on the 15th, since it was aimed at a lecture being given that afternoon at the Théatre de l'oeuvre by F. T. Marinetti, the Italian poet and leader of the Futurist movement. Marinetti had made statements to the press suggesting, not unjustifiably, that Dada was an offshoot of Futurism, and the Dadas came to the lecture in full force. Marinetti was presenting a new idiom called "Tactilism"; it was deflated by Picabia (who traced it to New York Dada) and then shouted down by the rest of the group (Aragon, Breton, Gabrielle Buffet, Péret, Ribemont-Dessaignes, Rigaut, and Tzara). Thus "The Futurist is dead. Of what? Of Dada."

The visit to the unremarkable church of Saint Julien le Pauvre kicked off the Grand Dada Season of 1921, and was the only one of the projected tours listed below to take place. It was advertised by a blue tract handed out on the Boulevard Saint Michel, and took place in the pouring rain before a tolerant audience of about fifty people. Breton spoke on the resurrection of the Dada spirit ("We rediscover ourselves as idiotic as at the first Dada manifestation"); Tzara gave a more poetically Dada speech beginning "Fiacre, shoe, hat, camembert, dancing, ministry, friendship, affair, pants, gasometer, affection, statue, literature, horsemanship, grrrr!!!"; Raymond Duncan, in toga, proposed that all the Dadas run for election. Ribemont-Dessaignes led the guided tour, reading random articles from the Larousse dictionary before each point of interest. The audience then received little surprise packets including obscene pictures and went home. Afterwards, the participants agreed that it had been a failure. (See Michel Sanouillet's *Dada à Paris,* pp. 244–48, for more details.)

DADA EXCITES EVERYTHING

(The signatories of this manifesto live in France, America, Spain, Germany, Italy, Switzerland, Belgium, etc., but have no nationality.)

DADA knows everything. DADA spits everything out.

BUT.......

HAS DADA EVER SPOKEN TO YOU:

about Italy
about accordions
about women's pants
about the fatherland
about sardines
about Fiume
YES – NO *about Art (you exaggerate my friend)*
about gentleness
about D'Annunzio
what a horror
about heroism
YES – NO *about mustaches*
about lewdness
about sleeping with Verlaine
about the ideal (it's nice)
about Massachusetts
YES – NO *about the past*
about odors
about salads
about genius. about genius. about genius
about the eight-hour day
and about Parma violets

NEVER NEVER NEVER

DADA doesn't speak. DADA has no fixed idea. DADA doesn't catch flies.

THE MINISTRY IS OVERTURNED. BY WHOM?

BY DADA

The Futurist is dead. Of What? Of DADA

A young girl commits suicide. Because of What? DADA
The spirits are telephoned. Who invented it? DADA
Someone walks on your feet. It's DADA
YES – NO If you have serious ideas about life,
If you make artistic discoveries
and if all of a sudden your head begins to crackle with laughter,
if you find all your ideas useless and ridiculous, know that

IT IS DADA BEGINNING TO SPEAK TO YOU

"Dada Excites Everything" ("Dada Soulève Tout"), translated by the editor from a collective manifesto dated January 12, 1921.

cubism constructs a cathedral of *artistic* liver paste

WHAT DOES DADA DO?

expressionism poisons *artistic* sardines

WHAT DOES DADA DO?

simultaneism is still at its first *artistic* communion

WHAT DOES DADA DO?

futurism wants to mount in an *artistic* lyricism-elevator

WHAT DOES DADA DO?

unanism embraces allism and fishes with an *artistic* line

WHAT DOES DADA DO?

neo-classicism discovers the good deeds of *artistic* art

WHAT DOES DADA DO?

paroxysm makes a trust of all *artistic* cheeses

WHAT DOES DADA DO?

ultraism recommends the mixture of these seven *artistic* things

WHAT DOES DADA DO?

creationism vorticism imagism also propose some *artistic* recipes

WHAT DOES DADA DO?

WHAT DOES DADA DO?

50 francs reward to the person who finds the best way to explain DADA to us

Dada passes everything through a new net.
Dada is the bitterness which opens its laugh on all that which has been *made consecrated forgotten* in our language in our brain in our habits. It says to you: There is Humanity and the lovely idiocies which have made it happy to this advanced age

DADA HAS ALWAYS EXISTED

THE HOLY VIRGIN WAS ALREADY A DADAIST

DADA IS NEVER RIGHT

Citizens, comrades, ladies, gentlemen
Beware of forgeries!

Imitators of DADA want to present DADA in an *artistic* form which it has never had

CITIZENS,

You are presented today in a pornographic form, a vulgar and baroque spirit which is not the PURE IDIOCY claimed by DADA

BUT DOGMATISM AND PRETENTIOUS IMBECILITY

Paris January 12, 1921

For all information
write "AU SANS PAREIL"
37, Avenue Kléber.
Tel. PASSY 25-22

E. Varèse, Tr. Tzara, Ph. Soupault, Soubeyran, J. Rigaut, G. Ribemont-Dessaignes, M. Ray, F. Picabia, B. Péret, C. Pansaers, R. Hülsenbeck, J. Evola, M. Ernst, P. Eluard, Suz. Duchamp, M. Duchamp, Crotti, G. Cantarelli, Marg. Buffet, Gab. Buffet, A. Breton, Baargeld, Arp., W. C. Arensberg, L. Aragon.

DADA
EXCURSIONS & VISITS

1ˢᵗVISIT:

The Church of
Saint Julien le Pauvre

DADA
A NEW CULT

NEXT VISITS:
Louvre Museum
Buttes Chaumont
St. Lazare Station
Mont du Petit Cardenas
Canal de l'Oureq
etc.

THURSDAY, APRIL 14, at 3 AM
(Saint Julien le Pauvre street—Saint-Michel and Cité Metro)

WE SHOULD CUT OUR NOSES LIKE OUR HAIR

FOOTRACES IN THE GARDEN

The transient dadaists in Paris, wishing to remedy the incompetence of suspect guides and cicerones, have decided to undertake a series of visits to chosen locations, in particular to those which really have no reason to exist.—It is wrong to insist on the picturesque (Janson de Sailly Lycée), historical interest (Mont Blanc), and sentimental value (the Morgue).—The game is not lost but it is necessary to act quickly.—To take part in this first visit is to realize human progress, possible destructions and the necessity to pursue our actions which you will swear to encourage by all means.

WASH YOUR BREASTS LIKE YOUR GLOVES

UP WITH UP•◀DOWN WITH DOWN

Under the direction of: Gabriele BUFFET, Louis ARAGON, ARP, Andre BRETON, Paul ELUARD, Th. FRAENKEL, J. HUSSAR, Benjamin PERET, Francis PICABIA, Georges RIBEMONT-DESSAIGNES, Jacques RIGAUT, Philippe SOUPAULT, Tristan TZARA.
(The piano was kindly put at our disposal by the Gavault company.)

THANKS FOR THE GUN

and just one more time
GOOD DAY

"Dada Excursions and Visits, First Visit: The Church of Saint Julien Le Pauvre," translated by the editor from an anonymous tract dated April 14, 1921.

Francis Picabia

Francis Picabia (1879–1953) was described at his death by his old friend and Dada colleague, Marcel Duchamp, as follows: "Many people respond by 'yes but. . . .' With Francis it was always 'no because. . . .' The incessant windfall of each instant, a multifaceted explosion which cut short all argument, . . . Freshness unceasingly renewed made him 'more than a painter.' " Picabia's sarcasm, wit, and personality were major ingredients of Dada. He had begun as an Impressionist painter, passed through a brief but important phase of nonobjective cubism, and while in New York from 1915 to 1917 made the "object portraits" (Alfred Stieglitz as a camera, himself as an automobile horn, "The American Girl" as a spark plug) that anticipated Dada montage techniques and Surrealist objects as well as making a satirical weapon of Duchamp's machine metaphysics. His Dada machine paintings, most of them made in New York, are generally acknowledged as his most influential work, his refusal to remain in even the most iconoclastic rut having led him to a proto-Op art and then to rather heavy-handed lyricism after the early 1920s.

From New York, Picabia went to Barcelona, where he continued to publish his Dada review *391*, then to Lausanne, where his collection of machine poems (*The Girl Born Without a Mother*) appeared. His arrival in Zurich in January, 1919, was a major event for Dada proper, representing a significant merger which was later to result in a series of explosions when all the Dadas gathered in Paris. There Picabia proved a totally confusing force even for the determined confusion of Dada. His independence led him to attack his colleagues on varying levels of seriousness or levity which are difficult to separate. "Dada is dead. Why did I kill Dada?" he wrote in 1921 when he broke definitively with the movement, having seen the *enfant terrible* becoming "fit for the couturiers." Nevertheless, he continued to publish his own vociferous organs: *391* (1917–24), *Cannibale, Pilhaou-Thibaou* (1921), and *La Pomme de pins* (1922), which was aimed at the tempests surrounding Breton's Congress of Paris. His Dada ballet *Relâche* and the film *Entr'acte* (both first performed in 1924 with music by Eric Satie, the latter filmed by René Clair) were uproarious predictions of Buñel's and Dali's Surrealist films.

DADA Manifesto

The Cubists want to cover Dada with snow; that may surprise you, but it is so, they want to empty the snow from their pipe to bury Dada.

Are you sure?

Perfectly sure, the facts are revealed by grotesque mouths. They think that Dada can prevent them from practising this odious trade: Selling art expensively.

Art costs more than sausages, more than women, more than everything.

Art is visible like God! (see Saint-Sulpice.)

Art is a pharmaceutical product for imbeciles.

The tables turn thanks to spirit; the paintings and other works of art are like strong-box *tables*, the spirit is inside and becomes more and more inspired according to the auction prices.

Farce, farce, farce, farce, farce, my dear friends.

Dealers do not like painting, they recognize the mystery of spirit . . .

Buy copies of autographs.

Don't be snobs, you will never be less intelligent because your neighbor possesses something exactly like yours.

No more fly specks on the walls.

There will be some anyway, that's clear, but a few less.

Dada is certainly going to become less and less detested, its police-pass will permit it to bypass processions chanting "Come, Ducky," what a sacrilege!

Cubism represents the dearth of ideas.

They have cubed paintings of the primitives, cubed Negro sculptures, cubed violins, cubed guitars, cubed the illustrated newspapers, cubed shit, and the profiles of young girls, how they must cube money!!!

Dada itself wants nothing, nothing, nothing, it's doing something so that the public can say: "We understand nothing, nothing, nothing."

The Dadaists are nothing, nothing, nothing—certainly they will come to nothing, nothing, nothing.

<div style="text-align:center">

Francis Picabia

who knows nothing, nothing, nothing.

</div>

Francis Picabia, "Manifeste DADA," translated by Margaret I. Lippard from 391, no. 12 (Paris, March 1920). Reprinted by permission of Mme Olga Picabia.

Art

The principle of the word BEAUTY is merely an automatic and visual convention. Life has nothing to do with what the grammarians call *Beauty*. Virtue, like patriotism, exists only for mediocre intellects who have devoted their entire lives to the tomb. This fountainhead of men and women who regard *Art* as a dogma whose *God* is the accepted convention must be dried up. We do not believe in *God,* no more than we believe in *Art,* or in its priests, bishops, and cardinals.

Art is, and can only be, the expression of contemporary life. *Beauty,* as an institution, uniquely resembles the *Musée Grévin*[1] and ricochets easily off the *souls* of dealers and connoisseurs of *Art,* keepers of the church *Museum* of crystallizations of the past.

Tralala Tralala

We do not advance

We find no nourishment in the *worship* of souvenirs and the representations of Robert Houdin.

You don't understand what we are doing, or do you? Ah well, dear *Friends,* we understand it even less, what luck, eh, you are right.— But do you believe that *God* knew French and English??? ???

You explain *Life* to him in these two beautiful languages Tralala Tralala Tralala Tralala Tralala Tralala.

Now observe with your sense of smell, forget the fireworks of beauty at 100,000, 200,000, or 199,000,000 dollars.

And now I've had enough. Those who do not understand will never understand and those who understand because they have to understand have no need of me.

Francis Picabia, "L'Art," translated by Margaret I. Lippard from Littérature, II, *no. 13 (Paris: February 12, 1920). Reprinted by permission of Mme Olga Picabia.*

[1] Editor's note: Wax museum in Paris.

FRANCIS PICABIA

Is an imbecile, an idiot, a pickpocket!!!

BUT

he saved Arp from constipation!

THE FIRST MECHANICAL WORK WAS CREATED BY MADAME TZARA THE DAY SHE PUT LITTLE TRISTAN INTO THE WORLD, HOWEVER SHE DIDN'T KNOW IT

FUNNY-GUY

FRANCIS PICABIA

is an imbecilic spanish professor who has never been dada
FRANCIS PICABIA IS NOTHING!

FRANCIS PICABIA *likes the morality of idiots*

Arp's binocle is Tristan's testicle

FRANCIS PICABIA IS NOTHING!!!!!!!!!!!

BUT: ARP WAS DADA BEFORE DADA

Binet-Valmer too
Ribemont-Dessaignes too
Philippe Soupault too
Tristan Tzara too
Marcel Duchamp too
Theodore Fraenkel too
Louis Vauxcelles too
Frantz Jourdain too
Louis Aragon too
Picasso too
Derain too
Matisse too
Max Jacob too
etc. . . . etc. . . . etc. . . .

FRANCIS PICABIA IS a wag / IS an idiot / IS a clown / IS NOT a painter / IS NOT a literary man / IS an imbecile / IS a Spaniard / IS a professor / IS NOT serious / IS rich / IS poor

EXCEPTING FRANCIS PICABIA
The only complete artist!

FRANCIS PICABIA *advises you to go see his paintings at the Salon d'Automne and gives you his fingers to kiss* FUNNY-GUY

MEN COVERED WITH CROSSES RECALL CEMETERIES

IF YOU WANT TO HAVE CLEAN IDEAS, CHANGE THEM LIKE SHIRTS

Francis-Picabia, "Funny Guy," translated by the editor from a tract distributed at the Salon d'Automne, Paris, 1921. Reprinted by permission of Mme Olga Picabia.

The Genius and the Fox Terrier

Those who possess a true creative faculty need only express themselves through themselves. The skills they have acquired are only a means to exteriorize themselves more completely in relation to others. They need not look for a personality, a new process, a new representation: the innovation is in them, because there are neither new art nor new men, but simply men with the gift of feeling, then expressing, what others never suspect in their environment. These men with antennas disturb us and attract us; genius can be discovered among them.

The art schools resemble schools for engineers—engineers who invent nothing, but know by heart what others have invented, and who often work to overwhelm very precise machines under the pretext of making "something else." Thus certain artists seek to perfect, to arrange the work of men of genius; they diminish that element which might shock the public; they dress that work in chastity belts or in bathing suits—since the genius is always wrong to manifest himself with so much life and freedom that he frightens those living in hot-houses! And that is why the current "genius" is made up, or looks ill: looking ill is even more fashionable than makeup; it is presented to us as though there were nothing better! However, the true genius is not a fashion, is not a type, does not invent himself: *he is*. Genius is not a curiosity, but the direct manifestation of life.

Today, there are men so malicious that they fabricate false money in a marvelous manner, and there are other men so interested that they accept this false money, by which they are not fooled, in the hopes of passing it on. What always amuses me is that it works. . . .

Art schools have increasingly found ways to mock genius by declaring that everyone who came before them is an idiot: Beethoven? He doesn't exist! Puvis de Chavannes? A bore. Rembrandt? He was good at cold-cuts! . . .

Now, if it is permissible to say that one is not *interested* by those people mentioned above, one cannot deny that they have done something, and even, in my opinion, something better than the art of Mr. Derain, for example. As for the Impressionists, they are treated as poor little painters who might just be permitted to say their prayers in the Cubist temple! Well, I, for one, find that the geniuses created by

Francis Picabia, "Le Genie et le Fox-Terrier," translated by the editor from Comoedia *(Paris: May 16, 1922). Reprinted by permission of Mme Olga Picabia.*

worn-out fantasy, the "flabbergasted types," resemble that bad cassoulet found Saturdays in a certain Montparnasse saloon. This "specialty" is made of trickeries, intrigues, speculations; no one likes it, no one believes in it, but everyone wants to taste it; partly out of snobbery, a good deal more out of the fear of missing a cheap meal. They only regret not having found buyers for the subproducts of their digestion. . . . In the meantime, all this *cuisine* serves the ambition of young and old poets whose only objective is to have their works read in an official theatre by some faker who knows how to amaze the public by blowing rouge in its eyes.

The genius doesn't give a s--- for all that, he loves only his liberty; every jewel box calling itself an *Institution* is a stifling prison. To him, even the chariot of glory seems irksome to drag along. . . .

The genius does not notice that he is alone, or if he notices, he does not complain of it—one is never so alone as among the so-called friends of the so-called movements, the so-called schools and the so-called admirers!

The genius does not think he must "do something": he acts, and does so without preoccupying himself with all those around him who criticize him and gently discourage him from evolving, fearing they will be forced to change their furniture. For many, in fact, to evolve uniquely consists of transporting the bathroom into the kitchen or the parlor into the w.c.! The New Spirit, dear Mr. Ozenfant,[1] director of a review less audacious than *I know all,* is to walk on all fours! That's all our good little modern artists have found out by thinking for so long that men stand on two feet!

Today they are trying to make us believe that everyone can have genius; men would like equality and God has created contrasts, but the hypothesis of God is the genius's image.

I know how dangerous it is to say these things out loud, so listen instead to this little story, and you will understand me:

Out for a walk the other day, in Barcelona, I met a Spanish friend followed by a dog who was a combination of German shepherd and red basset hound! An animal full of arrogance, he seemed not at all conscious of his ridiculousness; his gestures had little in common with his exterior appearance, and he played handsome all the time!

"What is that animal? It's a frightful bastard", I said. My friend looked worried, signaled me to be quiet, and waited until the dog had gone off under a tree. Then he whispered: "You mustn't discuss his race in his presence or he'll bite. He thinks he is a fox terrier!"

[1] Editor's note: The New Spirit refers to *L'Esprit Nouveau,* an art and literature periodical edited by painter-theorist Amadée Ozenfant and Jeanneret (Le Corbusier) in the 1920s.

Thank You, Francis!

One must become acquainted with everybody except oneself; one must not know which sex one belongs to; I do not care whether I am male or female, I do not admire men more than I do women. Having no virtues, I am assured of not suffering from them. Many people seek the road which can lead them to their ideal: I have no ideal; the person who parades his ideal is only an arriviste. Undoubtedly, I am also an arriviste, but my lack of scruples is an invention for myself, a subjectivity. Objectively it would consist of awarding myself the légion d'honneur, of wishing to become a minister or of plotting to get into the Institute! Well, for me, all that is shit!

What I like is to invent, to imagine, to make myself a new man every moment, then forget him, forget everything. We should be equipped with a special eraser, gradually effacing our works and the memory of them. Our brain should be nothing but a blackboard, or white, or, better, a mirror in which we would see ourselves for a moment, only to turn our backs on it two minutes later. My ambition is to be a man sterile for others; the man who sets himself up as a school disgusts me, he gives his gonorrhea to artists for nothing and sells it as dearly as possible to amateurs. Actually, writers, painters, and other idiots have passed on the word to fight against the "monsters," monsters who, naturally, do not exist, who are pure inventions of man.

Artists are afraid; they whisper in each other's ears about a boogeyman which might well prevent them from playing their dirty little tricks! No age, I believe, has been more imbecilic than ours. These gentlemen would have us believe that nothing is happening anymore; the train reversing its engines, it seems, is very pretty to look at, cows are no longer enough! The travelers to this backward Decanville are named: Matisse, Morand, Braque, Picasso, Léger, de Segonzac, etc., etc. . . . What is funniest of all is that they accept, as stationmaster, Louis Vauxcelles, whose great black napkin contains only a foetus!

Since the war, a ponderous and half-witted sentiment of morality rules the entire world. The moralists never discern the moral facts of appearances, the Church for them is a morality like the morality of drinking water, or of not daring to wash one's ass in front of a parrot! All that is arbitrary; people with morals are badly informed, and those who are informed know that the others will not inform themselves.

Francis Picabia, "Francis Merci!" translated by Margaret I. Lippard from Littérature, *n.s. no. 8 (Paris, January 1923). Reprinted by permission of Mme Olga Picabia.*

There is no such thing as a moral problem; morality like modesty is one of the greatest stupidities. The asshole of morality should take the form of a chamber-pot, that's all the objectivity I ask of it.

This contagious disease called morality has succeeded in contaminating all of the so-called artistic milieux; writers and painters become serious people, and soon we shall have a minister of painting and literature; I don't doubt that there will be still more frightful assininities. The poets no longer know what to say, so some are becoming Catholics, others believers; these men manufacture their little scribblings as Félix Potin does his cold chicken preserves; people say that Dada is the end of romanticism, that I am a clown, and they cry long live classicism which will save the pure souls and their ambitions, the simple souls so dear to those afflicted by dreams of grandeur!

However, I do not abandon the hope that nothing is finished yet, I am here, and so are several friends who have a love of life, a life we do not know and which interests us for that very reason.

Cacodylate[1]

Its parade whose effervescence has pitiless boundaries
made a cortege from a vivid pink cacodylate eye
in my life of Swiss overfeeding.
The chaises longues existed after death
which they thought would hide abandon it is clear,
all that, in a bit of crystal doctor
I glory infinitely in ivory trinkets
should I have to suffer today during this long journey
toward the pink negligee in folds like lighted tapers—
Abominably science like a warehouse
restricts the heart with an invisible caress
in something, I don't know what, but circular—
Spiral books represent intimate frailties
of bits of Dresden china lying scattered wherever glides
the lady fugitive floating[2] on chocolate isolation.
She has left me her hand of arsenic hygiene
in this furrowed place of flowing calm
like the entrance to a new marriage bed.

Francis Picabia, "Cacodilate," translated by Margaret I. Lippard from Poèmes et dessins de la fille née sans mère *(Lausanne: Reunies S.A., 1918). Reprinted by permission of Mme Olga Picabia.*

[1] Translator's note: Cacodylate is an acid salt, a combination of methyl and arsenic giving off noxious fumes, used as a medicine in treatment of tuberculosis, malaria, and skin diseases. It may also be used here as a pun on *caca/dilate*, or *caca/the lath (latte)*.

[2] Translator's note: Floating as in floating kidney.

Jean Cocteau

Jean Cocteau (1889–1963) was never an official Dada or Surrealist, though he participated in the movement's activities in Paris, where he was already, and precociously, famous for his poetry and for his collaboration with Picasso, Satie, Diaghelev, and Massine on the ballet *Parade* (1917). He was literary spokesman for "Les Six," had published a novel in 1913 and a book of poems in 1909. By 1917, when he heard about Zurich Dada through Breton, Apollinaire, Reverdy, *et al.*, he was already the "impertinent pageboy of the Champs Elysées quarter and 'grand couturier' of the new spirit" (Marcel Raymond). His ballet *Mariés de la Tour Eiffel* was presented in 1921 as part of the "Grand Dada Season" and he had collaborated on *Anthologie Dada* and other publications. Cocteau particularly admired the radical rejections of Picabia, to whom he wrote in 1920: "I know now why we differ so much and yet can touch each other. You are the extreme left, I am the extreme *right*." (He also called himself spokesman for the "classical left.") The theatrical aspects of Dada certainly attracted him, as did its high spirits and iconoclasm, though his own drawings remained firmly Picassoid, dry, coquettish, over-refined, and elegant. After the Dada period Cocteau spent most of his energies on writing plays and films, the most famous of which are *Le Sang du Poète* (1930–31), *La Machine Infernale* (1932), and *Orphée* (1927, 1950). In 1955 he was elected to the French Academy.

Picabia's Recovery

After a long convalescence, Picabia is cured. I congratulate him. I actually saw Dada leave him through the eye.

Picabia is one of the contagious tribe. He passes on his disease, he does not catch anyone else's.

It is amazing to find another patient of the same type: Tzara, showing all the symptoms of a *sickness contracted from someone else.* Although Tzara is afraid of becoming sympathetic, he is—we

Jean Cocteau, "La Guérison de Picabia," translated by Margaret I. Lippard from Le Pilhaou-Thibaou *(1921). Reprinted by permission of the estate of Jean Cocteau.*

find him very sympathetic. So let us try to find in his *condition* some reason for making him even more sympathetic. For example, it would be a pleasure to learn that he usurps the paternity of the word DADA, of the Dada thing, of the line drawn to put the chickens to sleep. This scandal for his naive gang would relieve him of an official role in relation to us, would finally compromise him, and would perhaps bring him before the Ubu-Dada tribunal.

If every member of the Suicide Club cheats, the dissolution of the club alone can put an end to universal boredom.

Didn't the president of the Suicide-Club-without-result recently try to slip the fatal ace into the cards held by Max Ernst, that amiable photographer?

Coming from the provinces, that is, Germany (let no one infer here any patriotic grievance), Dada fell among us in the height of its sickness. Its first cry: Let us sweep everything away! came just in the nick of time. Alas, I think of the Apollinaire lunch when Cendrars and some of the convivial guests had interrupted Madame Aurel's speech, and M. Napoleon Roynard exclaimed: "Since you don't know how to show respect for a woman we shall see . . . [*sic*] if you know how to listen to a man!" and, as he spoke, drew from his pocket a formidable manuscript.

Shut up! Let's shut up! proclaimed Dada. Then: shut up while I speak. Let me speak like Nietzsche, like Pascal, like Gustave Hervé, like Sarah Bernhardt. Dada gallops along raising a cloud of dust. Urchins jump onto his neck, caress the animal, give him sugar, bedeck him with carnations, pull the reins to the right. Poor wild Dada, here you are in the rue Madame! [1] Madame awakes. Madame opens her shutters. Madame sticks out her head. Madame lowers her eyes. Madame blushes, she doesn't dare!

Madame trembling opens the door. Madame and the stallion begin a veritable honeymoon!

But alas! a stallion is not a tortoise. Dada is dying. Dada is dead. Only the stable boys remain for Madame.

My dear Francis Picabia, how good it is to see you making your get-away by automobile. How fortunate that you are a poor man rich enough to have a large automobile and that you only steal purses that are worth the trouble.

[1] Editor's note: André Breton lived in the rue Madame.

Georges Ribemont-Dessaignes

Georges Ribemont-Dessaignes (1884–) was first a painter, but around 1921 he devoted himself to writing poetry, art criticism, and novels (*Céleste Ugolin* (1926) being the best-known of the latter). His machine drawings and paintings, similar to those of Picabia, appeared in *391, die Schammade, Mecano, de Stijl, Cannibale,* and elsewhere. He collaborated on *Littérature,* the ironically titled organ of early Parisian Dada, and was one of the movement's most active figures. He edited a Dada publication of his own—*Dd O₄H₂*—which never appeared, and was the author of two Dada antitheatre plays, *Le Serin muet* (1919) and *L'Empéreur de Chine* (1916), first performed during a Dada manifestation at the Théatre de l'oeuvre, March 27, 1920. Tzara wrote the preface to Ribemont-Dessaignes' 1920 exhibition at the Galerie Au Sans Pareil, which was entitled "Course in Electric Alpinism and the Breeding of Microcardiac cigarettes." In 1924 Ribemont-Dessaignes published a book on Man Ray and a novel—*L'Autruche aux Yeux Clos.* His work has been described by Samuel Putnam as marked by "an everpresent sense of mystery, by a certain gift of clairvoyance, and by an extraordinary degree of energy." In 1931 he wrote a history of Dada for *La Nouvelle Revue Française* that provided the basis for his book *Déja jadis; ou du Mouvement Dada à l'espace abstrait* (Paris, 1958).

Buffet

Art? Not Art?

Dada is against Art. Which means?
If you touch your fingers to dada flesh it comes away damp, sticky, and smelly. Odor *sui generis* [*sic*]. Rejecting Art internally, the Dadas secrete it externally. We must be fair, it is not their fault. Not the fault of all of them. In other men Art is at ease inside and outside.

Georges Ribemont-Dessaignes, "Buffet," translated by Margaret I. Lippard from *Littérature, no. 19 (Paris, May 1921).* Reprinted by permission of Georges Ribemont-Dessaignes.

Sitting on this milestone we may ask ourselves if Dada is anything more than a new literary, pictorial, etc. school—And then damn it! What military music to accompany the return to the barracks. D'Annunzio, however, is a horse of another color.

But it must be said: NO. You understand: NO, NO, no. And then the little bird goes on singing forever: one day, and another day, and then another day.

Here we are—all enemies, each his own grenade. Burst? Dada, dada, dada. Bits scattered about. All at once, Art. A new minute is being born. Twenty-six candles, then Art. There are thus some metals that cannot be left lying around. Venus in the sea is only a fish. On land, she is a great artist.

Poetry: Art; not Poetry: Art. Words like a game: Art. Pure sentences: Art. One sole meaning: Art; no meaning: Art. Words drawn by lot: Art. Mona Lisa: Art. Mona Lisa with mustaches: Art. Shit: Art. Newspaper announcement: Art.

We don't want it. But after a second and one glance, that's that. With all the more reason on the page of a book. And when Dada is cited. Oh, my God!—there are also those who are concerned with themselves and aspire to the papacy. On each step they leave the coagulated imprint of their personality. Yes, Yes, they express themselves: if they look at their feet out of the corner of an eye they are indeed obliged to realize that they have walked in art. Moreover, this brings happiness, and it is not the crowd that will hold it against them. What is only a repeated cutting of the personal diamond cannot appear to be art. The action of each facet on the spectator's mind takes care of deflowering the virgin.

What is to be done? Act against oneself? Art.

There remains the purge. Certainly the masses as they now stand will immediately fashion an artistic undergarment from the result of this purge, and will resell it deodorized at a reduced price. Dear friend, don't buy it.

Purge yourself. And don't let momentary reason appear and say: it smells bad—because its whole purpose is to clean itself. And the very principle of our cleaning is to offer its residue on the same plane as the perfumed breath of our health.

As for the famous diamond, don't look for it in there. Neither there nor elsewhere. It is enough to recognize it in your stomach thanks to X-rays guaranteed to give you the potbelly of Art.

And afterwards? There is no afterwards. Purge yourself forever. Aside from that, take up the grocery business, farming, medicine, business with Abyssinia, politics, assassination, philosophy, suicide, and even Art.

And Dada?
Dada, is —No, no.
But of course,

The Delights of Dada

Dada, like everyone, has his pleasures. Dada's principal pleasure is to see himself in others. Dada provokes laughter, curiosity, or anger. As these are three very attractive qualities, Dada is very happy.

Dada is still more happy when he is spontaneously laughed at. Since Art and Artists are very serious inventions, especially when they resort to the comic, one goes to the Comique[1] to laugh. Nothing of that here. We take nothing seriously. Thus they laugh, but only to make fun of us. Dada is very happy.

Curiosity is also aroused. Honest men, who know in their hearts how miracles like those of Father Colic or the tears of the Virgin are prepared, say to themselves that it would be more amusing to amuse themselves with us. Nor do they want to raze the whole Sacred Heart of Art, rather they rub shoulders with us to discover our recipe. Dada has no recipe, but it is always hungry. Dada is very happy.

As for anger, it is delicious. That is how great loves begin. The only concern for the future would be to be too well-loved. True, there would still remain the capacity to reverse the roles and laugh, desire, or become angry in our turn. (But what profit is there in waiting?) The beautiful mouth of someone who is vomiting insults is wide open, and Dada knows very well how to play at low-ball. Dada is very happy.

Georges Ribemont-Dessaignes, "Les Plaisirs de Dada," translated by the editor from Littérature, *no. 13 (Paris, May 1920). Reprinted by permission of Georges Ribemont-Dessaignes.*

[1] Translator's note: Opéra Comique.

Dada also loves to throw stones in the water, not to see what will happen, but to gaze stupidly at the little waves. Fishermen do not like Dada.

Dada loves to ring doorbells, to strike matches, to set fire to hair and beards. He puts mustard in the ciboriums, wine in the holy-water fonts, and margarine in the color tubes of painters.

He knows you and knows those who lead you. He loves you and does not love them. With you one can have fun. You probably love living, but have bad habits. You are too fond of what you have been taught to like. Cemeteries, melancholia are tragic loves. Venetian gondolas. You bay at the moon. You believe in Art and respect Artists.

It is enough to demolish all your little castles of cards and to restore your complete freedom, then you become friends of Dada. Beware of those who lead you. They are merely using your thoughtless love of fakery and posing to lead you by the nose for their own gain.

Are you so fond of your chain that you can be used with impunity as a dancing carnival bear? They flatter you and call you wild bears, Carpathian Bears. They speak of freedom and high mountains. This is to harvest the tithes of the bourgeois spectators. For a rotting carrot and the smell of honey, you dance. If you were not cowardly and enfeebled by being forced to look too long upon nonexistent heights and abstractions and all the humbug mounted in dogma, you would stand up straight, and you would, like us, play the massacre game. But you are afraid of no longer believing, and of bobbing like corks on the surface of a can of sparkling lemonade. You do not realize that one can be attached to nothing and still be joyful.

If the day should come when you snap out of it, Dada will rattle his jawbones as a sign of friendship. But if you get rid of the bedbugs to keep the flea-bags, Dada will use his little bug-bomb.

Dada is very happy.